The Native American Indian Artist Directory

by
Robert Painter

First Nations Art Publishing
Albuquerque, New Mexico
1998

The Native American Indian Artist Directory
First Edition - Copyright 1998
by Robert Painter
All rights reserved

Grateful acknowledgment is given to Navajo artist R.C. Gorman for his endorsement of this publication and to the many fine Native artists who add so much to our daily lives through the expression of their talents in such a wide variety of forms.

A special thanks to talented Yaqui designer Michelle Sauceda-Halliday for appearing on the cover wearing one of her beautiful dresses, and to her daughter Tisha, for being such a lovely young lady and making the photo session a delight!

And thanks to my good friend Alvina Yepa, award winning Jemez potter, for providing the beautiful pottery in Michelle's hands.

Published by
First Nations Art Publishing
P. O. Box 7596
Albuquerque, NM 87194

ISBN 0-9668806-0-9

Library of Congress # 98-96874

Printed in the United States by:
The New Valliant Co., 615 Gold Ave. S.W., Albuquerque, NM 87102
(A Native - owned company to whom we owe a debt of gratitude for helping make it possible to bring this project to completion.)

Table of Contents

Introduction Page 1

Acoma Page 7

Apache Page 17

Cherokee Page 21

Cochiti Page 29

Hopi Page 35

Isleta Page 53

Jemez Page 57

Navajo Page 69

San Felipe Page 141

San Ildefonso Page 145

Santa Clara Page 149

Santo Domingo Page 161

Sioux Page 175

Zuni Page 183

Table of Contents

Other Tribes Page 191

Conclusion Page 231

Index Page 233

About The Author Page 273

Notice to Artists Page 275

Introduction

Welcome to Indian Country. As you will see when you explore this directory, Indian Country can be almost anywhere! And Indian artists can be found wherever you travel in the United States. We're here to help you find the art you like and the artist who made it. At the same time you will have the wonderful experience of meeting the artist and sharing the meaning of the art directly. Rather than getting a secondhand interpretation that may lose a great deal in the translation from artist to original buyer to wholesaler to gallery or shop owner to you, you will have the opportunity to hear in person exactly what meaning or significance your newly acquired piece of art holds for the maker - and for you!

I would add, however, that some gallery owners have excellent rapport with their artists and because of their knowledge and experience can elicit a great deal of information from the artists that we may not even know to ask. And, in many cases, the art dealers have been responsible for the continuation, development and refinement of the art in which they deal.

This directory will take you on a trip through the vast reservation land of the Navajos, to the small, intimate villages like the Jemez and Acoma Pueblos and into the city where many of the fine Native artists have moved

to be closer to their final markets. These artists may be found in Alaska, Massachusetts, Florida, California, the Great Southwest or anywhere in between.

Not every artist has a phone number. Many use message phones with friends, relatives or nearby trading posts where they can be reached indirectly. Most have mailing addresses, although often these, too, are temporary or "borrowed." Some have e-mail and still others have websites. You will be given in this directory as much information as is possible to assist you in making contact with more than 2,000 artists.

Obviously, we cannot publish photos of all the artists or even of their artwork. This book would be too heavy to carry on your journey to Indian Country! We will provide you with the name, address, phone number, tribal affiliation, type of art and frequently, some description of the artwork.

Many of the artists have brochures, lists of awards, and other literature that they will gladly send you. We strongly recommend that you enclose a large self-addressed stamped envelope if you write to those who have no listed phone number. If you call, you may wish to ask if they have something to send. Some may have photographs or may be able to tell you where their art is available to be seen. Many of these artists have their work in major museums around the country,

including the Smithsonian, Eiteljorg, Maxwell, Heard, Pueblo Grande and others. Many have photos of their work in major art publications such as Southwest Art, Art of the West, American Indian Art, Indian Artist, Native Peoples, Cowboys & Indian, Yippy-Yi-Yea Western Lifestyles, and others. Some of the artists can tell you what back issues of these publications to check to find feature articles about them and their work. Your library or local book store may be an excellent source for additional reference information about individual artists.

We won't try to provide you with maps - AAA and a number of other services can provide far better maps made by professional cartographers than we could hope for - but we will provide some general directions and instructions to get you into the villages you wish to visit. And, we will also give you some estimated driving times and maybe a few recommendations about how far to try to go in one day. We'll even throw in a few sightseeing suggestions and tell you when we think is a good time to visit.

In order to make it easier to find the artist you may be looking for, or the type of artwork you may be seeking, we will place our information in alphabetical order. The tribal affiliation will be the main heading and the artists will be listed alphabetically by their last names. Sometimes you will find what appears to be the

same artist listed twice - well, it's either an error on our part, or there are two artists by the same name - you will see that the addresses are different, or the artist has two addresses and we weren't able to determine that it was the same person at both places. We have tried hard to make this directory as current as possible, but since many of the artists travel to shows, live for extended periods with relatives, or are just difficult to contact, we can't promise to be 100% accurate. But we do promise that you will be able to reach many of these artists if you wish and we feel confident that you will have a truly remarkable experience if you make the effort! We personally travel to a large number of Native art events on a regular basis and keep in frequent phone and mail contact with many artists as well.

Not all the tribal affiliations will be listed in the main chapters. Some of the groups for which we have fewer artists listed will be placed together under a separate section, although still listed alphabetically by tribal affiliation and by name.

We would like to make one final suggestion. When you find the artwork you like, buy it. But don't buy it just because it won a ribbon or prize. Make the purchase because the art calls out to you and has some meaning for you. The ribbons may fade over time and their meaning may become lost, but the significance of the artwork will have meaning to you for a lifetime.

Remember that the award does not necessarily mean that this is the artists' best work. I have often seen beautiful pieces displayed by an artist alongside award winning pieces that I thought were much nicer than the award winning pieces. In reality the judges might have even agreed with me, but the piece that won the award was the one that the artist chose to enter into the competition. *The judges never even saw the other pieces!* So don't be afraid to trust your own judgment. Unless you're a dealer and planning to sell the piece, you're the one who will live with the artwork so pick the one that has the most compelling attraction for you and forget about the ribbons. The awards speak of the quality of the workmanship and this workmanship will likely be apparent in the artist's other work as well.

To any artists we may have excluded, we apologize and suggest that you send your information to us immediately to be included in our annual supplement, that will provide listings of additional artists and corrected information. Also, any artists in the directory with incorrect addresses, phone #'s, etc. that you would like to have updated, please provide that information as well.

We hope you enjoy using the directory. We do plan to expand it greatly in the future and will consider any suggestions made to improve the directory. Happy trails – enjoy your visit to Indian Country!

Acoma Pueblo - Sky City

Acoma Pueblo is a perfect place to begin your adventures in Indian Country. Situated just an hour west of Albuquerque on I-40 and about 15 minutes south on SR 23, the village of Acoma dates back to around 1100 to 1200 AD. The San Esteban Del Rey Mission atop Sky City was constructed about 1629. You can learn more of the history of this enchanting place when you visit. You will have to register at the visitor's center at the bottom of the mesa and take a bus to the top - about $5 or $6 and well worth it. And if you don't feel like driving you can take a Gray Line tour from Albuquerque.

Some of the fabled Acoma potters will have items for sale at Sky City, but you will also find others by driving around the small surrounding areas where many of the Acoma residents live. You may want to call some numbers before you leave Albuquerque if there are specific people you wish to see, but if you wait till you get to the area you should still be able to find a few people at home. There is a trading post near the I-40 exit or you can use a pay phone at the Casino - you can't miss it on the north side of I-40 with all the trucks parked on the west side. You can also stop and ask directions from residents you see in their yards, but they might not know if the person you're seeking is home.

Acoma Pueblo

Two of my favorite potters in Acoma are Emma Lewis Mitchell and Delores Lewis Garcia, daughters of the late Lucy Lewis, who I first met while working in Gallup, NM. Emma and Delores are both fabulous potters and I know you'll enjoy meeting them if you get a chance. They make pottery with traditional Acoma designs and the old Mimbres designs as well. Emma lives a few miles west of the casino, just off I-40, but call first for directions and make sure she's at home. Between them they have won many awards and have an excellent video tape showing you exactly how they make their pottery in the traditional manner. I hope I remember to list the tape at the end of the book so you can buy a copy. Be sure and tell them Bob Painter sent you and maybe they'll give you a special deal! If you can find Dorothy Torivio at home, you'll see some of the most amazing painted designs on pottery you will ever hope to see. There are many more wonderful artists in the Acoma area as you will see from the following list.

I'd love to tell you more about Acoma, but since this isn't a travel guide, I'll just give you the list of artists that I promised. Good luck and enjoy your adventures in Acoma.

Acoma

Tamra L. **Abeita** — *Acoma*
 Pottery: Trad. & Contemp.; P.O. Box 21212, Carson City,
 NV 89721; (702) 841-5831; E-mail: Wuffie@webtv.net

Burgess P. **Abeita-James** — *Acoma*
 Pottery: Trad. & Contemp.; P.O. Box 21212, Carson City,
 NV 89721; (702) 841-5831; E-mail: PrinceB@webtv.net

Jose **Antonio** — *Acoma*
 Pottery: Handmade/Contemp.; P.O. Box 289, Acoma
 Pueblo, NM 87034

Melissa **Antonio** — *Acoma*
 Pottery: Traditional & Ceram.; P.O. Box 464, San Fidel,
 NM 87049; (505) 552-0246

Mildred **Antonio** — *Acoma*
 Pottery: Traditional & Ceram.; P.O. Box 464, San Fidel,
 NM 87049; (505) 552-0246

Clarice **Aragon** — *Acoma*
 Pottery: Pottery Balloons; 12621 Lomas Blvd. NE #14,
 Albuquerque, NM 87112; (505) 294-9644

Wanda **Aragon** — *Acoma*
 Pottery: Traditional; 12621 Lomas Blvd. NE #14,
 Albuquerque, NM 87112; (505) 294-9644

Marvis **Aragon, Sr.** — *Acoma*
 Pottery: Anasazi; 12621 Lomas Blvd. NE #14,
 Albuquerque, NM 87112; (505) 294-9644

Debbie G. **Brown** — *Acoma*
 Pottery: Traditional; P.O. Box 279, Acoma, NM 87034;
 (505) 552-7187

Irene **Castillo** — *Acoma*
Pottery: Storytellers & Minis; P.O. Box 5, Grants, NM
87020; (505) 552-9371

Darrell **Chino** — *Acoma*
Pottery; P.O. Box 472, Acoma, NM 87034; (505) 552-9325

Diana **Chino** — *Acoma*
Pottery; P.O. Box 273, Acomita, NM 87043; (505) 552-7692

Donna **Chino** — *Acoma*
Pottery; P.O. Box 472, Acoma, NM 87034; (505) 552-9325

Emil **Chino** — *Acoma*
Pottery: Trad. & Ceramic; P.O. Box 224, Acoma Pueblo,
NM 87034; (505) 552-7413

Velma **Chino** — *Acoma*
Pottery: Storytellers; P.O. Box 427, Acoma, NM 87034;
(505) 552-6423

Carrie **Chino-Charlie** — *Acoma*
Pottery; P.O. Box 463, San Fidel, NM 87049;
(505) 552-9243

Carolyn **Concho** — *Acoma*
Pottery: Trad. & Mimbres; P.O. Box 284, Acoma Pueblo,
NM 87034; (505) 552-7177

Frances **Concho** — *Acoma*
Pottery: Traditional; P.O. Box 273, San Fidel, NM 87049;
(505) 552-6788

Isidore **Concho** — *Acoma*
Pottery: Traditional; P.O. Box 273, San Fidel, NM 87049;
(505) 552-6788

Prudy **Correa** — *Acoma*
Pottery; P.O. Box 522, Isleta, NM 87022; (505) 869-6325

Darla K. **Davis** — *Acoma*
Pottery: Trad. & Contemp.; P.O. Box 60, Acoma, NM 87034; (505) 552-6473 (Messages)

Paula C. **Dominguez** — *Acoma*
Pottery; P.O. Box 45, San Fidel, NM 87049; (505) 552-6829

Charleen J. **Estevan** — *Acoma*
Pottery & Baskets: Traditional; P.O. Box 141, San Fidel, NM 87049; (505) 552-9061

Corrine **Garcia** — *Acoma*
Pottery: Storyteller-S.Bowls; San Fidel, NM 87049; (505) 552-9698

Marcus **Garcia** — *Acoma*
Pottery: Traditional & Ceram.; P.O. Box 524, San Fidel, NM 87049; (505) 552-9556

Margaret **Garcia** — *Acoma*
Pottery: Storytellers; P.O. Box 73, Acoma, NM 87034; (505) 552-6772

Sheryl **Garcia** — *Acoma*
Pottery: Traditional & Ceram.; P.O. Box 524, San Fidel, NM 87049; (505) 552-9556

Virginia **Garcia** — *Acoma*
Pottery: Traditional & Ceram.; P.O. Box 524, San Fidel, NM 87049; (505) 552-9556

W. **Garcia** — *Acoma*
Artist; P.O. Box 184, San Fidel, NM 87049; (505) 552-6418

Wilfred **Garcia, Sr.** — *Acoma*
Pottery; P.O. Box 184, San Fidel, NM 87049; (505) 552-6418

Mavis **Hayah** — *Acoma*
Pottery; P.O. Box 163, Acoma, NM 87034; (505) 552-6409

B. Greg **Histia** — *Acoma*
 Pottery: Corrugated & Trad.; P.O. Box 324, Acomita, NM 87034; (505) 552-9043

Jackie S. **Histia** — *Acoma*
 Pottery: Corrugated & Trad.; P.O. Box 324, Acomita, NM 87034; (505) 552-9043

Darius L. **James** — *Acoma*
 Pottery: Scraffito; P.O. Box 487, Acoma, NM 87034; (505) 552-6473

Rachel W. **James** — *Acoma*
 Pottery: Trad. & Contemp.; P.O. Box 487, Acoma, NM 87034; (505) 552-6473

Marie S. **Juanico** — *Acoma*
 Pottery: Traditional; P.O. Box 82, San Fidel, NM 87034; (505) 552-9683

Marietta P. **Juanico** — *Acoma*
 Pottery: Traditional; P.O. Box 88, Acoma Pueblo, NM 87034; (505) 552-6285

WayaGary **Keene** — *Acoma*
 Artist; P.O. Box 353, Acoma, NM 87034; (505) 552-6452

Melvilla R. **Kelsey** — *Acoma*
 Pottery: Trad. & Contemp.; 3730 N. Oracle Rd. #9, Tucson, AZ 85705

Regina **Leno-Shutiva** — *Acoma*
 Pottery; NM

Bernard **Lewis** — *Acoma*
 Pottery; P.O. Box 425, Acoma Pueblo, NM 87034; (505) 532-0361

Carmel **Lewis** — *Acoma*
 Pottery: Traditional/Anasazi; P.O. Box 35, San Fidel, NM
 87049

Carmen **Lewis** — *Acoma*
 Pottery: Trad. & Ceramic; P.O. Box 224, Acoma Pueblo,
 NM 87034; (505) 552-7413

Sharon **Lewis** — *Acoma*
 Pottery: Mimbres Design; P.O. Box 425, Acoma Pueblo,
 NM 87034; (505) 532-0361

Dolores **Lewis Garcia** — *Acoma*
 Pottery: Traditional/Anasazi; P.O. Box 56, San Fidel, NM
 87049; (505) 552-6534

Anne **Lewis Hanson** — *Acoma*
 Pottery: Traditional; 8239 Pinefield Dr., Antelope, CA
 95843; (916) 332-0356

Emma **Lewis Mitchell** — *Acoma*
 Pottery; P.O. Box 95, San Fidel, NM 87049; (505) 552-9295

Deann **Louis** — *Acoma*
 Pottery: Traditional; 103 Horace Rd., Grants, NM 87020;
 (505) 552-9774

Earl **Louis** — *Acoma*
 Pottery: Traditional; 103 Horace Rd., Grants, NM 87020;
 (505) 552-9774

Gerri **Louis** — *Acoma*
 Pottery: Traditional; 103 Horace Rd., Grants, NM 87020;
 (505) 552-9774

Irvin **Louis** — *Acoma*
 Pottery; 224 Paseo Del Volcan SW #236, Albuquerque,
 NM 87121

Reycita R. **Louis** — *Acoma*
Pottery; P.O. Box 344, San Fidel, NM 87049;
(505) 552-9321

Virginia **Lowden** — *Acoma*
Pottery: Traditional; P.O. Box 613, San Fidel, NM 87049;
(505) 552-6242

Rebecca **Lucario** — *Acoma*
Pottery; P.O. Box 421, Acoma, NM 87034

Sarah **Martinez** — *Acoma*
Pottery: Trad. & Storytellers; P.O. Box 261, San Fidel, NM
87049; (505) 552-7488

Angelina **Medina** — *Acoma-Zia-Zuni*
Pottery; P.O. Box 703, Zuni, NM 87327; (505) 782-4333

Karen **Miller** — *Acoma*
Pottery: Traditional/Ceramic; P.O. Box 735, Acoma
Pueblo, NM 87034; (505) 552-7441

Merlinda **Miller** — *Acoma*
Pottery: Traditional/Ceramic; P.O. Box 735, Acoma
Pueblo, NM 87034; (505) 552-7441

Charmae S. **Natesway** — *Acoma*
Pottery; P.O. Box 15, Acoma, NM 87034

Thomas **Natseway** — *Acoma*
Pottery: Miniatures; P.O. Box 15, Acoma, NM 87034

Evelyn **Ortiz** — *Acoma*
Pottery; P.O. Box 307, San Fidel, NM 87049;
(505) 552-9262

Georgia **Patricio** — *Acoma*
Pottery; P.O. Box 71, San Fidel, NM 87034; (505) 552-9061

Leo **Patricio** — *Acoma*
Pottery; P.O. Box 71, San Fidel, NM 87034; (505) 552-9061

Lionel **Patricio** — *Acoma*
Pottery; P.O. Box 71, San Fidel, NM 87034; (505) 552-9061

Marilyn **Ray** — *Acoma*
Pottery: Storytellers; 1300 Wilmoore, Albuquerque, NM 87106; (505) 246-8419

Maria "Lilly" **Salvador** — *Acoma*
Pottery: Traditional; P.O. Box 342, Acoma Pueblo, NM 87043; (505) 552-9501

Caroline **Sarracino** — *Acoma*
Pottery: Trad. & Contemp.; P.O. Box 444, San Fidel, NM 87049; (505) 552-7471

Judy **Shields** — *Acoma*
Pottery: Storytellers/Figurines; P.O. Box 235, Acoma, NM 87034; (505) 891-2473

Stella **Shutiva** — *Acoma*
Pottery; P.O. Box 22, San Fidel, NM 87049; (505) 552-9411

Melody **Simpson** — *Acoma*
Pottery: Etched/sculptures; P.O. Box 137, Acoma, NM 87034; (505) 552-7458

Dorothy **Torivio** — *Acoma*
Pottery; P.O. Box 181, Acoma, NM 87034

Frances **Torivio** — *Acoma*
Pottery; P.O. Box 301, Acoma, NM 87034

Jackie **Torivio** — *Acoma*
Pottery: Traditional; P.O. Box 429, Acoma Pueblo, NM 87034; (505) 552-9443

Mike **Torivio** — *Acoma*
Pottery: Traditional; P.O. Box 429, Acoma Pueblo, NM 87034; (505) 552-9443

Gary N. **Toya** — *Acoma*
 Pottery: Trad. & Contemp.; P.O. Box 277, Jemez Pueblo, NM 87024; (505) 834-7319

Inez V. **Toya** — *Acoma*
 Pottery: Trad. & Contemp.; P.O. Box 277, Jemez Pueblo, NM 87024; (505) 834-7319

Delma **Vallo** — *Acoma*
 Pottery: Traditional; 103 Horace Rd., Grants, NM 87020; (505) 552-9774

Freida H. **Vallo** — *Acoma*
 Pottery: Traditional; 103 Horace Rd., Grants, NM 87020; (505) 552-9774

Kim M. **Vallo** — *Acoma*
 Pottery: Trad. & Contemp.; 2620 Duranes Rd. NW, Albuquerque, NM 87104; (505) 244-9584

Sandra **Victorino** — *Acoma*
 Pottery: Traditional Fineline; P.O. Box 178, Acomita, NM 87034; (505) 552-7208

Shyatesa **White Dove** — *Acoma*
 Pottery; 1124 Palomas SE, Apt.A., Albuquerque, NM 87108; (505) 262-9191

Apache

You may not have thought of Apaches as artists, but maybe you've been watching too many old Western movies. I can assure you that there a number of exceptionally fine artists on our list.

Most of our artists are concentrated in New Mexico and Arizona. The Jicarilla and Mescalero Apaches in New Mexico and the San Carlos Apaches in Arizona.

If you go to Arizona look for the baskets of Velveeta Volante, Evelyn Henry and others. Philip Titla and Duke Sine are award winning two-dimensional artists from Arizona that you won't want to miss.

In Santa Fe you can see the works of outstanding sculptors Craig Dan Goseyun and Robert Garcia, winners of many awards from many major art events. Also, the very fine silverwork of Apache/Navajo artist Gibson Nez.

And northwest of Santa Fe in Dulce on the Jicarilla Apache reservation you may find the Pesata family and others who make the unique Apache "burden" baskets.

In the Washington, D.C. area look for the beadwork of Mary Velarde. Apache Country can be anywhere!

Apache

Charles P. **Acuna** — *Apache*
Artifacts; P.O. Box 1681, Taos, NM 87571; (505) 758-1262

Andrew **Alvarez** — *Apache-Yaqui*
Jewelry: Gold, Silver, Inlay; Long Beach, CA;
(562) 423-7059

MaryJane **Dudley** — *Apache*
Baskets; P.O. Box 779, San Carlos, AZ 85550

Oliver **Enjady** — *Apache-Mescalero*
Artist: Paintings, Sculpture; P.O. Box 624, Mescalero, NM
88340; (505) 671-4693

Robert **Garcia** — *Apache*
Sculptor; Rt. 20, Box 33T, Santa Fe, NM 87501;
(505) 471-3222

Craig Dan **Goseyun** — *Apache-San Carlos*
Sculptor: Bronze, Stone, Steel; 1704B Llano, #304, Santa
Fe, NM 87505; (505) 471-928

Evelyn **Henry** — *Apache*
Baskets; P.O. Box 305, San Carlos, AZ 85550

Tyron **Hoahwah** — *Apache-Comanche*
Artist: Sculptor/Silversmith; P.O. Box 786, Mescalero,
NM 88340; (505) 671-9176

Crystal M. **Julian** — *Apache-Jicarilla*
Pottery: Micaceous; P.O. Box 315, Dulce, NM 87528;
(505) 759-3737

Rainey **Julian** — *Apache-Jicarilla*
Jewelry: Silver; P.O. Box 315, Dulce, NM 87528;
(505) 759-3737

Arlene **Kast** — *Apache*
 Dolls: Trad. & Contemp.; P.O. Box 546, San Carlos, AZ 85550

Yolanda **Martinez** — *Apache*
 P.O. Box 735, Fairview, NC 28730; (704) 628-0003

Julian **Nez** — *Apache-Navajo*
 Jewelry; 3233 Stella Rd., Prospect, TN 38477; (615) 424-3330

Sheldon **NunezVelarde** — *Apache-Jicarilla*
 Pottery & Beadwork, Dolls; P.O. Box 974, Dulce, NM 87528

Thelma **Padilla** — *Apache*
 Baskets; P.O. Box 305, San Carlos, AZ 85550

Melvin **Pasata** — *Apache-Jicarilla*
 Sculptor; P.O. Box 964, Dulce, NM 87528; (505) 759-3562

Joan **Pesata** — *Apache-Jicarilla*
 Baskets; P.O. Box 114, Dulce, NM 87528; (505) 759-3298

Lydia **Pesata** — *Apache-Jicarilla*
 Baskets; P.O. Box 114, Dulce, NM 87528; (505) 759-3298

Melanie **Pesata** — *Apache-Jicarilla*
 Baskets; P.O. Box 114, Dulce, NM 87528; (505) 759-3298

Evelyn **Rope** — *Apache*
 Baskets; P.O. Box 718, San Carlos, AZ 85550

Beverly Jose **Sacoman** — *Apache-Mescalero*
 Artist; 80 Apache Ridge, Santa Fe, NM 87505; (505) 466-3968

Duke W. **Sine** — *Apache*
 Artist: Graphics, Paintings; P.O. Box 1045, Sells, AZ 85634; (520) 383-2544

Philip **Titla** — *Apache*
 Artist; P.O. Box 497, San Carlos, AZ 85550; (520) 475-2405

Gordan **Torres** — *Apache-San Carlos*
 Artist; 121 SecondCanyon, Mescalero, NM 88340;
 (505) 257-6739

Cris **Velarde** — *Apache*
 Pottery: Micaceous; 9 S. Santa Clara, Espanola, NM
 87532; (505) 753-8485

Mary M. **Velarde** — *Apache-Jicarilla*
 Beadwork: Jewelry; 2132 Massachusetts Ave.,
 Washington, DC 20008; (202) 496-9474

Carson N. **Vicenti** — *Apache*
 Artist; P.O. Box 874, Dulce, NM 87528; (505) 759-3434

Velveeta **Volante** — *Apache*
 Baskets; P.O. Box 1254, Oracle, AZ 85623; (520) 896-2901

Cherokee

This is probably one of the more geographically diverse groups of artists in the directory. The list runs from Florida to California with larger numbers in Oklahoma and Texas. Even New Jersey and Alabama. You may not have to leave home to find a fine Cherokee artist!

This group includes a large percentage of two dimensional artists, including John White, Ron Mitchell and Bill Rabbit, all from Oklahoma and all whom you'll enjoy meeting. If you're lucky enough to catch John White at an art show, you'll get to see him work right before your eyes – he has an amazing talent to work with you and create just the image that you're looking for! And when you find Bill Rabbit, you'll probably find his daughter Traci, another fine Cherokee artist. Ron Mitchell's work is always beautifully framed and ready to hand as soon as you get it home.

Stay in Oklahoma and you'll find some terrific baskets by Mavis Doering, Mary Aitson and Peggy Brennan.

If you're crazy about horses, you have to call Diana Beach. My favorite of Diana's is a painting of the little people painting a "Paint" pony. She'll tell you some of the Cherokee legends of the "little people" if you ask.

Cherokee

If you're looking for a fantastic gift for your gentleman friend a knife by the famous Ted Miller might be in order - and, of course, they can be used by women!

If you get down to the old mining town of Bisbee, Arizona (south of Tucson), you'll definitely want to call on Jesse Hummingbird, winner of may awards in southwest Native art shows. He was the T-shirt and poster artist for the 71st Indian Ceremonial in Gallup, NM, in 1992 and the Indian Arts & Crafts Association Artist of the Year in 1996.

If you're in New Jersey and just can't make it out west you may want to call Zack Brown Bear. His feather work is extraordinary. Call him and find out where his next show is. He travels to a lot of Powwows - all the way down to Florida.

I know Indiana license plates used to have the slogan "Wander" on them, but if you're a stay at home type you may want to call on Hoosier resident Cherokee artist Brad Hawiyeh-ehi in Bloomington. His painted gourds are exceptional and you'll enjoy meeting him.

All the artists mentioned above are multiple award winners, but I just don't have room to list all the awards they've won.

Cherokee

Mary **Aitson** — *Cherokee*
Baskets; 2419 Cherry, Woodward, OK 73801;
(405) 256-3862

Troy **Anderson** — *Cherokee*
Artist; rt. 5, Box 171TA, Siloam Springs, AR 72761;
(501) 524-5814

R.H. Bob **Annesley** — *Cherokee*
Artist & Sculptor; P.O. Box 3, Missouri City, TX 77459;
(713) 729-8960

John **Balloue** — *Cherokee*
Artist; 26838 Grandview Ave., Hayward, CA 94542;
(510) 538-4003

Diana **Beach** — *Cherokee*
Artist; HC 30, Box 1772, Lawton, OK 73501;
(405) 246-3360

Carola **Bicksler** — *Cherokee*
Beadwork, Dolls, Dr.ums & Jewelry; P.O. Box 484, Vian,
OK 74962; (918) 773-3004

Robert L. **Bicksler** — *Cherokee*
Beadwork, Dolls, Dr.ums & Jewelry; P.O. Box 484, Vian,
OK 74962; (918) 773-3004

Peggy **Brennan** — *Cherokee*
Baskets; P.O. Box 5404, Edmond, OK 73083;
(405) 478-7835 (Messages)

Deanna **Broughton** — *Cherokee*
Sculptor & Miniatures; HC 70, Box 226B, Ardmore, OK
73401; (580) 226-5973

Diamond **Brown** — *Cherokee*
Educator: Dancing, Tanning+; 2715 Greenvalley Rd., Snellville, GA 30278; (770) 985-0478, (704) 479-2695

Zack **Brown Bear** — *Cherokee*
Featherwork; P.O. Box 52, Berlin, NJ 8009

Michael A. **Cheatham** — *Cherokee*
Jewelry & Ethnic Artifacts; 9477 Avenida Acero, Spring Valley, CA 91977; (619) 475-6215

Larry A. **Croslin** — *Cherokee*
Baskets; P.O. Box 2608, Muskogee, OK 74402; (918) 683-5363

Squirrel **Croslin, Jr.** — *Cherokee*
Baskets; P.O. Box 1159, Vian, OK 74962; (918) 773-8861

Tis Mal **Crow** — *Cherokee-Lumbee*
Beadwork & Carving; 681 Blue Springs Rd., Speedwell, TN 37870; (423) 562-4664

Mavis **Doering** — *Cherokee*
Baskets; 12401 Tr. Oaks Dr., #116, Oklahoma City, OK 73120; (405) 752-9943

Jim **Durham** — *Cherokee*
Scrimshaw; Whitewood, SD

Debbe **Edwards** — *Cherokee*
Sculptor: Wildlife; 10110 S. 520 Rd., Miami, OK 74354; (918) 542-9627

Jean **Engler** — *Cherokee*
Artist: Oils; 5000 S. Quaker #105, Tulsa, OK 74105; (918) 749-2036

Marsha **Frazier** — *Cherokee*
Dolls: Beadwork; 266 Bear Canyon, Bozeman, MT 59715; (406) 586-7091, (406) 587-7606

Bill **Glass** — *Cherokee*
Artist; HCR 64, Box 1410, Locust Grove, OK 74352;
(918) 479-8884

Marian **Goodwin** — *Cherokee*
Artist: Oils; 1021 S. Oklahoma, Cherokee, OK 73728;
(580) 596-3346

Donald E. **Greenwood** — *Cherokee*
Jewelry; 10414 Autumn Meadow Ln., Houston, TX 77064

John **Guthrie** — *Cherokee*
Artist: Sculptor; 710 Victor St., Tahlequah, OK 74464;
(918) 458-1814

John **Guthrie** — *Cherokee*
Artist: Watercolors, Etc.; P.O. Box 2430 1062, Pensacola,
FL 32513; (405) 748-1711

Monica **Hansen** — *Cherokee*
Artist; P.O. Box 580802, Tulsa, OK 74158; (918) 743-8621

Brad **Hawiyeh-ehi** — *Cherokee*
Gourds: Painted; P.O. Box 1887, Edgewood, NM 87015;
(505) 286-4160

K. **Henderson** — *Cherokee*
Artist; 1521 Dorchester, Muskogee, OK 74403;
(918) 683-0545; E-mail: hstudio@galstar.com, Web:
www.galstar.com/~hstudio/

Brooks **Henson** — *Cherokee*
Artist; HCR 64, Box 1794, Locust Grove, OK 74352;
(918) 479-6161

Jesse T. **Hummingbird** — *Cherokee*
Artist; 102 Silver St., Bisbee, AZ 85603; (520) 432-7305

Anita C. **Jackson** — *Cherokee*
Artist: Acrylic & collage; P.O. Box 72, Kiowa, OK 74553;
(918) 432-5769

Barbara **Johnson** — *Cherokee*
Clothing: Ribbon Shirts; P.O. Box 483, Pennington, AL 36916; (800) 608-1558

Dusti **Lockey** — *Cherokee-Goigi-tsi-Qua*
Beadwork: Leather Clothing, Etc.; P.O. Box 468, Little Elm, TX 75068; (972) 294-2175; E-mail: summerbird@juno.com

Betty **Maney** — *Cherokee*
Baskets: Miniatures; P.O. Box 170, Cherokee, NC 28719; (828) 497-7708

Serena **Mankiller** — *Cherokee*
Jewelry & Deerskin Pouches; P.O. Box 117, Flagstaff, AZ 86002; (520) 774-5488

Dewayne **Matthews** — *Cherokee-Chick*
Artist: Monotypes; 1339 S. Riverside Dr. #D, Tulsa, OK 74127; (918) 582-7332

Pat **McAllister** — *Cherokee*
Artist; 5307 Hwy. 62 West, Eureka Springs, AR 72632; (501) 253-5353, (800) 732-5353

Ted **Miller** — *Cherokee-M/P*
Knives, Jewelry, Etc.; Rt. 2, Box 242, Vinita, OK 74301; (918) 782-4312, (800) 984-0337

Anna B. **Mitchell** — *Cherokee*
Pottery; P.O. Box 195, Vinita, OK 74301; (918) 256-3702

Ron **Mitchell** — *Cherokee*
Artist; Rt. 1, Box 263, Prague, OK 74864; (405) 567-2856

Steve **Mitchell** — *Cherokee*
Sculptor; 1547-1/2 S. Newport, Tulsa, OK 74120; (918) 585-3931, (405) 567-2856

Eddie **Morrison** — *Cherokee*
 Sculptor: Wood Carvings; P.O. Box 148, Caldwell, KS
 67022; (316) 845-2259

Jane **Osti** — *Cherokee*
 Pottery; P.O. Box 315, Salina, OK 74365; (918) 434-2021

Tiana **Proctor** — *Cherokee*
 Artist; Rt. 1, Box 675, Watts, OK 74964; (918) 723-4200

Bill **Rabbit** — *Cherokee*
 Artist; P.O. Box 34, Pryor, OK 74362; (918) 825-3716

Traci **Rabbit** — *Cherokee*
 Artist; P.O. Box 34, Pryor, OK 74362; (918) 825-5657

Polly **Rattler** — *Cherokee*
 Dolls: Corn Husk; P.O. Box 704, Cherokee, NC 28719;
 (828) 497-3423

Bill "Wolf" **Roberson** — *Cherokee*
 Artist: Feathers; P.O. Box 18986, Fountain Hills, AZ
 85269; (602) 837-1577

Jeanne **Rorex** — *Cherokee*
 Artist; 5905 W. 103 St. South, Oktaha, OK 74450;
 (918) 683-9366

Bert **Seabourn** — *Cherokee*
 Artist; 6105 Covington Ln., Oklahoma City, OK 73132

Bobbi **Shelton** — *Cherokee*
 Artist; P.O. Box 565, Cedar Crest, NM 87008;
 (505) 281-3760

Mary **Stone** — *Cherokee*
 Baskets; 3608 SE 26th, Del City, Ok 73115; (405) 670-2862;
 E-mail: mstone777@aol.com

Virginia **Stroud** — *Cherokee-Creek*
Artist; 3404 W. Broadway St., Muskogee, OK 74401

F. Maxine **Studer** — *Cherokee*
Misc.; 466 N. McDonel St., Lima, OH 45801;
(419) 228-1097

Dorothy **Sullivan** — *Cherokee*
Artist; P.O. Box 732, Norman, OK 73070; (405) 360-0751

George L. **Thorne** — *Cherokee*
Artist: etc.; P.O. Box 1162, Tahlequa, OK 74464;
(918) 868-3633

Donald **Vann** — *Cherokee*
Artist; P.O. Box 746, Austin, TX 78767; (512) 472-7701

Roberta A. **Wallace** — *Cherokee-Apache*
Pottery; P.O. Box 6206, Norman, OK 73070; (405) 447-2233

Ginny **Watts** — *Cherokee-Comanche*
Gourd Art; Rt. 15, Box 352-A, Denton, TX 76201;
(940) 484-1698; E-mail: Dr.Wuensche@aol.com

John A. **White** — *Cherokee*
Artist; P.O. Box 5305, Ardmore, OK 73403; (580) 226-4824

Patty A. **Wollett** — *Cherokee*
Apparel & Jewelry, Rattle, Etc.; 211 Sooner Dr., Nowata,
OK 74048; (918) 273-1625

Kathryn **Yauney** — *Cherokee*
Sculptor: Clay & Mixed-Media; 1021 Cardiff, Casper, WY
82609; (307) 472-3506

Montie **Young** — *Cherokee*
Gourds & Antler Pipes; HC 78, Box 113, Leslie, AR 72645

Cochiti

Cochiti Pueblo is located north of Albuquerque not far off I-25 on the road to Santa Fe. The Cochiti people are famous for storyteller pottery and for excellent drums, both of which you'll easily find if you take the time for a short drive from either Albuquerque or Santa Fe. Of course, you can also stop at Casino Hollywood at San Felipe Pueblo for a very nice all you can eat buffet lunch or dinner. And maybe, even win a few dollars in one of the slot machines!

If you get to Cochiti you have to call Snowflake Flower and see her unusual and outstanding storytellers. Each of her creations has a story of its own. I remember one from about 10 or 12 years ago designed with the constellation Pleiades in mind. Each of the seven sisters peaked out from the skirt of the storyteller mother. All of Stephanie's (her other name) storytellers are unique to her. She also creates nativity sets which you will enjoy year after year during the holidays (and in between!)

As you may know, Cochiti Pueblo is the place that gets the credit for the storyteller pottery development and there are many excellent potters in the Pueblo. Virgil Ortiz is world famous for his unusual and innovative style. You can often see gallery ads for his work in a number of art publications featuring Native arts.

Cochiti

The storytellers of Vangie Suina are especially nice and, of course, there is the famous silversmith and jeweler Cippy Crazyhorse, whose work is found in galleries across the United States and beyond. The silverwork of James Eustace is worth seeking out as well.

The artwork of Dominic Arquero and Ivan Trujillo may be enjoyed on your trip to Cochiti as well.

One of the biggest reasons to visit Cochiti is to find a drum. If you want a little drum for your child or a big drum for yourself or a really big drum for a piece of furniture or your next Powwow this is the place to look for a very special item that can last a lifetime.

Some of the Cochiti drum makers live in Santa Fe, but retain a family home in the Pueblo. The Herrera family does excellent work and you'll probably find Arnold Herrera or one of his sons around to show you a drum. If you have a need for a special size or shape, you can likely order exactly what you want and have it shipped to you - if you're getting a large drum, you probably won't have room for it in your car anyway! Try Marcus Chalan or Bill Martin - they make excellent drums as well.

I hope you enjoy your visit to Cochiti - it's a lovely village filled with really nice people!

Cochiti

Dominic **Arquero** — *Cochiti*
Artist; 203 Quapaw, Santa Fe, NM 87501; (505) 984-0388

Johnnie B. **Arquero** — *Cochiti*
Drums; P.O. Box 45, Cochiti, NM 87041; (505) 465-2934

Josephine **Arquero** — *Cochiti*
Pottery; P.O. Box 45, Cochiti, NM 87041; (505) 465-2934

Marcus **Chalan** — *Cochiti*
Drums & other Arts & Crafts; P.O. Box 122, Cochiti, NM
87072; (505) 465-2495

Martha **Chalan** — *Cochiti*
Drums & other Arts & Crafts; P.O. Box 122, Cochiti, NM
87072; (505) 465-2495

Mary O. **Chalan** — *Cochiti*
Pottery: Storytellers/Figurines; P.O. Box 90, Cochiti
Pueblo, NM 87072; (505) 465-2514

Cippy **CrazyHorse** — *Cochiti*
Jewelry; P.O. Box 94, Cochiti, NM 87072; (505) 465-2549,
(505) 465-2375

James **Eustace** — *Cochiti*
Silversmith; P.O. Box 140, Cochiti, NM 87072

Snowflake **Flower** — *Cochiti*
Pottery: Storytellers/Nativity; P.O. Box 126, Cochiti, NM
87072; (505) 465-1509

David **Gordon** — *Cochiti*
P.O. Box 70, Cochiti, NM 87072; (505) 465-0725

Arnold **Herrera** — *Cochiti*
Drums; 15 Camino Quieto, Santa Fe, NM 87505;
(505) 473-4352

Carlos **Herrera** — *Cochiti*
Drums; 15 Camino Quieto, Santa Fe, NM 87505;
(505) 473-4352

Steve **Herrera** — *Cochiti*
Drums; P.O. Box 51, Cochiti, NM 87072; (505) 465-2349

Tim **Herrera** — *Cochiti*
Drums; 15 Camino Quieto, Santa Fe, NM 87505;
(505) 473-4352

Tomas **Herrera** — *Cochiti*
Drums; 15 Camino Quieto, Santa Fe, NM 87505;
(505) 473-4352

Bill **Martin** — *Cochiti*
Drums & Figurines; P.O. Box 143, Cochiti Pueblo, NM
87072; (505) 465-2426

Mary **Martin** — *Cochiti*
Drums & Figurines; P.O. Box 143, Cochiti Pueblo, NM
87072; (505) 465-2426

Janice **Ortiz** — *Cochiti*
Pottery & Figurines; P.O. Box 146, Cochiti, NM 87072;
(505) 823-1491, (505) 465-2939

Juanita **Ortiz** — *Cochiti*
Pottery: Trad. & Contemp.; P.O. Box 146, Cochiti, NM
87072; (505) 465-2939, (505) 986-5080

Seferina **Ortiz** — *Cochiti*
Pottery; P.O. Box 146, Cochiti, NM 87072; (505) 465-2939

Virgil **Ortiz** — *Cochiti*
Pottery; P.O. Box 146, Cochiti, NM 87072; (505) 465-2939,
(505) 986-5080

Nadine **Pecos** — *Cochiti*
P.O. Box 136, Cochiti Pueblo, NM 87072

Redbird — *Cochiti*
P.O. Box 137, Cochiti, NM 87072; (505) 465-2672

Annette **Romero** — *Cochiti-San Ild.*
Pottery: Traditional; P.O. Box 159, Cochiti, NM 87072;
(505) 465-0513

Maria P. **Romero** — *Cochiti*
Pottery: Storytellers; P.O. Box 74, Cochiti, NM 87072;
(505) 465-2923

Anthony **Suina** — *Cochiti*
Pottery: Storytellers, Nativity; P.O. Box 144, Cochiti, NM
87072; (505) 465-2332

Dena M. **Suina** — *Cochiti*
Pottery: Storytellers; P.O. Box 31, Cochiti Pueblo, NM
87072; (505) 465-0605

Vangie **Suina** — *Cochiti*
Pottery: Storytellers, Nativity; P.O. Box 144, Cochiti, NM
87072; (505) 465-2332

Elizabeth **Trujillo** — *Cochiti*
Pottery; P.O. Box 141, Cochiti, NM 87072; (505) 465-1503

Gabe **Trujillo** — *Cochiti*
Drums; P.O. Box 72, Cochiti, NM 87041

Ivan **Trujillo** — *Cochiti*
Artist; P.O. Box 1281, Pena Blanca, NM 87041;
(505) 465-2712

Katy **Trujillo** — *Cochiti*
Pottery: Storytellers; P.O. Box 72, Cochiti, NM 87041

Leonard **Trujillo** — *Cochiti*
Pottery: Storytellers; P.O. Box 147, Cochiti, NM 87072;
(505) 465-2757

Mary **Trujillo** — *Cochiti*
 Pottery: Storytellers; P.O. Box 147, Cochiti, NM 87072;
 (505) 465-2757

Hopi

The Hopi Reservation is located in Arizona entirely within the boundaries of the vast Navajo reservation. From Albuquerque head west to Gallup, north on US 666 to SR 264 then west to the Hopi reservation. You'll want a good map, although the roads are very well marked. Just don't turn off on any dirt roads unless you know where you're going.

There are many excellent craftspeople and artists among the Hopi. Silverwork, Pottery, Weaving and Kachina carving are the staple art items to be found here. Following World War II, the development of the famous overlay silverwork was supervised by Fred Kabotie, well known Hopi artist. Many outstanding silversmiths have worked their way through the Hopi Guild training program to become productive and talented jewelry makers. My first Indian jewelry piece was a belt buckle by Hopi silversmith Lawrence Saufkie. Lawrence is still producing excellent work.

Hopi weaver Ramona Sakiestewa has become an exceptionally talented artist, first designing blankets for Pendleton, and now for her own company. Her own weavings are sought after by collectors worldwide. Other Hope weavers make fine sash belts and traditional hand-woven dresses and kilts.

Hopi

Probably the most distinctive art among the Hopi is the Kachina. Carved of cottonwood root and often from a single piece it can vary from the very simple older style to the contemporary elaborate intricately carved artwork that may command hundreds or even several thousand dollars! Carvers like Glenn Fred have elevated the art to a remarkable level.

Two dimensional artists also abound among the Hopi. Dan Lomahaftewa and David Dawangyumptewa are two outstanding artists that are in great demand.

The Nampeyo name is synonymous with the best in Hopi pottery. There are a number of Nampeyo descendants practicing the art today. My good friend Darlene James makes interesting tiles as well as more traditional pottery and often sells out early at art events. If you're looking for truly outstanding Hopi pottery look for Steve Lucas. He won best of show at an event in Florida not long ago and wins awards wherever he displays his work.

Hopi baskets are hard to find and wonderful - don't miss any opportunity you get to buy one if you visit Hopi. And don't miss my favorite village - Walpi! A truly enchanting place.

Hopi

Lawrence **Acadiz** — *Hopi*
Kachinas; 101 W. Veteran's Blvd., Tucson, AZ 85713;
(602) 624-5218, (602) 743-0319

Ronald D. **Adams, Sr.** — *Hopi*
Kachinas; P.O. Box 382, Polacca, AZ 86042; (520) 737-2796

Robert S. **Albert** — *Hopi*
Hopi Art; 8978 -102 E. Tanque Verde, Tucson, AZ 85749;
(520) 760-0633

Robert **Allison** — *Hopi*
Kachinas; P.O. Box 385, Polacca, AZ 86042; (520) 737-2607

Ramona **Ami** — *Hopi*
Pottery; P.O. Box 349, Polacca, AZ 86042; (602) 737-2541

Art **Batala** — *Hopi*
Jewelry; P.O. Box 32, Kykotsmovi, AZ 86039

Dan **Bert** — *Hopi*
Kachinas; 8635 Jupiter Dr., Flagstaff, AZ 86004;
(520) 526-8749

Cecil **Calnimptewa** — *Hopi*
Kachinas; P.O. Box 37, Kykotsmovi, AZ 86039;
(520) 734-2406

Darin **Calnimptewa** — *Hopi*
Kachinas; 555 E. 10th Ave. #6, Denver, CO 80203;
(303) 831-7225

Karen K. **Charley** — *Hopi*
Pottery; P.O. Box 1047, Keams Canyon, AZ 86034;
(602) 738-5195, (602) 737-2278

Manuel Denet **Chavarria** — *Hopi*
Kachinas: Traditional style; P.O. Box 271, Polacca, AZ
86042; (520) 737-9457

Forrest **Chimerica** — *Hopi*
Kachinas; 4721 N. 27th Dr., Phoenix, AZ 85017;
(602) 249-0701

Delores **Coochyamptewa** — *Hopi*
A & C.; 990 W. Thorpe #54, Flagstaff, AZ 86001

Kencrick **Coochyamptewa** — *Hopi*
A & C.; 990 W. Thorpe #54, Flagstaff, AZ 86001

Paul **Coochyamptewa** — *Hopi*
Kachinas; 3345 N. Steves.Blvd., Flagstaff, AZ 86004;
(520) 526-4742

Bennard **Dallasvuyaoma** — *Hopi*
Jewelry: Mosaic Inlay Gold/Silver; 2902 Trellis NW,
Albuquerque, NM 87107; (505) 344-7689

Neil **David** — *Hopi*
Kachinas, Paintings & Drawings; P.O. Box 257, Polacca,
AZ 86042; (520) 737-9441, (520) 737-9340

Roderick **Davis** — *Hopi*
Artist; P.O. Box 11216, Phoenix, AZ 85061; (602) 265-3199

Alice **Dawa** — *Hopi*
Jewelry; P.O. Box 127, Second Mesa, AZ 86043; (520) 734-2430

Bernard **Dawa** — *Hopi*
Jewelry; P.O. Box 127, Second Mesa, AZ 86043; (520) 734-2430

Alice **Dawahoya** — *Hopi*
Baskets; P.O. Box 127, Shungopavi, AZ 86043

David **Dawangyumptewa** — *Hopi*
Artist; P.O. Box 3327, Flagstaff, AZ 88003; (520) 779-3881

Cedric **Dawavendewa** — *Hopi*
Artist: Painting & Pottery; P.O. Box 2243, Tuba City, AZ
86045; (520) 283-4766

Gerald **Dawavendewa** — *Hopi*
P.O. Box 41927, Tucson, AZ 85717; (520) 325-6453

Richard L. **Dawavendewa** — *Hopi*
Paintings: Hopi Art; P.O. Box 898, Tuba City, AZ 86045;
(520) 523-7976

Jonathan **Day, Sr.** — *Hopi*
Kachinas; P.O. Box 911, Hotevilla, AZ 86030;
(520) 734-2360

Carol **Duwyenie** — *Hopi*
Pottery & Baskets; 2500 Sawmill Rd. #513, Santa Fe, NM
87505; (505) 986-9702

Joseph **Duwyenie** — *Hopi*
Kachinas; P.O. Box 996, Hotevilla, AZ 86030;
(602) 734-2596, (602) 894-6546

Mary **Duwyenie** — *Hopi*
Weaving & Baskets; 3723 E. Taylor, Phoenix, AZ 85008;
(602) 244-9161

Megan **Duwyenie** — *Hopi*
2500 Sawmill Rd. #513, Santa Fe, NM 87505;
(505) 986-9702

Preston **Duwyenie** — *Hopi*
Clay & Metal; Rt.5, Box 451, Espanola, NM 87532;
(505) 753-5680

Glenn D. **Fred** — *Hopi*
Kachinas; RR 5, Box 318-AA, Santa Fe, NM 87501;
(505) 455-7189; Web: www.bearmountain.com

Aaron J. **Fredericks** — *Hopi*
Kachinas; P.O. Box 915, Kykotsmovi, AZ 86039;
(520) 734-9380

Evelyn **Fredericks** — *Hopi*
Sculptor; Rt. 19, Box 118, Santa Fe, NM 87505;
(505) 982-9440

Armand **Fritz** — *Hopi*
Kachinas; P.O. Box 684, Keams Canyon, AZ 86034;
(520) 738-5665

Fawn N. **Garcia** — *Hopi*
Pottery: (Navasie); P.O. Box 1030, Keams Canyon, AZ
86034; (520) 734-2201

James **Garcia** — *Hopi*
Pottery; P.O. Box 1030, Keams Canyon, AZ 86034;
(520) 734-2201

Ros **George** — *Hopi*
Kachinas; 3839 W. Osborn, Phoenix, AZ 85019;
(602) 278-2457, (520) 283-6816

Lee **Grover, Jr.** — *Hopi*
Kachinas; P.O. Box 522, Kykotsmovi, AZ 86039;
(520) 734-9407

Sandra **Hamana** — *Hopi*
Wall Decor; P.O. Drawer 193, Kykotsmovi, AZ 86039

Steveh **Harris** — *Hopi*
Hopi Artist; 11464 N. 24th Dr., Phoenix, AZ 85029

Robert A. **Homer** — *Hopi-Zia*
Pottery; P.O. Box 94, Gallup, NM 87305; (505) 722-9181

Aaron **Honanie** — *Hopi*
Carver: Silversmith; P.O. Box 2315, Tuba City, AZ 86045;
(520) 283-4242

Anthony E. **Honanie** — *Hopi*
Jewelry; 4121 E. Glenhaven, Phoenix, AZ 85044;
(602) 759-5334

Antone **Honanie** — *Hopi*
Jewelry: Silver; P.O. Box 257, Kykotsmovi, AZ 86039;
(520) 734-2234

Delbridge **Honanie** — *Hopi*
Kachinas & Paintings; 1819 N. Turquoise Dr., Flagstaff,
AZ 86001; (520) 779-5500, (520) 734-2200

Ernest W. **Honanie** — *Hopi*
Jewelry & Carving; P.O. Box 257, Kykotsmovi, AZ 86039;
(520) 734-6631, (520) 737-1212

Hilda **Honanie** — *Hopi*
Baskets & Jewelry; P.O. Box 290, Second Mesa, AZ 86043;
(602) 734-9278

Jimmie **Honanie** — *Hopi*
Kachinas & Overlay; P.O. Box 2436, Tuba City, AZ 86045;
(520) 283-5477

Philbert **Honanie** — *Hopi*
Kachinas & Sculptures; P.O. Box 64, Hotevilla, AZ 86030

Phillip **Honanie** — *Hopi*
Jewelry; P.O. Box 290, Second Mesa, AZ 86043;
(520) 734-9278

Watson **Honanie** — *Hopi*
Jewelry: Silver & Gold; P.O. Box 79, Hotevilla, AZ 86030;
(520) 779-2305

Barry **Honyouti** — *Hopi*
Furniture; P.O. Box 994, Hotevilla, AZ 86030; (520) 734-2528

Brian **Honyouti** — *Hopi*
Kachinas; P.O. Box 254, Hotevilla, AZ 86030; (602) 734-2205

Rick **Honyouti** — *Hopi*
Furniture; P.O. Box 994, Hotevilla, AZ 86030; (520) 734-2528

Ron **Honyouti** — *Hopi*
Kachinas; P.O. Box 139, Hotevilla, AZ 86030;
(602) 734-2205 (Messages)

Bryson **Huma** — *Hopi*
Kachinas & Pottery; P.O. Box 616, Polacca, AZ 86042;
(520) 737-2391

Marlon **Huma** — *Hopi*
Kachinas; P.O. Box 820, Polacca, AZ 86042; (520) 737-9486

Rondina **Huma** — *Hopi*
Pottery; P.O. Box 667, Polacca, AZ 86042; (602) 737-2288

Donna **Humetewa** — *Hopi*
Clothing; P.O. Box 272, Kykotsmovi, AZ 86039;
(520) 699-3418

Darlene **James** — *Hopi*
Pottery & Tiles; P.O. Box 653, Polacca, AZ 86042;
(520) 727-2684

Michael D. **Jenkins** — *Hopi*
Kachinas; 3001 N. Ellen St., Flagstaff, AZ 86004;
(520) 773-0965

Mark **Jiron** — *Hopi*
Jewelry; 709 Kathryn Ave., Santa Fe, NM 87501;
(505) 982-2336

Ross **Joseyesva** — *Hopi*
P.O. Box 686, Second Mesa, AZ 86043; (520) 734-9565

Michael **Kabotie** — *Hopi*
Hopi Artist; P.O. Box 30703, Flagstaff, AZ 86003;
(520) 526-3673

Gloria **Kahe** — *Hopi*
Pottery; P.O. Box 1096, Keams Canyon, AZ 86034;
(520) 737-2563

Clayton **Kaniatobe** — *Hopi*
Kachinas; AZ; (520) 214-9698

Wilmer **Kaye** — *Hopi*
Kachinas; P.O. Box 1225, Zuni, NM 87327; (505) 782-2180

Adrianne R. **Keene** — *Hopi*
Artist: Painting & Pottery; P.O. Box 2243, Tuba City, AZ
86045; (520) 283-4766

Darrell W. **Kewanwytewa** — *Hopi*
Kachinas; P.O. Box 128, Second Mesa, AZ 86043;
(520) 734-2207

Elroy **Kewanyama** — *Hopi*
Kachinas; P.O. Box 824, Kykotsmovi, AZ 86039

Michelene **Kewanyama** — *Hopi*
Kachinas; P.O. Box 824, Kykotsmovi, AZ 86039

Anderson **Koinva** — *Hopi*
Jewelry & Xmas Ornaments; P.O. Box 2785, Apache
Junc., AZ 85217; (602) 982-1577

Fred **Koruh** — *Hopi*
Dolls: Kokopelli Split Dolls; P.O. Box 419, Zuni, NM
87327; (505) 782-2821

Susie **Kuyvaya** — *Hopi*
Baskets; P.O. Box 342, Kykotsmovi, AZ 86039

Vernon **Laban** — *Hopi*
Kachinas; P.O. Box 102, Hotevilla, AZ 86030; (520) 779-3595

Steve W. **LaRance** — *Hopi-Assiniboine*
Sculptor; P.O. Box 2872, Flagstaff, AZ 86003;
(520) 526-7962; E-mail: denlarart@aol.com

Bryan **Loma** — *Hopi*
Kachinas; 3011 N. Stapley Dr., Mesa, AZ 85203;
(602) 964-6489

Herman **Loma** — *Hopi*
Kachinas; 3007 N. Stapley Dr., Mesa, AZ 85203;
(602) 649-9170

Dan V. **Lomahaftewa** — *Hopi*
Paintings; 223 N. Guadalupe #136, Santa Fe, NM 87501;
(505) 984-0729

Linda **Lomahaftewa** — *Hopi-Choctaw*
Paintings; Rt. 11, Box 20, #59, Santa Fe, NM 87501;
(505) 455-7773; E-mail: llomahaftewa@iaiacad.org

Carol **Lomahoema** — *Hopi*
Original Art; 2321 N. 52nd St. #24, Phoenix, AZ 85008

Alfred Bo **Lomahquahu** — *Hopi*
Kachinas; 1908 Lizard Ln., Holbrook, AZ 86025;
(520) 524-3795

Ramson **Lomatewama** — *Hopi*
Hopi Artist; 8105 Stardust Tr., Flagstaff, AZ 86994;
(520) 526-8999

Peggy **Lomay** — *Hopi*
Jewelry; 709 Kathryn Ave., Santa Fe, NM 87501;
(505) 982-2336

Wilmer **Lomayaoma, Sr.** — *Hopi*
Jewelry; P.O. Box 128, Second Mesa, AZ 86043;
(520) 734-2207

Remalda **Lomayestewa** — *Hopi*
Baskets; P.O. Box 44, Second Mesa, AZ 86043

Steve **Lucas** — *Hopi*
Pottery; 301 Calle Pinon, Gallup, NM 87301;
(505) 863-5705, (520) 737-2345

Yvonne E. **Lucas** — *Hopi-Laguna*
Pottery; 301 Calle Pinon, Gallup, NM 87301;
(505) 863-5705, (520) 737-2345

Loren B. **Maha** — *Hopi*
Jewelry: Gold & Silver; 4401 Montgomery Blvd. NE 146,
Albuquerque, NM 87109; (505) 881-8573

Carl **Mahape** — *Hopi*
Kachinas, Ornaments, Etc.; 6436 Cathy NE,
Albuquerque, NM 87109; (505) 821-9131

Donald **Mahkewa Jr.** — *Hopi*
Pottery; P.O. Box 594, Keams Canyon, AZ 86034;
(520) 738-5467

Gloria **Mahle** — *Hopi*
Kachinas & Pottery; P.O. Box 616, Polacca, AZ 86042;
(520) 737-2391

Dean **Michaels** — *Hopi*
Kachinas; 3001 N. Ellen St., Flagstaff, AZ 86004;
(520) 773-0965

Monongya — *Hopi*
Jewelry; P.O. Box 287, Old Oraibi, AZ 86039;
(602) 283-4637

Aldrick **Mooya** — *Hopi*
Kachinas; P.O. Box 86, Kykotsmovi, AZ 86039;
(602) 995-2986, (520) 734-2519

Naavaasya — *Hopi*
P.O. Box 304, Old Oraibi, AZ 86039

Elvira **Naha** — *Hopi*
P.O. Box 201, Polacca, AZ 86042

Emmaline **Naha** — *Hopi*
Pottery; P.O. Box 223, Polacca, AZ 86042

Marty **Naha** — *Hopi*
P.O. Box 201, Polacca, AZ 86042

Rainy **Naha** — *Hopi*
Pottery; P.O. Box 633, Polacca, AZ 86042; (520) 738-5428

Jocelyn **Namingha** — *Hopi*
Pottery & Paintings; P.O. Box 809, Polacca, AZ 86042;
(520) 737-2785

Les **Namingha** — *Hopi*
Pottery & Paintings; P.O. Box 809, Polacca, AZ 86042;
(520) 737-2785

PamTahbo **Namingha** — *Hopi*
Potter; 408 E. Birch #3, Flagstaff, AZ 86001; (520) 213-1105

Crecinda **Namoki** — *Hopi*
Kachinas; 2504 N. Center, Apt.#2, Flagstaff, AZ 86004;
(520) 913-0236

Lawrence **Namoki** — *Hopi*
Kachinas & Pottery; P.O. Box 51, Tuba City, AZ 86045;
(520) 737-2606, (520) 283-4679

Lucinda E. **Namoki** — *Hopi*
Kachinas & Pottery; P.O. Box 51, Tuba City, AZ 86045;
(520) 737-2606, (520) 283-4679

Valerie **Namoki** — *Hopi*
Pottery: Storytellers; 4401 Montgomery Blvd. NE 101,
Albuquerque, NM 87109; (505) 881-3643

Watson **Namoki** — *Hopi*
Kachinas; 2504 N. Center, Apt.#2, Flagstaff, AZ 86004;
(520) 913-0236

Curtis **Naswyowma** — *Hopi-Taos*
Kachinas; 1182 Tovar Tr. #46, Flagstaff, AZ 86001;
(520) 525-2952

Dawn **Navasie** — *Hopi*
Pottery; P.O. Box 594, Keams Canyon, AZ 86034;
(520) 738-5467

Gary **Negale** — *Hopi*
Kachinas; 2505 E. 24th St., Farmington, NM 87401;
(505) 324-6236

Verna "Sonwai" **Nequatewa** — *Hopi*
Jewelry; P.O. Box 56, Hotevilla, AZ 86030; (520) 734-2433

Burt **Nicholas** — *Hopi*
Kachinas & Jewelry; P.O. Box 856, Kykotsmovi, AZ
86039; (520) 734-2377

Lou **Nicholas** — *Hopi*
Kachinas & Jewelry; P.O. Box 856, Kykotsmovi, AZ
86039; (520) 734-2377

Kim **Obrzut** — *Hopi*
Sculptor; 8875 Mary's Dr., Flagstaff, AZ 86004;
(520) 526-5569; E-mail: kobrzut@infomagic.com

Delmar **Polacca** — *Hopi*
Pottery; P.O. Box 919, Tuba City, AZ 86045; (520) 283-6370

Thomas **Polacca** — *Hopi*
P.O. Box 329, Polacca, AZ 86042

Trish **Polacca** — *Hopi*
Pottery; P.O. Box 919, Tuba City, AZ 86045; (520) 283-6370

Orin **Poley** — *Hopi*
Kachinas; P.O. Box 444, Kykotsmovi, AZ 86039;
(602) 734-2592

Frank **Poolheco** — *Hopi*
Arts & Crafts; 90 California Pine Rd., Rio Rancho, NM
87124; (505) 892-7146

Terri **Poolheco** — *Hopi*
Arts & Crafts; 90 California Pine Rd., Rio Rancho, NM
87124; (505) 892-7146

Gene **Pooyouma** — *Hopi*
Jewelry: Silver; P.O. Box 46, Hotevilla, AZ 86030

Margaret **Pooyouma** — *Hopi*
Hopi Crafts; P.O. Box 315, Kykotsmovi, AZ 86039;
(520) 734-9425

Gayver **Puhuyesva** — *Hopi*
Kachinas; 488 S. 400 West, Richfield, UT 84701;
(801) 896-2044

Al **Qoyawayma** — *Hopi*
Pottery; 8738 E. Clarendon, Scottsdale, AZ 85251;
(602) 947-1082; E-mail: alq@primenet.com,
www.aises.uthscsa.edu/aiq

Emerson **Quannie** — *Hopi*
Jewelry: Gold & Silver; P.O. Box 882, Mesa, AZ 85211;
(602) 834-3791, (602) 964-3566

Kevin H. **Quannie** — *Hopi*
Kachinas; 814 E. Indian School Rd., Phoenix, AZ 85014;
(602) 268-5402

Gerry **Quotskuyva** — *Hopi*
Hopi Artist; 461 Forest Rd., Sedona, AZ 86336;
(520) 203-0554

David A. **Rogge** — *Hopi*
Kachinas, Ornaments, Etc.; 6436 Cathy NE,
Albuquerque, NM 87109; (505) 821-9131

Mary Coin **Rogge** — *Hopi*
Kachinas, Ornaments, Etc.; 6436 Cathy NE,
Albuquerque, NM 87109; (505) 821-9131

Silas **Roy** — *Hopi*
Kachinas; P.O. Box 1395, Tuba City, AZ 86045;
(520) 283-4654

Jean **Sahme** — *Hopi*
Pottery; P.O. Box 394, Polacca, AZ 86042; (520) 737-2370

Alfonso **Sakeva, Jr.** — *Hopi*
Rattles & Kachinas; (520) 734-9427

Abel **Sakiestewa** — *Hopi*
Kachinas & Paintings; 414 N. 73rd St., Scottsdale, AZ
85257; (602) 946-8277, (602) 946-2632

Ramona **Sakiestewa** — *Hopi*
Weaver; P.O. Box 2472, Santa Fe, NM 87504;
(520) 982-8282

Lydia **Sakiestwea** — *Hopi*
Kachinas & Beadwork; 414 N. 73rd St., Scottsdale, AZ
85257; (602) 946-2632

Griselda **Saufkie** — *Hopi*
Baskets; P.O. Box 128, Second Mesa, AZ 86043;
(520) 734-2207

Joyce Ann **Saufkie** — *Hopi*
Baskets; P.O. Box 112, Second Mesa, AZ 86043

Lawrence **Saufkie** — *Hopi*
Jewelry; P.O. Box 128, Second Mesa, AZ 86043;
(602) 734-2207

Gloria **Sekakuku** — *Hopi*
Baskets; P.O. Box 978, Keams Canyon, AZ 86034;
(602) 737-9267

Sidney **Sekakuku, Jr.** — *Hopi*
Jewelry; P.O. Box 416, Second Mesa, AZ 86043;
(520) 734-2267

Selwyn W. **Sekaquaptewa** — *Hopi*
Kachinas; P.O. Box 628, Kykotsmovi, AZ 86039;
(520) 734-9578

Alberta **Selina** — *Hopi*
Baskets & Jewelry; P.O. Box 726, Second Mesa, AZ 86043; (520) 734-6695

Roger **Selina** — *Hopi*
Jewelry; P.O. Box 514, Second Mesa, AZ 86043; (520) 734-2538

Vanessa **Selina** — *Hopi*
Jewelry; P.O. Box 514, Second Mesa, AZ 86043; (520) 734-2538

Weaver **Selina** — *Hopi*
Jewelry; P.O. Box 726, Second Mesa, AZ 86043; (520) 734-6695

Raymond **Sequaptewa** — *Hopi*
Jewelry; P.O. Box 726, Hotevilla, AZ 86036

Dee **Setalla** — *Hopi*
Pottery; P.O. Box 152, Keams Canyon, AZ 86034; (520) 289-0404

Pauline **Setalla** — *Hopi*
Pottery; P.O. Box 152, Keams Canyon, AZ 86034; (520) 289-0404

Henry **Shelton** — *Hopi*
Kachinas; 1711-1/2 Arrowhead, Flagstaff, AZ 86001

Peter H. **Shelton III** — *Hopi*
Hopi Artist; 6180 E. Peaks Pkwy., Flagstaff, AZ 86004; (520) 526-6851

Lee **Sockyma** — *Hopi*
Kachinas; 2610 N. 50th Ave., Phoenix, AZ 85035; (602) 278-6764

Michael **Sockyma** — *Hopi*
Jewelry; P.O. Box 96, Kykotsmovi, AZ 86039; (520) 734-5141

Theodora **Sockyma** — *Hopi*
Jewelry; P.O. Box 96, Kykotsmovi, AZ 86039; (520) 734-5141

Manfred **Susunkewa** — *Hopi*
Kachinas; 12574 W. Palm Ln., Avondale, AZ 85323;
(602) 935-9060

Norma **Susunkewa** — *Hopi*
Baskets; 12574 W. Palm Ln., Avondale, AZ 85323;
(602) 935-9060

Sheryl L. **Susunkewa** — *Hopi*
Artist: Paintings/Crafts; 12574 W. Palm Ln., Avondale,
AZ 85323; (602) 935-9060

Mark **Tahbo** — *Hopi*
Pottery; P.O. Box 231, Polacca, AZ 86042

Dianna **Tahbo-Howard** — *Hopi*
Pottery; P.O. Box 401, Polacca, AZ 86042; (520) 737-9331

Evangeline **Talahaftewa** — *Hopi*
Baskets; P.O. Box 25, Second Mesa, AZ 86043

Roy **Talahaftewa** — *Hopi*
Jewelry: Gold & Silver; P.O. Box 2038, Keams Canyon,
AZ 86034; (520) 738-5667

Stacy **Talahytewa** — *Hopi*
Kachinas; P.O. Box 1675, Tuba City, AZ 86045;
(602) 283-4848

Lomasohu **Tawaventiwa** — *Hopi*
P.O. Box 41927, Tucson, AZ 85717; (520) 325-6453

Alvin **Taylor** — *Hopi*
Kachinas; P.O. Box 14, Kykotsmovi, AZ 86039

Cindy **Taylor** — *Hopi*
Jewelry; P.O. Box 337, Kykotsmovi, AZ 86039;
(520) 734-9394

Max **Taylor** — *Hopi*
Kachinas; P.O. Box 12, Kykotsmovi, AZ 86039;
(602) 734-6604

Milson **Taylor** — *Hopi*
Jewelry; P.O. Box 337, Kykotsmovi, AZ 86039;
(520) 734-9394

Clark **Tenakhongva** — *Hopi*
Kachinas; P.O. Box 294, Polacca, AZ 86042

Miriam **Tewayguna** — *Hopi*
P.O. Box 239, Polacca, AZ 86042; (520) 737-2676

Bertram **Tsavadawa** — *Hopi*
Kachinas & Paintings; P.O. Box 412, Second Mesa, AZ
86043

Oliver Z. **Tsinnie** — *Hopi-Navajo*
Kachinas; P.O. Box 1831, Tuba City, AZ 86045;
(520) 283-5852

Buddy **Tubinaghtewa** — *Hopi*
Kachinas & Paintings; P.O. Box 34321, Phoenix, AZ
85067; (602) 203-0362, (602) 252-8840

Bertha **Wadsworth** — *Hopi*
Baskets; P.O. Box 65, Second Mesa, AZ 86043

Alexander **Youvella, Sr.** — *Hopi*
Kachinas; Rt. 11, Box 57TP, Santa Fe, NM 87501

Elsie **Yoyokie** — *Hopi*
Jewelry; P.O. Box 340, Kykotsmovi, AZ 86039

Gary **Yoyokie** — *Hopi*
Jewelry; P.O. Box 340, Kykotsmovi, AZ 86039

Elmer **Yungotsuna** — *Hopi*
Kachinas; P.O. Box 22082, Flagstaff, AZ 86002;
(520) 779-2972

Isleta

Isleta Pueblo is located just south of Albuquerque. Just drive south on I-25 and watch for the signs. And you can't miss the Isleta Gaming Palace, one of the sponsors of the 1998 River of Hope Indian Art Market in Albuquerque.

Isleta has a well known family of storyteller potters headed by Stella Teller. Their pottery is noted for its beautiful pastel colors not found on other traditional pottery. Caroline Carpio and Mary Lou Kokaly are also award winning potters from Isleta.

Jeannette Ferrara has made a name for herself designing high quality clothing from Pendleton fabrics, including coats, vests and other attractive items.

Andy Abeita is a noted fetish carver from Isleta and is very active in working to insure the continuing quality and authenticity of Native American Indian art.

Tony Jojola has been recognized for his innovative and imaginative work in glass.

Isleta also has a number of silversmiths, including 1995 Indian Arts & Crafts Association Artist of the Year Andy Kirk!

Isleta

Andy **Abeita** — *Isleta*
Fetishes; 12 Chaparral Ln., Peralta, NM 87042;
(505) 869-8148; E-mail: laboraex@worldnet.att.net

Augustine D. **Abeita** — *Isleta-Chippewa*
Sculptor & Jewelry; P.O. Box 21212, Carson City, NV
89721; (702) 841-5831; E-mail: Boyadam1@webtv.net

Gloria **Abeita** — *Isleta*
Clothing; P.O. Box 310, Isleta, NM 87022; (505) 869-3740

Francisco **Benavidez** — *Isleta*
Jewelry; 347 Tribal Rd. 66, Albuquerque, NM 87105;
(505) 869-4722

Caroline **Carpio** — *Isleta*
Pottery: Storytellers, Sculpt.; P.O. Box 1222, Peralta, NM
87042; (505) 869-0827; E-mail: CrlnCarpio@aol.com

M. Lisa **Chavez** — *Isleta*
Artist; 36420 41st East, Palmdale, CA 93552; (805) 2816437

Robert A. **Edaakie** — *Isleta*
Paintings: Kachina & Wildlife; P.O. Box 73, Isleta Pueblo,
NM 87022; (505) 869-6656, (505) 869-3660

Jeanette **Ferrara** — *Isleta*
Clothing: Pendleton; P.O. Box 338, Isleta Pueblo, NM
87022; (505) 869-7841

Bert **Jojola** — *Isleta*
Pottery & Jewelry; P.O. Box 336, Isleta Pueblo, NM 87022;
(505) 869-6561

Joseph R. **Jojola** — *Isleta*
Jewelry; P.O. Drawer A., W.S.M.R., NM 88002;
(505) 678-6473

Tony **Jojola** — *Isleta*
Glass; P.O. Box 166, Isleta Pueblo, NM 87022;
(505) 869-3769, (505) 869-3660

Vernon **Jojola** — *Isleta*
Pottery & Jewelry; P.O. Box 336, Isleta Pueblo, NM 87022;
(505) 869-6561

Wanda **Jojola** — *Isleta*
Clothing; P.O. Box 460, Isleta Pueblo, NM 87022;
(505) 869-3307

Andy Lee **Kirk** — *Isleta*
Jewelry: Gold & Silver; P.O. Box 460, Isleta Pueblo, NM
87022; (505) 869-6098

Melanie **Kirk** — *Isleta*
Jewelry; P.O. Box 173, Isleta, NM 87022; (505) 869-6098

Michael **Kirk** — *Isleta*
Jewelry: Gold & Silver; P.O. Box 418, Isleta Pueblo, NM
87022; (505) 869-3317, Fax 869-8107

Michael L. **Kirk** — *Isleta*
Jewelry; P.O. Box 173, Isleta, NM 87022; (505) 869-6098

Mary Lou **Kokaly** — *Isleta-San Juan*
Pottery: Storytellers; 5046 Thiel Ct. NW, Albuquerque,
NM 87114; (505) 898-7874

Ron **Martinez** — *Isleta-Taos*
Pottery: Trad. & Contemp.; 330 Tribal Rd. #65,
Albuquerque, NM 87105; (505) 869-5254, (505) 869-9303

Kimberlee **Ponder** — *Isleta*
Clothing; P.O. Box 460, Isleta Pueblo, NM 87022;
(505) 869-3307, (505) 869-5959

Sofie **Salvador** — *Isleta*
Weaving: Pueblo style; 10 Tribal Rd. #24, Bosque Farms,
NM 87068; (505) 869-6372

Deborah J. **Sanchez** — *Isleta*
 Paintings: Works in Clay; P.O. Box 430, Isleta Pueblo, NM 87022; (505) 869-6779

Shirpoya — *Isleta*
 Artist; P.O. Box 577, Isleta, NM 87022; (505) 869-0449

Cindy **Sosa** — *Isleta*
 Jewelry: Silver & Gold; 3547 Hwy. 47, Bosque Farms, NM 87068; (505) 869-7230

Robin **Teller** — *Isleta*
 Pottery; P.O. Box 135, Isleta Pueblo, NM 87022; (505) 869-3118

Stella **Teller** — *Isleta*
 Pottery; P.O. Box 135, Isleta Pueblo, NM 87022; (505) 869-3118

Jemez

Jemez Pueblo is located about an hour northwest of Albuquerque. Take I-25 north to Highway 44. West through Bernalillo (if you're there on the right weekend stop at the wine festival) to Highway 4 then just a few miles to the Pueblo. If you call ahead try to get very detailed directions. I usually get lost and drive around in circles awhile before I find my friends' homes. Not a lot of house number here.

Jemez has a lot of wonderfully talented artists. This easy trip will really pay off for you if you make the effort to visit. There are dozens and dozens of really good potters making a wide variety of pottery. My very good friends Alvina Yepa and Emily & Leonard Tsosie constantly win awards wherever they go. I know one early morning at Indian Market in Santa Fe when I went to help Alvina retrieve her pots from the judging arena, she was delighted to have a Best of Division ribbon on a pot. I have also seen her win at the Pueblo Grande Museum show in Phoenix - or maybe it was the Heard Museum show! They have participated in art events as far away as Florida and I know their work is found in collections worldwide. Alvina makes melon and traditional pots while Emily & Leonard concentrate on outstanding storytellers and nativity sets.

The beautiful, intricately carved designs on pottery by Lorraine Chinana and Carol Vigil are not to be missed.

Jemez

And don't miss Judy Toya and other Toya family members who also craft excellent storyteller pottery. You have to see the amazing work of Kathleen Wall and the masks of Fannie Loretto – daughter & mother.

Jemez is also blessed with extemely talented sculptors Clifford Fragua and Victor Vigil. Both are award winning artists and Cliff has contributed much time and energy to the benefit of the Indian Arts & Crafts Association as well as assisting Jemez Pueblo in producing a fine annual art show at the Red Rocks just north of the Pueblo.

If you want to pick up a really great T-shirt while you're in the area try to find one designed by George Toya. Every time I wear mine, someone asks about it. I used to try to get George to sell them to me wholesale, but he always told me he sold them all anyway and didn't want to discount them. They are really very nice!

You can go on up to Santa Fe by driving north from Jemez through Los Alamos. On the way you'll pass the Soda Dam where you can stop and put your feet in the cold, clear water – especially if it's a nice warm day.

You may want to combine this trip with a visit to San Ildefonso and/or Santa Clara Pueblos farther north.
Tip – buy some freshly made bread to eat on the way!

Jemez

Aaron **Cajero** — *Jemez*
Pottery: Storytellers, Etc.; P.O. Box 86, Jemez Pueblo, NM 87024; (505) 834-7091

Anita **Cajero** — *Jemez*
Pottery: Storytellers, Etc.; P.O. Box 86, Jemez Pueblo, NM 87024; (505) 834-7091

Esther **Cajero** — *Jemez*
Pottery: Storytellers, Etc.; P.O. Box 377, Jemez Pueblo, NM 87024; (505) 834-7533

Joe **Cajero** — *Jemez*
Pottery: Storytellers, Etc.; P.O. Box 377, Jemez Pueblo, NM 87024; (505) 834-7533

Joe **Cajero, Jr.** — *Jemez*
Sculptor: Clay; 93 Juniper Rd., Placitas, NM 87043; (505) 867-3773

Dolores C. **Casiquito** — *Jemez*
Pottery & Belt Weaving; Jemez Pueblo, NM 87024; (505) 834-7371

Jeronima **Casiquito** — *Jemez*
Pottery & Belt Weaving; P.O. Box 186, Jemez Pueblo, NM 87024; (505) 834-7371

Regina A. **Casiquito** — *Jemez*
Pottery & Belt Weaving; P.O. Box 186, Jemez Pueblo, NM 87024; (505) 834-7371

Angela **Chinana** — *Jemez*
Pottery: Traditional Incised; P.O. Box 413, Jemez Pueblo, NM 87024; (505) 834-7463

Donald **Chinana** — *Jemez*
Pottery; P.O. Box 92, Jemez Pueblo, NM 87024

Leo **Chinana** — *Jemez*
Jewelry; P.O. Box 83, Jemez Pueblo, NM 87024

Lorraine **Chinana** — *Jemez*
Pottery: Traditional Incised; P.O. Box 413, Jemez Pueblo, NM 87024; (505) 834-7463

Lydia B. **Chinana** — *Jemez*
Seamstress: Embroidery; P.O. Box 278, Jemez Pueblo, NM 87024; (505) 834-7516

Gerry **Daubs** — *Jemez*
4405 Goodrich NE, Albuquerque, NM 8710

B.J. **Fragua** — *Jemez*
Pottery; P.O. Box 45146, Rio Rancho, NM 87124; (505) 898-3788

Bonnie **Fragua** — *Jemez*
Pottery: Storytellers; P.O. Box 171, Jemez Pueblo, NM 87024; (505) 834-1014

Cindy **Fragua** — *Jemez*
Pottery: Cornmaidens; P.O. Box 171, Jemez Pueblo, NM 87024; (505) 834-9308

Cliff **Fragua** — *Jemez*
Sculptor: Stone, Bronze; P.O. Box 250, Jemez Pueblo, NM 87024; (505) 892-6516; E-mail: singingstonestudio@worldnet.att.net, Web: www.singstonestudio.com

Glendora **Fragua** — *Jemez*
Pottery; 207 Summerwinds, Rio Rancho, NM 87124; (505) 891-2866

Janeth **Fragua** — *Jemez*
Pottery: Storytellers, Etc.; P.O. Box 171, Jemez Pueblo, NM 87024; (505) 834-2011

Juanita C. **Fragua** — *Jemez*
Pottery; P.O. Box 389, Jemez Pueblo, NM 87024;
(505) 824-7556

Laura **Fragua** — *Jemez*
Artist & Potter; SR 2, Box 1933, Tularosa, NM 88352;
(505) 585-4870

Linda L. **Fragua** — *Jemez*
Pottery: Storytellers; P.O. Box 205, Jemez Pueblo, NM
87024; (505) 834-7663

Melinda T. **Fragua** — *Jemez*
Pottery: Storytellers; P.O. Box 551, Jemez Pueblo, NM
87024; (505) 834-7578

Philip **Fragua** — *Jemez*
Pottery: Storytellers; P.O. Box 205, Jemez Pueblo, NM
87024; (505) 834-7663

Rose T. **Fragua** — *Jemez*
Pottery: Storytellers, Etc.; P.O. Box 171, Jemez Pueblo,
NM 87024; (505) 834-2011

Virginia **Fragua** — *Jemez*
Pottery; P.O. Box 314, Jemez Pueblo, NM 87024

Emily **Fragua Tsosie** — *Jemez*
Pottery: Storytellers; P.O. Box 372, Jemez Pueblo, NM
87024; (505) 834-7561

Bertha **Gachupin** — *Jemez*
Pottery; P.O. Box 11, Jemez Pueblo, NM 87024

Clara **Gachupin** — *Jemez*
Pottery; P.O. Box 375, Jemez Pueblo, NM 87024

Debrah C. **Gachupin** — *Jemez*
Pottery & Belt Weaving; P.O. Box 186, Jemez Pueblo, NM
87024; (505) 834-7371

Delia J. **Gachupin** — *Jemez*
Pottery; P.O. Box 544, Jemez Pueblo, NM 87024; (505) 834-7592

Henrietta T. **Gachupin** — *Jemez*
Pottery: Storytellers; P.O. Box 252, Jemez Pueblo, NM 87024; (505) 834-7232

Laura **Gachupin** — *Jemez*
Pottery; P.O. Box 433, Jemez Pueblo, NM 87024; (505) 834-7429

Wilma M. **Gachupin** — *Jemez*
Pottery; P.O. Box 355, Jemez Pueblo, NM 87024; (505) 834-7752

Helen S. **Garcia** — *Jemez*
Pottery: Storytellers; P.O. Box 489, Jemez Pueblo, NM 87024

Lloyd **Garcia** — *Jemez*
Jewelry; P.O. Box 489, Jemez Pueblo, NM 87024

Gabriel G. **Gonzales** — *Jemez*
Pottery; Box 55, Lorca Dr., Santa Fe, NM 87505; (505) 473-4275; E-mail: archvr@roadrunner.com, Web: www.taosnet.com/architectVRe/html/

H. Tafoya **Henderson** — *Jemez*
Pottery: Trad. & Contemp.; P.O. Box 618 Hwy.4, Jemez Pueblo, NM 87024; (505) 834-7053

Royce EB **Kohlmeyer** — *Jemez*
Jewelry; 1836 Cherokee Rd. NW, Albuquerque, NM 87107; (505) 344-6653

Bea **Loretto** — *Jemez*
Pottery: Storytellers, Etc.; P.O. Box 74, Jemez Pueblo, NM 87024; (505) 552-9407

Estella **Loretto** — *Jemez*
Pottery; 708 Canyon Rd., Gypsy Alley #6, Santa Fe, NM 87501; (505) 989-4793

Felicia **Loretto** — *Jemez*
Pottery: Friendship Pots; 1223 Calle Corazzi, #26, Santa Fe, NM 87505; (505) 473-1447

Glenda K. **Loretto** — *Jemez*
Pottery; 1017 Avenida de las Campanes, Santa Fe, NM 87505; (505) 424-0119

Priscilla **Loretto** — *Jemez*
Pottery & Figurines; P.O. Box 295, Jemez Pueblo, NM 87024; (505) 834-7356

Diane **Lucero** — *Jemez*
Pottery: Storytellers; P.O. Box 220, Jemez Pueblo, NM 87024; (505) 834-7154

Joyce **Lucero** — *Jemez*
Pottery: Storytellers; P.O. Box 220, Jemez Pueblo, NM 87024; (505) 834-7154

Mary **Lucero** — *Jemez*
Pottery: Storytellers; P.O. Box 220, Jemez Pueblo, NM 87024; (505) 834-7154

Mary J. **Lucero** — *Jemez*
Pottery: Storytellers; P.O. Box 24, Jemez Pueblo, NM 87024; (505) 834-7650

Virginia **Lucero** — *Jemez*
Pottery: Storytellers; P.O. Box 474, Jemez Pueblo, NM 87024; (505) 834-7650

Carol G. **Lucero-Gachupin** — *Jemez*
Pottery; P.O. Box 210, Jemez Pueblo, NM 87024; (505) 834-7757

Mary T. **Madalena** — *Jemez*
Pottery; P.O. Box 241, Jemez Pueblo, NM 87024;
(505) 834-1007

Reyes **Madalena** — *Jemez-Zia-Cochiti*
Pottery; 1070 Wagner, Moab, UT 84532; (801) 259-8419;
E-mail: madalena@lasal.net, Web: www.meganova.con/
accent-art

Carmelita **Magdalena** — *Jemez*
Pottery; P.O. Box 157, Jemez Pueblo, NM 87024

Ruby **Panana** — *Jemez*
Pottery; P.O. Box 426, Jemez Pueblo, NM 87024;
(505) 834-7629

AllenBruce **Paquin** — *Jemez-Zuni-La*
Jewelry: Gold & Silver; P.O. Box 548, Jemez Pueblo, NM
87024

Marie G. **Romero** — *Jemez*
Pottery; P.O. Box 178, Jemez Pueblo, NM 87024;
(505) 834-7429

Geraldine **Sandia** — *Jemez*
Pottery; P.O. Box 209, Jemez Pueblo, NM 87024;
(505) 834-7543

Natalie **Sandia** — *Jemez*
Pottery; P.O. Box 209, Jemez Pueblo, NM 87024;
(505) 834-7543

Rachael **Sandia** — *Jemez*
Pottery; P.O. Box 209, Jemez Pueblo, NM 87024;
(505) 834-7543

Caroline **Sando** — *Jemez*
Pottery: Storytellers; P.O. Box 428, Jemez Pueblo, NM
87024; (505) 834-7645

Pauline **Sarracino** — *Jemez*
Kachinas; P.O. Box 481, Jemez Pueblo, NM 87024;
(505) 834-7083

Vivian **Sarracino Jr.** — *Jemez*
Pottery; P.O. Box 408, Jemez Pueblo, NM 87024; (505) 834-7083

Caroline **Seonia** — *Jemez*
Pottery: Storytellers, Etc.; P.O. Box 6, Jemez Pueblo, NM
87024; (505) 834-7572

Cornelia J. **Shije** — *Jemez*
Pottery; 4904 Golden Thread NE, Albuquerque, NM
87113; (505) 823-9541

Mary **Small** — *Jemez*
Pottery: Gray Glaze; P.O. Box 348, Jemez Pueblo, NM
87024; (505) 834-7773

Brenda **Tafoya** — *Jemez*
Pottery: Polished, Carved; P.O. Box 61, Jemez Pueblo,
NM 87024; (505) 834-7157

Vangie **Tafoya** — *Jemez*
Pottery: Trad. & Contemp.; P.O. Box 363, Jemez Pueblo,
NM 87024; (505) 834-7057

Laverne L. **Tosa** — *Jemez*
Pottery: Stone Polished; P.O. Box 295, Jemez Pueblo, NM
87024; (505) 834-7115

Phyllis M. **Tosa** — *Jemez*
Pottery; P.O. Box 117, Jemez Pueblo, NM 87024; (505) 834-7016

Sefora **Tosa** — *Jemez*
Baskets; P.O. Box 145, Jemez Pueblo, NM 87024

Anita **Toya** — *Jemez*
Pottery: Storytellers, Nativity; P.O. Box 374, Jemez
Pueblo, NM 87024; (505) 834-7501

Benjamin **Toya** — *Jemez*
Pottery: Storytellers; P.O. Box 481, Jemez Pueblo, NM 87024; (505) 834-7083

Camilla **Toya** — *Jemez*
Pottery; P.O. Box 336, Jemez Pueblo, NM 87024; (505) 834-7594

Damian **Toya** — *Jemez*
Pottery; P.O. Box 336, Jemez Pueblo, NM 87024; (505) 834-7594

Eloise **Toya** — *Jemez*
Pottery: Traditional; P.O. Box 142, Jemez Pueblo, NM 87024; (505) 834-7704

George **Toya** — *Jemez*
T-Shirts; P.O. Box 391, Sandia Park, NM 87047; (505) 281-8876

Geraldine **Toya** — *Jemez*
Pottery: Storytellers; P.O. Box 481, Jemez Pueblo, NM 87024; (505) 834-7083

Jacob M. **Toya** — *Jemez*
Artist; P.O. Box 103, Jemez Pueblo, NM 87024

Judy **Toya** — *Jemez*
Pottery: Storytellers; P.O. Box 195, Jemez Pueblo, NM 87024

Lawrence **Toya** — *Jemez*
Pottery; P.O. Box 362, Jemez Pueblo, NM 87024; (505) 834-0817

Mary Rose **Toya** — *Jemez*
Pottery: Traditional; P.O. Box 142, Jemez Pueblo, NM 87024; (505) 834-7704

Maxine **Toya** — *Jemez*
Pottery; P.O. Box 336, Jemez Pueblo, NM 87024; (505) 834-7594

Norma **Toya** — *Jemez*
Pottery: Traditional; P.O. Box 142, Jemez Pueblo, NM 87024; (505) 834-7704

Ruby **Toya** — *Jemez*
Pottery; P.O. Box 362, Jemez Pueblo, NM 87024; (505) 834-0817

Melinda **Toya Fragua** — *Jemez*
Pottery; P.O. Box 551, Jemez Pueblo, NM 87024; (505) 834-7578

Yolanda **Toya-Toledo** — *Jemez*
Pottery; P.O. Box 425, Jemez Pueblo, NM 87024; (505) 834-9124, (505) 834-1013

Leonard **Tsosie** — *Jemez*
Pottery: Storytellers; P.O. Box 372, Jemez Pueblo, NM 87024; (505) 834-7561

Mary S. **Tsosie** — *Jemez*
Pottery; P.O. Box 365, Jemez Pueblo, NM 87024; (505) 834-7135

Carol D. **Vigil** — *Jemez*
Pottery: Traditional; P.O. Box 443, Jemez Pueblo, NM 87024; (505) 834-2016

Felix **Vigil** — *Jemez*
Artist; P.O. Box 76, Jemez Pueblo, NM 87024; (505) 834-7772

James A. **Vigil** — *Jemez*
Sculptor; P.O. Box 453, Jemez Pueblo, NM 87024; (505) 829-3045

Paul **Vigil** — *Jemez*
Artist: Watercolors; Rt. 11, Box 57TP, Santa Fe, NM 87501; (505) 983-7075

Victor **Vigil** — *Jemez*
Sculptor; P.O. Box 384, Jemez Pueblo, NM 87024;
(505) 834-7324

Georgia **Vigil-Toya** — *Jemez*
Pottery: Etched, polished; P.O. Box 423, Jemez Pueblo,
NM 87024; (505) 834-2027

Adrian **Wall** — *Jemez*
Sculptor; 2224B Rio Grande NE, Albuquerque, NM
87104; (505) 765-1703

Kathleen **Wall** — *Jemez*
Pottery: Clay Sculptor; P.O. Box 513, Jemez Pueblo, NM
87024; (505) 834-7823

Corina Y. **Waquie** — *Jemez*
Baskets: Yucca & Pottery; P.O. Box 73, Jemez Pueblo, NM
87024; (505) 834-7229

Alvina **Yepa** — *Jemez*
Pottery: Red, Polished, Carved; P.O. Box 164, Jemez
Pueblo, NM 87024; (505) 834-7599

Emma **Yepa** — *Jemez*
Pottery: Traditional; P.O. Box 222, Jemez Pueblo, NM
87024; (505) 834-7831

Ida **Yepa** — *Jemez*
Pottery; P.O. Box 222, Jemez Pueblo, NM 87024;
(505) 834-7831

Lawrence **Yepa** — *Jemez*
Pottery: Stone Polish, Carved; P.O. Box 339, Jemez
Pueblo, NM 87024; (505) 834-7004

Lupita **Yepa** — *Jemez*
Pottery: Stone Polish, Carved; P.O. Box 339, Jemez
Pueblo, NM 87024; (505) 834-7004

Navajo

There are Navajo artists across the United States, from California to Florida, but the majority are closer to home in New Mexico and Arizona. It's worth a trip west to find some of the more than 800 Navajo artists listed in this directory. The reason there are more Navajo artists than any other group is probably pretty simple – there are more Navajo people!

When many people think of Native American Art they think of one person first – R. C. Gorman. Having had the opportunity to meet Mr. Gorman on several occasions I can tell you that in addition to being a very special artist, he is also a kind and generous host. I have had the good fortune of being a guest at his home outside Taos during Indian Market and have had the opportunity to assist at an appearance he made at a gallery in Florida. His patience and consideration for his admiring public sets a fine example for all artists.

The list of Navajo artists is so long and so outstanding it is hard to isolate just a few to tell you about. Hopefully you will use this directory to get to know many of them yourselves.

Let me offer some information about just a few. First, I hope everyone gets an opportunity to see firsthand the unbelievable weaving of Navajo Rug Artist Paula Begay. She is a considerate and thoughtful person with

Navajo

an extraordinary talent. If you can afford one of her exquisite Navajo rugs, don't hesitate for a moment to make the purchase – you'll enjoy it every time you look at it. Also, you'll want to find rugs by Barbara Teller Ornelas and one of the Laughing sisters and Marylou Schultz and, and, and too many to mention them all! If you're traveling to a National Park during the summer, it's likely you'll find a weaver set up there giving demonstrations and selling their weavings. And, don't miss the Crownpoint Rug Auction held monthly at the Crownpoint Elementary School auditorium in, of all places, Crownpoint, NM.
I used to teach a group of Navajo Headstart teachers in a classroom down the hall back in the late 60's.

I could tell you about sculptors Tim Washburn, Robert Tsosie, Ben Woody and others, but I think I'll just let you have the exciting adventure of meeting them for yourselves. These are all award winning artists, but many fine Navajo artists are not award winners simply because they haven't entered any competitions. And if you're buying art, buy what you like – don't just buy blue ribbons!

Navajoland has many, many fine silversmiths. The price range can be as extraordinary as the craftsmanship. Take your time and look at many pieces, then decide on a piece that will be your one of a kind treasure for the

Navajo

rest of your life - enjoy it!

If you're looking for Navajo pottery you have several choices to make - and not just among potters. There are the traditional "pitch" pots, usually a dark brown color coated with pinon pitch and there are the more recently developed "greenware" pots that have been handpainted and etched or carved. These latter pots can be very attractive and are usually relatively inexpensive - just remember that you are getting a pot that is not handmade, but does have a hand done finish. The "pitch" pots are often very utilitarian pots and, in many cases, will even hold water - be sure to ask! Many of the traditional Navajo potters live in an area near Shonto , Kayenta and the Cow Springs Trading Post. Look for Silas & Bertha Claw - you will love their pottery with unusual attachments like a cow inside a corral on the side. Hard to explain, so see for yourself. Also, they make beautiful clay fetish necklaces that are really nice and very reasonable. And while in the area try to find Alice Cling. Her work is more contemporary in appearance and very finely finished and delicate! I treasure my Alice Cling pottery.

Look for outstanding two dimensional artists like W.B. Franklin, Beverly Blacksheep, Tony Abeyta, Shonto Begay and many, many more great talents.

Navajo

Take the time to visit the new Navajo Nation Museum in Window Rock, Arizona, attend the Navajo Nation Fair, also in Window Rock and, of course, visit the Navajo Nation Headquarters and see the actual Window Rock formation just above the tribal buildings.

Recently a number of new motels have opened on the Navajo Reservation and there are more opportunities to spend more time in the area. For additional information you may wish to call the Navajoland Tourism Department at (520) 871-6436.

The Navajo Nation is a place that you will always remember once you've experienced the enormous variety of the land. From the pine forests around Crystal to the mystical Shiprock area to the Red Rocks near Gallup to the spectacular Monument Valley which you've seen in countless TV commercials and movies, Navajoland is truly an enchanting place.

Whoops! I almost forgot. I want to tell you about Elizabeth Deschinny. She makes dye charts that show you where the vegetal dyes come from that are used in making Navajo rugs. Very interesting and decorative.

Also, if you go to the Crownpoint Rug Auction – they do serve Indian tacos – so wait and eat dinner there!

Navajo

Roberta **Abeita** — *Navajo*
Fetishes; 12 Chaparral Ln., Peralta, NM 87042;
(505) 869-8148; E-mail: laboraex@worldnet.att.net

Elizabeth **Abeyta** — *Navajo*
Sculptor; 2501 Vista Larga NE, Albuquerque, NM 87106;
(505) 268-5401

Pablita **Abeyta** — *Navajo*
Sculptor: Clay; 1427 E. Capitol SE, Washington, DC
20003; (202) 543-8517

Tony **Abeyta** — *Navajo*
Artist; #1 St. Francis Plaza, Rancho deTaos, NM 87557;
(505) 751-9671

Edgar **Adakai** — *Navajo*
Pottery: Ceramic; P.O. Box 3123, Kayenta, AZ 86033;
(520) 697-8606

Sarah M. **Aguilar** — *Navajo*
Jewelry; P.O. Box 340-1063, Sanders, AZ 86512

Jerald **Albert** — *Navajo*
Beadwork; P.O. Box 626, Window Rock, AZ 86515

Carol H. **Alcott** — *Navajo*
P.O. Box 3596, Tuba City, AZ 86045; (520) 283-5761

Michael **Alcott** — *Navajo*
Jewelry; P.O. Box 3596, Tuba City, AZ 86045;
(520) 283-6686

Lynda **Alsburg** — *Navajo*
Jewelry, Beadwork, Etc.; P.O. Box 1043, Waterflow, NM
87421

Robert **Alsburg** — *Navajo*
Jewelry, Beadwork, Etc.; P.O. Box 1043, Waterflow, NM 87421

Virginia **Ambrose** — *Navajo*
Weaver: Navajo Rugs; P.O. Box 182, Ft. Defiance, AZ 86504

Ricki **Anderson, Jr.** — *Navajo*
Crafts: Misc.; P.O. Box 905, Jamestown, NM 87347

Allen **Aragon** — *Navajo*
Jewelry & Pottery Designs; P.O. Box 163, Thoreau, NM 87323; (505) 836-1471

Nanaba **Aragon** — *Navajo*
Weaver, Etc.: Video tapes available; 25408 Illinois Ave., Sunlakes, AZ 85248; (602) 895-6672

Lawrence **Arnilth** — *Navajo*
Jewelry; P.O. Box 466, Tsaile, NM 86556; (520) 724-3260

Able **Arthur** — *Navajo*
Jewelry; P.O. Box 894, Navajo, NM 87328; (520) 729-5694 (Messages only)

Cheryl Ann **Arviso** — *Navajo*
Jewelry; 24-13 Wilder Ln., Santa Fe, NM 87505; (505) 920-3612

Larry **Ashkie** — *Navajo*
Artist: Paintings, Etc.; P.O. Box 55, Pinon, AZ 87323

Betty **Austin** — *Navajo*
Pottery: Ceramic; P.O. Box 2103, Shiprock, NM 87420

Fidel **Bahe** — *Navajo*
Jewelry; P.O. Box 306, Winslow, AZ 86047

Irene **Bahe** — *Navajo*
Seamstress: Clothing; P.O. Box 1115, Chinle, AZ 86503; (520) 755-3283

Kristyne **Bahe** — *Navajo*
Jewelry; P.O. Box 164, Mentmore, NM 87319

Virginia Y. **Ballenger** — *Navajo*
Clothing; P.O. Box 1282, Gallup, NM 87305;
(505) 722-6837, (800) 377-6837

Ben **Barney** — *Navajo*
Jewelry, Rugs, Dolls & A&C; P.O. Box 1124, Gallup, NM
87301; (505) 726-9022

Vivian **Barney** — *Navajo*
Crafts: Dream Catchers, Etc.; P.O. Box 901, Keams
Canyon, AZ 86034

Lorena **Bartlett** — *Navajo*
Pottery; Cow Springs Trading Post, Tonalea, AZ 86044

Bobby **Becenti** — *Navajo*
Jewelry & Horse Trainer; P.O. Box 2573, Gallup, NM
87305

Harrison **Becenti** — *Navajo*
Jewelry; P.O. Box 1237, St. Michaels, AZ 86511

Ida **Becenti** — *Navajo*
Jewelry; P.O. Box 2573, Gallup, NM 87305

Larry B. **Becenti** — *Navajo*
Artist: Oil Paintings; P.O. Box 1634, Kirtland, NM 87417;
(505) 598-5714

Robert **Becenti** — *Navajo*
Artist: Original Oils; P.O. Box 1634, Kirtland, NM 87417;
(505) 598-5714

Darrell **Bedoni** — *Navajo*
Flutes; 801 E. McKellip, # 15-C, Tempe, AZ 85281;
(602) 970-6255

Pat **Bedoni** — *Navajo*
Jewelry; 2903 E. 24th, Farmington, NM 81402;
(505) 326-7810

Ron **Bedonie** — *Navajo*
Jewelry; 149 N. Phyllis #101, Mesa, AZ 85201;
(602) 898-7603

Abraham **Begay** — *Navajo*
Jewelry; 17 N. Leroux St. #101, Flagstaff, AZ 86001;
(520) 774-8651

Alvin **Begay** — *Navajo*
Jewelry; P.O. Box 1432, Winslow, AZ 86047;
(602) 657-3294

Ambrose **Begay** — *Navajo*
Artist: Watercolors; P.O. Box 435, Thoreau, NM 87323

Anna **Begay** — *Navajo*
Jewelry & Rug weaver; P.O. Box 291, Kykotsmovi, AZ
86039

Annie **Begay** — *Navajo*
Jewelry, Rugs, Dolls & A&C; P.O. Box 1124, Gallup, NM
87301; (505) 726-9022

Aretha **Begay** — *Navajo*
Beadwork; 801 E. Mesa #2, Gallup, NM 87301

Aretha **Begay** — *Navajo*
Pottery; P.O. Box 322, Mentmore, NM 87319

Arlene **Begay** — *Navajo*
Jewelry; P.O. Box 3020, Window Rock, AZ 86515;
(520) 871-5477

Arthur **Begay** — *Navajo*
Jewelry; 610 Carlisle SE, Albuquerque, NM 87106;
(505) 260-0219

Betty L. **Begay** — *Navajo*
Crafts: Bags, purses, Etc.; Teesto CPU Box 7137, Winslow, AZ 86047

Bia, Jr. **Begay** — *Navajo*
Beadwork: Custom Orders; P.O. Box 1583, Window Rock, AZ 86515

Bobby **Begay** — *Navajo*
Jewelry; 3 Rd. 6271 NBU, Kirtland, NM 87417

Carlos **Begay** — *Navajo*
Sculptor: Folk Art; 812 N. 16th St., #B, Cottonwood, AZ 86326; (520) 634-4371

Clifford **Begay** — *Navajo*
Jewelry; P.O. Box 342, Many Farms, AZ 86538

Donovan **Begay** — *Navajo*
Artist: Paint on feathers; P.O. Box 1840, Tuba City, AZ 86045; (520) 283-5819

Douglas **Begay** — *Navajo*
Beadwork; P.O. Box 28, Round Rock, AZ 86547

Dy **Begay** — *Navajo*
Weaver; AZ; (602) 922-9232, (520) 674-3494

Eddie **Begay** — *Navajo*
Jewelry; P.O. Box 875, Teec Nos Pos, AZ 86514; (520) 656-3233

Elden **Begay** — *Navajo*
Sandpainter: Yei be chei; P.O. Box 123, Church Rock, NM 87311

Frances **Begay** — *Navajo*
Jewelry & Rugs; P.O. Box 2608, Gallup, NM 87305

Frances **Begay** — *Navajo*
Jewelry; P.O. Box 6427, Santa Fe, NM 87502

Franklin **Begay** — *Navajo*
Jewelry; P.O. Box 116, Church Rock, NM 87311;
(505) 722-3483

Fred **Begay** — *Navajo-Ute*
Sculptor; P.O. Box 22277, Santa Fe, NM 87502;
(505) 473-3591

George **Begay** — *Navajo*
Jewelry & Rugs; P.O. Box 2608, Gallup, NM 87305

Harvey **Begay** — *Navajo*
Artist: Graphic Designs (4-color process); 416 W.
Broadway, Farmington, NM 87401; (505) 326-3658

Harvey **Begay** — *Navajo*
Jewelry; P.O. Box 773258, Steamboat Springs, CO 80477;
(970) 879-8055

Irene **Begay** — *Navajo*
Jewelry; P.O. Box 875, Teec Nos Pos, AZ 86514;
(520) 656-3233

Jerry **Begay** — *Navajo*
Jewelry; P.O. Box 2071, Chinle, AZ 86503; (520) 674-5427

Kary **Begay** — *Navajo*
Jewelry; HCR 63, Box 6075, Winslow, AZ 86047;
(520) 657-3219

Larry **Begay** — *Navajo*
Jewelry; P.O. Box 705, Pinon, AZ 86510; (520) 725-3225

Leroy **Begay** — *Navajo*
Jewelry; P.O. Box 331, Pinon, AZ 86510; (520) 725-3225;
E-mail: ribegay@prodigy.net

Lorraine **Begay** — *Navajo*
Jewelry: Gold & Silver; P.O. Box 186, Kykotsmovi, AZ
86039

Lula M. **Begay** — *Navajo*
Jewelry; P.O. Box 1432, Winslow, AZ 86047; (602) 657-3294

Mae D. **Begay** — *Navajo*
Weaver: Navajo Rugs; P.O. Box 262, Tuba City, AZ 86045

Nellie S. **Begay** — *Navajo*
Weaver: Rugs; P.O. Box 3308-59, Farmington, NM 87499;
(505) 324-0612

Patsy **Begay** — *Navajo*
Sandpainter; P.O. Box 1676, Tohatchi, NM 87325;
(505) 732-4402

Paul J. **Begay** — *Navajo*
Jewelry; P.O. Box 2442, Gallup, NM 87305

Phyllis **Begay** — *Navajo*
Woodwork: Custom Cabinets; P.O. Box 942, Tuba City,
AZ 86045; (520) 283-4388

Rena **Begay** — *Navajo*
Weaver: Chief's Blankets; P.O. Box 69, Pinon, AZ 86510;
(520) 725-3225

Richard **Begay** — *Navajo*
Jewelry; 6500 N. Hwy. 89, Cabin #2, Flagstaff, AZ 86004;
(520) 522-0181

Roberta **Begay** — *Navajo*
Jewelry; P.O. Box 1045, Teec Nos Pos, AZ 86514;
(970) 565-9144

Sadie **Begay** — *Navajo*
Weaver: Navajo Rugs (Custom Orders); P.O. Box 374,
Chinle, AZ 86503; (520) 674-2042

Sarah P. **Begay** — *Navajo*
Weaver; P.O. Box 3037, Indian Wells, AZ 86031;
(520) 654-3390 (Messages)

Sharon A. **Begay** — *Navajo*
Weaver: Navajo Rugs; P.O. Box 354, Pinon, AZ 86510

Shirley **Begay** — *Navajo*
Beadwork: Custom Orders; P.O. Box 1583, Window Rock, AZ 86515

Shonto **Begay** — *Navajo*
Artist; 8610 Arroyo Tr., Flagstaff, AZ 86004;
(520) 527-1734

Steven J. **Begay** — *Navajo*
Jewelry; HCR 63, Box 6075, Winslow, AZ 86047;
(520) 657-3219

Tillie **Begay** — *Navajo*
Baskets: Wedding baskets; P.O. Box 1020, Ganado, AZ 86505

Victor **Begay** — *Navajo*
Jewelry; P.O. Box 1045, Teec Nos Pos, AZ 86514;
(970) 565-9144

Wallace **Begay** — *Navajo*
Artist; P.O. Box 268, Thoreau, NM 87323; (505) 862-7526

Willie **Begay** — *Navajo*
Beadwork: Custom Orders; P.O. Box 1583, Window Rock, AZ 86515

Wilma **Begay** — *Navajo*
Jewelry; P.O. Box 2071, Chinle, AZ 86503; (520) 674-5427

Woody **Begay** — *Navajo*
Woodwork: Custom Cabinets; P.O. Box 942, Tuba City, AZ 86045; (520) 283-4388

Zeal J. **Begay** — *Navajo*
Jewelry & Sculptor; P.O. Box 917, Pinon, AZ 86510

Harrison **Begay, Jr.** — *Navajo*
Pottery; 1115-H N. Riverside Dr. #101, Espanola, NM 87532; (505) 753-6359

Ben **Begaye** — *Navajo*
Jewelry: Eagle Feather Designs; P.O. Box 3317, Indian Wells, AZ 86031

Ben **Begaye** — *Navajo*
Jewelry; P.O. Box 494, Pinon, AZ 86510

Jacquelynn **Begaye** — *Navajo*
Weaver: Navajo Rugs; P.O. Box 126, Sanostee, NM 87461

Rex Al **Begaye** — *Navajo*
Artist; 2121 Wood St. H134, Sarasota, FL 34237; (941) 957-3084

Sylvia C. **Begaye** — *Navajo*
Weaver: Navajo Rugs/Dolls; P.O. Box 512, Ft. Defiance, AZ 886504; (520) 729-5781

Vernon **Begaye** — *Navajo*
Jewelry; P.O. Box 40994, Mesa, AZ 85202; (602) 868-1812

Grace **Begody** — *Navajo*
Weaver; P.O. Box 3605, Tuba City, AZ 86045

Elouise J. **Bekis** — *Navajo*
Crafts: Seamstress; P.O. Box 1116, Shiprock, NM 87420

Alice **Belen** — *Navajo*
Weaver: Navajo Rugs; P.O. Box 123, Fruitland, NM 87416; (505) 598-5900

Jack **Belen** — *Navajo*
Woodwork; P.O. Box 123, Fruitland, NM 87416; (505) 598-5900

James **Belone** — *Navajo*
Jewelry; P.O. Box 1747, Tohatchi, NM 87325; (505) 735-2279

Arland F. **Ben** — *Navajo*
Jewelry; P.O. Box 1067, Estancia, NM 87016;
(505) 384-4248

Herbert **Ben, Sr.** — *Navajo*
Sandpainter; P.O. Box 2930, Shiprock, NM 87420

Rosabelle **Ben, Sr.** — *Navajo*
Sandpainter; P.O. Box 2930, Shiprock, NM 87420

Alice **Benally** — *Navajo*
Sashes; P.O. Box 382, Canoncito, NM 87026;
(505) 836-2846

Annie E. **Benally** — *Navajo*
Jewelry; Farmington, NM 87401; (505) 326-4622

Arlene **Benally** — *Navajo*
Jewelry; P.O. Box 1474, Kayenta, AZ 86033;
(520) 697-8530

Chester **Benally** — *Navajo*
Jewelry; 914 E. Aztec, Gallup, NM 87301; (505) 722-0890,
(505) 722-0042

Christina **Benally** — *Navajo*
Beadwork; 209 NE English Dr., Moore, OK 87319;
(405) 794-1625

Darrell **Benally** — *Navajo*
P.O. Box 1474, Kayenta, AZ 86033; (602) 697-3309

Donna **Benally** — *Navajo*
Weaver: Navajo Rugs; P.O. Box 861, Kirtland, NM 87417

Eric **Benally** — *Navajo*
Jewelry; Farmington, NM 87401; (505) 326-4622

Ernest **Benally** — *Navajo*
Jewelry: Inlay with Overlay; P.O. Box 2138, Gallup, NM
87305; (505) 722-2401

Etta **Benally** — *Navajo*
Beadwork; 209 NE English Dr., Moore, OK 87319;
(405) 794-1625

Fernandez **Benally** — *Navajo*
Pottery; P.O. Box 385, Bernalillo, NM 87004; (505) 771-1318

Francis **Benally** — *Navajo*
Weaver: Navajo Rugs; P.O. Box 69, Red Valley, AZ 97544;
(520) 653-5717

John **Benally** — *Navajo*
Herbalist & Storyteller; P.O. Box 16, Red Valley, AZ 86544

Judy **Benally** — *Navajo*
Pottery: Ceramic; P.O. Box 1732, Shiprock, NM 87420

Leo J. **Benally** — *Navajo*
Moccasins: Handmade to order; P.O. Box 2922, Window
Rock, AZ 86515

Nellie G. **Benally** — *Navajo*
Beadwork, Navajo Rugs & Pottery; P.O. Box 16, Red
Valley, AZ 86544

Perry **Benally** — *Navajo*
Leatherwork: Rodeo Gear Bags, Etc.; Kirtland, NM 87417

Richard **Benally** — *Navajo*
Artist; 39 Apache Ridge Rd., RR #3, Santa Fe, NM 87505;
(505) 466-3740

Sam **Benally** — *Navajo*
Jewelry; P.O. Box 1474, Kayenta, AZ 86033; (520) 697-8530

Billy **Betoney** — *Navajo*
Jewelry; HCR, Box 458, Winslow, AZ 86993

Randall **Beyale** — *Navajo*
Sculptor; 2237 E. Sheridan, Phoenix, AZ 85006; (602) 273-7965

Wayne Nez **Beyale** — *Navajo*
Artist: Acrylics; 4600 S. Logan St., Englewood, CO 80110;
(303) 781-4610

Katherine **Bia** — *Navajo*
Clothing: Seamstress (Native Designs); P.O. Box 1628,
Kayenta, AZ 86033; (520) 525-2766

Norman **Bia** — *Navajo*
Jewelry; 1396 Sunset Rd. #14, Winslow, AZ 86047;
(520) 289-2759

Sam **Bia, Jr.** — *Navajo*
Jewelry; P.O. Box 3440, Indian Wells, AZ 86031

Leonard **Bill** — *Navajo*
Jewelry; 709 S. 4th St., Gallup, NM 87301; (505) 722-5219

Linda **Bill** — *Navajo*
Pottery; 709 S. 4th St., Gallup, NM 87301; (505) 722-5219

Tommie **Billie** — *Navajo*
P.O.Box 3184, Tuba City, AZ 86045; (520) 283-4349

George **Billie, Jr.** — *Navajo*
Jewelry; 501 Vermont NE #C, Albuquerque, NM 87108;
(505) 254-0327

Ben **Billy** — *Navajo*
Artist & Ceramic Pots; HC 58 Box 70, Ganado, AZ 86505;
(520) 654-3283

Carmelita **Billy** — *Navajo*
Pottery; Rt. 9, Box 202, Brimhall, NM 87310;
(505) 979-0528

Dennison **Billy** — *Navajo*
Pottery; Rt. 9, Box 202, Brimhall, NM 87310;
(505) 735-2254

Timothy **Billy** — *Navajo*
Artist; P.O. Box 35, Manuelito, NM 87301; (505) 722-3073, (505) 722-0711

Dorothy **Bitsilly** — *Navajo*
Clothing: Pendleton fabrics; P.O. Box 45, Tohatchi, NM 87325

Darlene **Black** — *Navajo*
Art: Wood Burning art; Red Lake Store, Tonalea, AZ 86044

Jim **Black** — *Navajo*
Art: Wood Burning art; Red Lake Store, Tonalea, AZ 86044

Lorraine **Black** — *Navajo*
Weaver: Rugs; P.O. Box 360, 137, Monument Valley, UT 84536

Rosallez **Black** — *Navajo*
Jewelry, Needlepoint & Turq.; P.O. Box 360103, Mon. Valley, UT 84536

Sally **Black** — *Navajo*
Weaver: Rugs; P.O. Box 360, 137, Monument Valley, UT 84536; (801) 739-4285

Alice **Blackgoat** — *Navajo*
Jewelry; P.O. Box 371, Window Rock, AZ 86515

Jeanie **Blackgoat** — *Navajo*
Jewelry; Route 5, Box 23, Gallup, NM 87301

Beverly **Blacksheep** — *Navajo*
Artist; P.O. Box 4514, Blue Gap, AZ 86520

Bernice **Bonney** — *Navajo*
Jewelry; Albuquerque, NM 87109; (505) 299-8973, (505) 296-2918

Virginia **Boone** — *Navajo*
Herbalist; P.O. Box 86105, Tucson, AZ 85754; (520) 743-9874

Allen **Boy** — *Navajo*
Jewelry; P.O. Box 1404, Shiprock, NM 87420

Rose **Boy** — *Navajo*
Jewelry; P.O. Box 1404, Shiprock, NM 87420

Allen **Boyd** — *Navajo*
Jewelry; 531 Airport Rd. #31, Santa Fe, NM 87505;
(505) 471-5950

Brenda **Boyd** — *Navajo*
Beadwork: Traditional; P.O. Box 3826, Farmington, NM
87499; (505) 326-7855

Emma R. **Boyd** — *Navajo*
Jewelry; P.O. Box 2609, Shiprock, NM 87420

Leroy **Boyd** — *Navajo*
Jewelry; P.O. Box 2609, Shiprock, NM 87420

Mary **Boyd** — *Navajo*
Weaver: Navajo Rugs; P.O. Box 861, Kirtland, NM 87417

Paula **Boyd** — *Navajo*
Jewelry; 531 Airport Rd. #31, Santa Fe, NM 87505;
(505) 471-5950

Genieve **Bradley** — *Navajo*
Weaver, Jewelry, Pottery; P.O. Box 1888, Kayenta, NM
86033; (520) 697-3336

Roland **Brady** — *Navajo*
Jewelry Illustrator; P.O. Box 2389, Shiprock, NM 87420;
(602) 697-3576

Winona **Brown** — *Navajo*
Weaver: Navajo Rugs (Custom orders); P.O. Box 143,
Lupton, AZ 86508

Nate **Browning** — *Navajo*
Clothing; P.O. Box 142, Gallup, NM 87305; (800) 509-2365

Clifford **Brycelea** — *Navajo*
Artist; 1721 Montano St., Santa Fe, NM 87501;
(505) 984-8632

Samuel **Burnside** — *Navajo*
Jewelry; P.O. Box 3955, Canoncito, NM 87026

C. J. **Butler** — *Navajo*
Jewelry; P.O. Box 1351, Kirtland, NM 87417

Lorrain **Butler** — *Navajo*
Jewelry; P.O. Box 1351, Kirtland, NM 87417

Kee **Carl, Jr.** — *Navajo*
T-shirts: Caps, Cups, Etc.; P.O. Box 851, Window Rock,
AZ 86515

Emma **Carviso Jr.** — *Navajo*
Jewelry; P.O. Box 501, Ft. Wingate, NM 87316;
(505) 488-5942

Wilson **Carviso Jr.** — *Navajo*
Jewelry; P.O. Box 501, Ft. Wingate, NM 87316;
(505) 488-5942

Ben **Chapo** — *Navajo*
Jewelry; P.O. Box 183, Chambers, AZ 86502

Lena **Chapo** — *Navajo*
Jewelry; P.O. Box 183, Chambers, AZ 86502

Blanche **Charley** — *Navajo*
Clothing: Seamstress; 2600 E. 7th Ave. #35, Flagstaff, AZ
86004; (520) 526-2877

Cecelia **Charley** — *Navajo*
Jewelry; P.O. Box 139, Sawmill, AZ 86549

David **Charley** — *Navajo*
Jewelry; P.O. Box 1353, Kayenta, AZ 86033;
(520) 697-8546

Harlan **Charley** — *Navajo*
Weaver: Navajo Rugs; P.O. Box 1145, Window Rock, AZ
86515

Robert **Charley** — *Navajo*
Bows, Arrows; P.O. Box 10, Aneth, UT 85610

Rose **Charley** — *Navajo*
Jewelry; DilconSchool #108, Winslow, AZ 86047

Wilton D. **Charley** — *Navajo*
Artist: Pencil, Pastels, Etc.; P.O. Box 400, Teec Nos Pos,
AZ 86514

Ric **Charlie** — *Navajo*
Jewelry; (602) 894-0814

Albert **Chavez** — *Navajo*
Kachinas; P.O. Box 1634, Crownpoint, NM 87313;
(505) 786-7127

Evelyn **Chavez** — *Navajo*
Crafts: Eagle Bolo w/Fringes; P.O. Box 367, Canoncito,
NM 87026

Fannie **Chavez** — *Navajo*
Jewelry; P.O. Box 216, Canoncito, NM 87026

John **Chavez** — *Navajo*
Crafts: Eagle Bolo w/Fringes; P.O. Box 367, Canoncito,
NM 87026

Julia **Chavez** — *Navajo*
Crafts: Navajo Dolls; P.O. Box 1688, Bloomfield, NM
87413

Al **Chee** — *Navajo*
Artist; 17616 N. 32nd Pl., Phoenix, AZ 85032;
(602) 992-5960

Bernice **Chee** — *Navajo*
Weaver: Navajo Rugs; P.O. Box 2, Lukachukai, AZ 86507;
(520) 724-3273, (520) 724-6604 Messages

Carlis M. **Chee** — *Navajo*
Artist; P.O. Box 505, Santa Fe, NM 87504; (505) 747-3737

Donny **Chee** — *Navajo*
Jewelry, Painting, Crafts; P.O. Box 2119, Kaibeto, AZ
86053; (520) 672-2854

Elizabeth **Chee** — *Navajo*
Jewelry, Painting, Crafts; P.O. Box 2119, Kaibeto, AZ
86053; (520) 672-2854

Evelyn **Chee** — *Navajo*
Jewelry; P.O. Box 262, Vanderwagon, NM 87326;
(505) 778-5630

Frank **Chee** — *Navajo*
Jewelry; P.O. Box 262, Vanderwagon, NM 87326;
(505) 778-5630

Herman **Chee** — *Navajo*
Jewelry; P.O. Box 360235, Mon. Valley, UT 84536

Janelle **Chee** — *Navajo*
17616 N. 32nd Pl., Phoenix, AZ 85032; (602) 992-5960

Norma **Chee** — *Navajo*
Crafts: Purses, Key Chains, +; P.O. Box 236, Sanostee, NM
87461

Norris M. **Chee** — *Navajo*
Artist; 306 Santa Fe Dr., Lexington, NE 68850;
(308) 324-3667

Raymond **Chee** — *Navajo*
Kachinas & Cultural Carvings; P.O. Box 2876, Page, AZ 86040

Ronald **Chee** — *Navajo*
Artist; 2523 Poplar Ln., Costa Mesa, CA 92627; (714) 722-8555

Ernest **Chee/Baldwin** — *Navajo*
Craft: Rug Loom Lamps; P.O. Box 502, Crownpoint, NM 87313

Genevieve **Chee/Baldwin** — *Navajo*
Craft: Rug Loom Lamps; P.O. Box 502, Crownpoint, NM 87313

Chiaz — *Navajo*
Jewelry; (813) 397-1844

Pearlena **Chiquito** — *Navajo*
Moccasins: Navajo; Kayenta, AZ 86033; (520) 697-3432 (Messages)

Laura **Christie** — *Navajo*
Jewelry; P.O. Box 1122, Page, AZ 86040; (520) 698-3266

Johnny **Clah** — *Navajo*
Crafts: Kachinas, Earrings, +; P.O. Box 2311, Shiprock, NM 87420

Mistele **Clah** — *Navajo*
Crafts: Kachinas, Earrings, +; P.O. Box 2311, Shiprock, NM 87420

Ben **Clark** — *Navajo*
Jewelry; P.O. Box 1055, Chinle, AZ 86503; (520) 674-2327

Chester **Clark** — *Navajo*
Jewelry; P.O. Box 1055, Chinle, AZ 86503; (520) 674-2327

Don **Clark** — *Navajo*
Artist: Oils, Pastels, Charcoals; 1190 Coronado Rd., Corrales, NM 87048; (505) 792-2301

Irene **Clark** — *Navajo*
Weaver: Rugs; P.O. Box 898, Navajo, NM 87328; (505) 777-2437

Bertha **Claw** — *Navajo*
Pottery; Cow Springs Trading Post, Tonalea, AZ 86044

Silas **Claw** — *Navajo*
Pottery; Cow Springs Trading Post, Tonalea, AZ 86044

Emma **Claw-Gums** — *Navajo*
Ceramics: Figurines, Vases, Etc.; P.O. Box 873, St. Johns, AZ 85936; (520) 337-2327

Alice W. **Cling** — *Navajo*
Pottery; P.O. Box 7321, Shonto, AZ 86054; (505) 283-8856

Ann B. **Clitso** — *Navajo*
Baskets: Navajo Wedding Bas; P.O. Box 792, Kayenta, AZ 86033; (520) 697-5520 (Messages)

Lola S. **Cody** — *Navajo*
Weaver: Navajo Rugs; HC 61, Box 126, Winslow, AZ 86047; (520) 522-9084

Frances **Coolidge** — *Navajo*
Jewelry; P.O. Box 2243, Shiprock, NM 87420

Stephan **Coolidge** — *Navajo*
Jewelry; P.O. Box 2243, Shiprock, NM 87420

Cecilia **Coyote** — *Navajo*
Gourd Art: Ornaments; P.O. Box 588, Cortez, CO 81321; (970) 565-2034

Mac **Coyote** — *Navajo*
Artist: Acrylics; P.O. Box 588, Cortez, CO 81321; (970) 565-2034

Gracie **Craig** — *Navajo*
Jewelry: Sand Casting; P.O. Box 511, Crownpoint, NM 87313

Johnson **Craig** — *Navajo*
Jewelry: Sand Casting; P.O. Box 511, Crownpoint, NM 87313

Natani **Creations** — *Navajo*
Necklaces: Bone & Bead; P.O. Box 929, Chimayo, NM 87522; (505) 753-3590

Edison **Cummings** — *Navajo*
Jewelry: Silver & Gold; 2259 W. Ella Ave., #102, Mesa, AZ 85201; (602) 610-8221

Emma J. **Curley** — *Navajo*
Weaver: Navajo Rugs; P.O. Box 3271, Shiprock, NM 87420

Polly **Curley** — *Navajo*
Weaver: Navajo Rugs; P.O. Box 561, Ganado, AZ 86505

Presley **Curley** — *Navajo*
Jewelry; HCR2 Box 2601, Thoreau, NM 87323

Ira **Custer** — *Navajo*
Jewelry: Tufa Casting, Etc.; P.O. Box 275, Gallup, NM 87305; (505) 727-5016

Louva **Dahozy** — *Navajo*
Clothing & Navajo foods, Etc.; P.O. Box 1060, Ft. Defiance, AZ 86504

Saraphine **Dailey** — *Navajo*
Weaver: Navajo Rugs; P.O. Box 374, Chinle, AZ 86503; (520) 674-2042

Buffy **Dailley** — *Navajo*
Beadwork; 39 Apache Ridge Rd., RR #3, Santa Fe, NM 87505; (505) 466-3740

Steven A. **Darden** — *Navajo-Cheyen*
Beadwork & Featherwork, Etc.; 4450 N. Randall,
Flagstaff, AZ 86004; (520) 527-3889

Harold **Davidson** — *Navajo*
Sculptor; P.O. Box 211, Mentmore, NM 87319;
(505) 863-2524

Danny **Davis** — *Navajo*
Artist: Pencil, Oil, Acrylics +; P.O. Box 185,
Vanderwagon, NM 87326; (505) 735-2330 (Messages)

Kate **Davis** — *Navajo*
Pottery; Cow Springs Trading Post, Tonalea, AZ 86044

Mary Lou **Davis** — *Navajo*
Pottery; Cow Springs Trading Post, Tonalea, AZ 86044

Cheryl **Dawes** — *Navajo*
Craft: Beadwork, Etc.; P.O. Box 488, Shiprock, NM 87420

Lucy **Dawes** — *Navajo*
Jewelry; P.O. Box 488, Shiprock, NM 87420

Lyna A. **Dawes** — *Navajo*
Jewelry; P.O. Box 20, Mexican Springs, NM 87320

Nelvis **Dawes** — *Navajo*
Jewelry; P.O. Box 488, Shiprock, NM 87420

Dawn'A D. — *Navajo*
Artist; P.O. Box 546, Elephant Butte, NM 87935

Roger **Deale** — *Navajo*
Artist: PrismaColor, Etc.; 2617 D E Albany, Broken Arrow,
OK 74014; (918) 355-6041

Thomas **Deel** — *Navajo*
Jewelry: Gold & Silver; P.O. Box 313, Tuba City, AZ
86045; (602) 283-5864

LeRoy **DeJolie** — *Navajo*
Photography; E-mail: navajoland@dejolie.com

Harry **Denetchilee** — *Navajo*
Sandpainter; P.O. Box 1271, Fruitland, NM 87416

Marian **Denipah** — *Navajo-SanJuan*
Artist: Paintings; P.O. Box 2872, Flagstaff, AZ 86003;
(520) 526-2300; E-mail: denlarart@aol.com

Laura **Dennison** — *Navajo*
Beadwork: Custom Caps; P.O. Box 833, Ft. Defiance, AZ
86504

Isabell **Deschinny** — *Navajo*
Dye Charts: Vegetable; Drawer L., Window Rock, AZ
86515; (602) 871-2510

Norbert **Dishface** — *Navajo*
Jewelry; P.O. Box 100-278, Aneth, UT 84510

David **Draper** — *Navajo*
Sculptor: Stone/Wood; 15 E. Jackson St., Phoenix, AZ
85004; (602) 258-0558

Arlene **Edd** — *Navajo*
Jewelry, Pottery & Beadwork; HC-71, Box 2, Tonalea, AZ
86044

Rolland **Ellsworth** — *Navajo*
Saddles: Custom Made; Rt. 2, Box 13, Ramah, NM 87321;
(505) 775-7155

Lyn **Elwood** — *Navajo*
Sandpainter; P.O. Box 3055, Shiprock, NM 87420

Melvin **Elwood** — *Navajo*
Sandpainter; P.O. Box 3055, Shiprock, NM 87420

Anthony C. **Emerson** — *Navajo*
Artist; P.O. Box 719, Kirtland, NM 87417; (505) 598-9641

Travis E. **Emerson** — *Navajo*
Figurines: Clay-Folk Artist; P.O. Box 7972, Newcomb, NM 87455; (505) 598-6284

Darrel **Eskeets** — *Navajo*
Jewelry; P.O. Box 443, Houck, AZ 86505

Phyllis B. **Etcitty** — *Navajo*
Jewelry; P.O. Box 983, Fruitland, NM 87416; (505) 598-6525

Violet **Etcitty** — *Navajo*
Jewelry; 4715 Gila, Sp. # 40, Farmington, NM 87401

Erne **Etsitty** — *Navajo*
P.O. Box 949, Window Rock, AZ 86515; (505) 371-5456

Fannie **Etsitty** — *Navajo*
P.O. Box 949, Window Rock, AZ 86515; (505) 371-5456

Joe **Eulynda** — *Navajo*
Navajo Dolls; P.O. Box 1054, Gallup, NM 87301

Margaret **Everly** — *Navajo*
Jewelry; 344 58th St. NW, Albuquerque, NM 87105; (505) 831-3597

Matilda R. **Farrell** — *Navajo*
Clothing, Quilts, Pillows, Etc.; P.O. Box 553, Many Farms, AZ 86538; (520) 781-6913 (Messages)

Gilbert **Foster** — *Navajo*
Seamstress: Dolls, Baby Quilts, Etc.; P.O. Box 159, Waterflow, NM 87421; (505) 368-4195

Rosanna **Foster** — *Navajo*
Seamstress: Dolls, Baby Quilts, Etc.; P.O. Box 159, Waterflow, NM 87421; (505) 368-4195

Cindy N. **Fowler** — *Navajo*
Sculptor, Beadwork, Etc.; P.O. Box 2512, Shiprock, NM 87420; (505) 368-5629

Cinibah **Francis** — *Navajo*
Jewelry: Silver Bead Necklace; P.O. Box 183, Chambers, AZ 86502

George **Francis** — *Navajo*
Jewelry: Silver & Gold; P.O. Box 1611, Fruitland, NM 87416; (505) 598-5351

Esther **Frank** — *Navajo*
Sandpainter; P.O. Box 441, St. Michaels, AZ 86511

Richy **Frank, sr.** — *Navajo*
Artist; P.O. Box 1198, Thoreau, NM 87323

Irene W. **Franklin** — *Navajo*
Seamstress: Trad. Navajo Dr.esses; P.O. Box 244, Tohatchi, NM 87325; (505) 735-2225

W.B. **Franklin** — *Navajo*
Artist: Oils, Acrylics, Etc.; P.O. Box 477, Flagstaff, AZ 86002; (520) 774-9490

Connie **Franklin-Pablo** — *Navajo*
Beadwork; P.O. Box 3308, Farmington, NM 87499

Ernest **Franklin, Sr.** — *Navajo*
Artist; P.O. Box 244, Tohatchi, NM 87325; (505) 735-2225

Dan **Frewin** — *Navajo*
Dolls, Flutes & Beadwork; 229 S. 300 East, Springville, UT 84663; (801) 489-8039

Lapita **Frewin** — *Navajo*
Dolls, Flutes & Beadwork; 229 S. 300 East, Springville, UT 84663; (801) 489-8039

Johnson & **Fulton** — *Navajo*
Jewelry & Beadwork; P.O. Box 1699, Shiprock, NM 87420

Michael **Garcia** — *Navajo*
Jewelry & Sculptor; NM; (505) 455-2093

Nelson **Garcia** — *Navajo*
Jewelry; P.O. Box 34364, Phoenix, AZ 85067;
(602) 230-7389

Michael **Garrity, Sr.** — *Navajo*
Crafts: Baskets, Wall Hangings; P.O. Box 1655,
Lukachukai, AZ 86507

Claude **Gatewood** — *Navajo*
Crafts: Basket Earrings; P.O. Box 1678, Lukachukai, AZ
86507

David **Gaussoin** — *Navajo-Picuris*
Jewelry; P.O. Box 2491, Santa Fe, NM 87504;
(505) 471-4335

Wayne N. **Gaussoin** — *Navajo-Picuris*
P.O. Box 2491, Santa Fe, NM 87504; (505) 471-4335

Leonard **Gene** — *Navajo*
Jewelry; Las Vegas, NV; (702) 644-2356

Carrie **George** — *Navajo*
Jewelry; P.O. Box 1262, Cuba, NM 87023

Nathan **George** — *Navajo*
Jewelry; P.O. Box 1262, Cuba, NM 87023

Sara **Gibson** — *Navajo*
Jewelry; P.O. Box 329, Thoreau, NM 87323

Henry **Goldtooth** — *Navajo*
Jewelry; P.O. Box 1437, Winslow, AZ 86047

Karlis R. **Goldtooth** — *Navajo*
Bows: Navajo Traditional; P.O. Box 3534, Tuba City, AZ
86045

Corline **Goman** — *Navajo*
Ornaments, Etc.; P.O. Box 7239, Nazlini, AZ 86540;
(520) 755-3831

Harrison **Goman** — *Navajo*
Ornaments, Etc.; P.O. Box 7239, Nazlini, AZ 86540;
(520) 755-3831 (Messages)

Arnold **Goodluck** — *Navajo*
Jewelry; P.O. Box 369, Houck, AZ; (520) 688-2316

Michael **Goodluck** — *Navajo*
Woodwork: Flutes, Carving; P.O. Box 349, Ft. Defiance,
AZ 86504; (520) 729-2589

Ronald **Goodluck** — *Navajo*
Artist; P.O. Box 1361, Crownpoint, NM 87313

Ronaldo **Goodluck** — *Navajo*
Sculptor & Paintings, Drawings; P.O. Box 325, Lupton,
AZ 86508; (505) 866-1779, (505) 224-0676

Virgil **Goodluck** — *Navajo*
Woodwork: Flutes, Carving; P.O. Box 349, Ft. Defiance,
AZ 86504; (520) 729-2589

Louise R. **Goodman** — *Navajo*
Pottery; Tonalea, AZ; (602) 283-4303

Melvin **Gordo** — *Navajo*
Jewelry; Albuquerque, NM 87123; (505) 271-8299

Eva **Gorman** — *Navajo*
Beadwork; P.O. Box 265, Chinle, AZ 86503;
(520) 674-3764?

Harrison **Gorman** — *Navajo*
Artist; P.O. Box 7009, Nazlini, AZ 86540; (520) 755-3283
(Messages)

R.C. **Gorman** — *Navajo*
Artist; P.O. Box 1756, Taos, NM 87571; (505) 758-3250;
Web: www.taoswebb.com/RCGORMAN

Richard **Gorman** — *Navajo*
Paintings & Carving; 414 Anita Dr., Holbrook, AZ 86025;
(520) 524-9300

Collier **Greyhat** — *Navajo*
Jewelry; P.O. Box 3705, Page, AZ 86040

Delora A. **Guerro** — *Navajo*
Jewelry; P.O. Box 3955, Canoncito, NM 87026

Roger **Haley** — *Navajo*
Artist: Sandpainter; P.O. Box 1421, Gallup, NM 87305;
(505) 722-6694

Lucy **Hardy** — *Navajo*
Crafts: Ceramics, beadwork+; 2800 E. Aztec, Sp43,
Gallup, NM 87301; (505) 863-2041

Lucy **Hardy** — *Navajo*
Jewelry & Pottery; 2800 E. Aztec, Sp43, Gallup, NM
87301; (505) 863-2041

Annabell **Harrison** — *Navajo*
Seamstress: Clothing, Pillows, Etc.; P.O. Box 35, Shiprock,
NM 87420

Bertha **Harrison** — *Navajo*
Jewelry; P.O. Box 52, Ft. Defiance, AZ 86504

Daisy **Harrison** — *Navajo*
Jewelry; P.O. Box 352, Shiprock, NM 87420;
(505) 368-5137, (505) 368-4150

Jimmie **Harrison** — *Navajo*
Artist: Jewelry; P.O. Box 1818, Shiprock, NM 87420;
(505) 368-4101

Jimmie **Harrison** — *Navajo*
Jewelry; P.O. Box 30333, Albuquerque, NM 87190;
(505) 897-1755

Leo J. **Harrison** — *Navajo*
Jewelry; P.O. Box 352, Shiprock, NM 87420;
(505) 368-5137, (505) 368-4150

Cecilia J. **Harvey** — *Navajo*
Beadwork; P.O. Box 320, Navajo, NM 87328

Marletha S. **Harvey** — *Navajo*
Weaver: Rugs, Belts; P.O. Box 2132, Chinle, AZ 86503;
(602) 725-3390

Ethel **Haskie** — *Navajo*
Clothing: Seamstress; P.O. Box 1182, Fruitland, NM 87416

Mary Lou **Haskie** — *Navajo*
Baskets: Wedding Baskets; P.O. Box 2, Kayenta, AZ 86033

Vernon C. **Haskie** — *Navajo*
Jewelry; P.O. Box 264, Lukachukai, AZ 86507; (520) 787-2381

Elsie **Henderson** — *Navajo*
Crafts: Indian Doll Lamps +; P.O. Box 362, Shiprock, NM
87420

Frederick **Henry** — *Navajo*
Jewelry; P.O. Box 1163, Chinle, AZ 86503; (520) 674-5500

Nusie **Henry** — *Navajo*
Jewelry; P.O. Box 496, Crownpoint, NM 87313;
(505) 786-5678

Ronnie **Henry** — *Navajo*
Jewelry; P.O. Box 496, Crownpoint, NM 87313;
(505) 786-5678

Lula **Herder** — *Navajo*
Jewelry; P.O. Box 3114, Page, AZ 86040

Lorraine A. **Hesuse** — *Navajo*
Jewelry & Beadwork; 24 B Wilder Ln., Santa Fe, NM
87505; (505) 920-3612

Ida Mae **Hobbs** — *Navajo*
 Jewelry; P.O. Box 685, Navajo, NM 87328

Terrylene **Hobbs** — *Navajo*
 Jewelry; P.O. Box 1708, Lukachukai, NM 86507

L. Bruce **Hodgins** — *Navajo*
 Jewelry: Gold & Silver; P.O. Box 2823, Flagstaff, AZ 86003

Anderson **Hoskie** — *Navajo*
 Clothing: Seamstress; P.O. Box 975, Gallup, NM 87301

John **Hoskie** — *Navajo*
 Jewelry; P.O. Box 321, Mentmore, NM 87319

Randy **Hoskie** — *Navajo*
 Jewelry; 6508 Vuelta Ventura, Santa Fe, NM 87501

Virginia **Hosteen** — *Navajo*
 Crafts: Woven Purses; P.O. Box 52, Lukachukai, AZ 86507

Conrad **House** — *Navajo*
 Artist: Multi-media; P.O. Box 70, St. Michaels, AZ 86511

Grace **Huber** — *Navajo*
 Jewelry; 3401 Cinza Dr., Gallup, NM 87301;
 (505) 722-2839

Berlinda H. **Huhbbard** — *Navajo*
 Jewelry & Sandpaintings; P.O. Box 1833, Cuba, NM 87013

Cody **Hunter** — *Navajo*
 Jewelry: Story Bracelets; P.O. Box 1072, Chinle, AZ 86503;
 (520) 674-3316

Danny **Jackson** — *Navajo*
 Jewelry; P.O. Box 1662, Chinle, AZ 86503; (505) 674-5976

Gene **Jackson** — *Navajo*
 Jewelry; P.O. Box 1662, Chinle, AZ 86503; (602) 674-5976

Lorraine **Jackson** — *Navajo*
Jewelry; P.O. Box 1662, Chinle, AZ 86503; (505) 674-5976

Martha **Jackson** — *Navajo*
Jewelry; P.O. Box 1662, Chinle, AZ 86503; (602) 674-5976

Ron Toahani **Jackson** — *Navajo*
Artist: Paintings, Masks; P.O. Box 26994, Tempe, AZ 85285; (602) 777-9514; E-mail: ronj777@msn.com, Web: www.temptees.com

Tommy **Jackson** — *Navajo*
Jewelry; P.O. Box 72, Ganado, AZ 86505

Melvin **Jackson, Sr.** — *Navajo*
Jewelry; P.O. Box 1424, Window Rock, AZ 86515; (520) 729-2537

Lawrence **Jacquez** — *Navajo*
Folk Artist: Carvings, Etc.; P.O. Box 275, Nageezi, NM 87037; (505) 320-6172

Rozita **Jake** — *Navajo*
Yarns: Sheep Wool; P.O. Box 719, Shiprock, NM 87420; (505) 368-4356, (505) 368-5125

Darlene **James** — *Navajo*
Sandpainter: Yei be chei; P.O. Box 123, Church Rock, NM 87311

Jimmy **James** — *Navajo*
Jewelry; P.O. Box 4223, Yah Ta Hey, NM 87375; (505) 863-6320

PeterRay **James** — *Navajo*
Artist: Painting/Ceramics; 35 RD 7585 Box 5237, Bloomfield, NM 87413

Alan **Jensen** — *Navajo*
Jewelry: Navajo Wedding Baskets; P.O. Box 10202, Tonalea, AZ 96044; (520) 672-2477

Justin **Jensen** — *Navajo*
Crafts: Car Ornaments, Etc.; P.O. Box 971, St. Johns, AZ
85936; (520) 337-2809

Melvin **Jensen** — *Navajo*
Jewelry; P.O. Box 5214, Leupp, AZ 86035

Winterhawk **Jewelry** — *Navajo*
Jewelry; P.O. Box 435, Teec Nos Pos, AZ 86514; (520) 656-3417

Clinton **Jim** — *Navajo*
Jewelry & Pottery, Etc.; P.O. Box 3745, Crownpoint, NM
87313

Ed **Jim** — *Navajo*
Sandpainter; P.O. Box 1719, Sheep Springs, NM 87364

Eleanora **Jim** — *Navajo*
Sandpainter; P.O. Box 1719, Sheep Springs, NM 87364

Haskie **Jim** — *Navajo*
Jewelry; P.O. Box 214, Thoreau, NM 87323

Kee John **Jimmy** — *Navajo*
Weaver: Navajo Rugs, Lamps; P.O. Box 2441, Riverside
#20, Chinle, AZ 86503

Alfred L. **Joe** — *Navajo*
Jewelry; P.O. Box 760, Winslow, AZ 86047; (520) 289-9196,
(520) 607-0694

Dolly L. **Joe** — *Navajo*
P.O. Box 594, Keams Canyon, AZ 86034

Elsie J. **Joe** — *Navajo*
Pottery; P.O. Box 1767, Shiprock, NM 87420;
(505) 368-4447, (602) 993-3582

Kathleen **Joe** — *Navajo*
Beadwork; P.O. Box 1284, Lukachukai, AZ 86507

Larry R. **Joe** — *Navajo*
Jewelry; HCR-63, Box 272, Winslow, AZ 86407;
(520) 607-7108

Rita **Joe** — *Navajo*
Jewelry; 1242 County Rd. 205, Durango, CO 81301;
(970) 259-1363

Sarah **Joe** — *Navajo*
Navajo Dolls: Pow Wow Princess; P.O. Box 289,
Rehoboth, NM 87322

David K. **John** — *Navajo*
Paintings & Clay Sculptures; P.O. Box 101, Kayenta, AZ
86033; (520) 674-1428

Johnny **John** — *Navajo*
Woodwork: Wall & Key Plaques; P.O. Box 142, Shiprock,
NM 87461

Maybelle **John** — *Navajo*
Jewelry; 306 Edwardo, Holbrook, AZ 86025; (520) 524-1830

Thompson **John** — *Navajo*
Jewelry; P.O. Box 144, St. Michaels, AZ 86511; (602) 871-3425

Vicki **John** — *Navajo*
Woodwork: Wall & Key Plaques; P.O. Box 142, Shiprock,
NM 87461

Cecilia **Johnson** — *Navajo*
Dolls: Weaving Dolls; P.O. Box 413, Vanderwagon, NM
87326

Hattie L. **Johnson** — *Navajo*
Seamstress: Shawls, Robes, Etc.; P.O. Box 1291, Shiprock,
NM 87420

Larry **Johnson** — *Navajo*
Sandpainter, Stone Painting, Etc.; P.O. Box 549, Teec Nos
Pos, AZ 86514

Mary A. **Johnson** — *Navajo*
Crafts: Hand Made; P.O. Box 1604, Window Rock, AZ 86515

Peter **Johnson** — *Navajo*
Jewelry; P.O. Box 2398, Moriarty, NM 87035; (505) 832-5006

Tommy **Johnson** — *Navajo*
Jewelry; P.O. Box 4007, Yah Ta Hey, NM 87375

Paul **Jones** — *Navajo*
Jewelry; P.O. Box 329, Crownpoint, NM 87313; (505) 786-5483

Pauline **Jones** — *Navajo*
Jewelry; P.O. Box 329, Crownpoint, NM 87313; (505) 786-5483

Jones **Juan** — *Navajo*
Jewelry; P.O. Box 3308, Farmington, NM 87401

Jones L. **Juan** — *Navajo*
Jewelry: Storyteller Jewelry; P.O. Box 1522, Chinle, AZ 865032

Wanda **Juan** — *Navajo*
Jewelry; P.O. Box 3308, Farmington, NM 87401

Raymond L. **Judge** — *Navajo*
Artist: watercolors, Pen/Ink; P.O. Box 2792, Flagstaff, AZ 86003

Darrell **Jumbo** — *Navajo*
Jewelry; P.O. Box 791, Ft. Defiance, AZ 86504; (520) 729-2326

Gilberto **Jumbo** — *Navajo*
Jewelry; P.O. Box 33, Chinle, AZ 87538; (520) 674-5033

Jennifer **Jumbo** — *Navajo*
Artist; 2811 Ousdahl Rd., Lawrence, KS 66046

Frances **June** — *Navajo*
Dolls: Navajo Dolls; P.O. Box 1713, Kaibeto, AZ 86503

Roy **Kady** — *Navajo*
Weaver: Navajo Rugs; P.O. Box 651, Teec Nos Pos, AZ 86514; (520) 656-3237

Wilbert **Kady** — *Navajo*
Sculptor; P.O. Box 1054, Teec Nos Pos, AZ 86514; (520) 656-3282

Jennifer **Kaskalla** — *Navajo*
P.O. Box 2362, Kirtland, NM 87417

Jeanette **Katoney** — *Navajo*
Artist; P.O. Box 817, Hotevilla, AZ 86030; (520) 734-2433

Alice L. **Kee** — *Navajo*
Jewelry; P.O. Box 15103, Farmington, NM 87401

Gus **Keene, Sr.** — *Navajo*
Jewelry; P.O. Box 117, San Fidel, NM 87049; (505) 552-6452

Shonie C. **Keith** — *Navajo*
Artist: Acrylics; P.O. Box 651, Kayenta, AZ 86033; (520) 697-3436

Robert **Kelly** — *Navajo*
Jewelry; 2403 Baca Ct., Gallup, NM 87301

Christine **Keyonnie** — *Navajo*
Jewelry; P.O. Box 1423, Winslow, AZ 86047; (520) 657-3377

Julius **Keyonnie** — *Navajo*
Jewelry; P.O. Box 1423, Winslow, AZ 86047; (520) 657-3377, (520) 521-0224

Joe L. **Kieyoomia** — *Navajo*
Jewelry; P.O. Box 1253, Shiprock, NM 87420; (505) 326-0820, (505) 632-9165

Jim B. **King, Jr.** — *Navajo*
Artist: Pencils, Ink, Etc.; P.O. Box 1341, Shiprock, NM 87420; (505) 368-4601 (Messages)

Arlene **Kirstine** — *Navajo*
Embroidery; P.O. Box 851, Farmington, NM 87499; (505) 327-3249

Yvonne **Kurley** — *Navajo*
Clothing: Seamstress; 35 Rd. 6407, NBU 36A, Kirtland, NM 87417; (505) 587-6767

Arresta **La Russo** — *Navajo*
Clothing: Seamstress; 101 E. Birch, Flagstaff, AZ 86001; (520) 799-9752

Bob **Lansing** — *Navajo*
Pottery; P.O. Box 659, Cortez, CO 81321

Charlene **Laughing** — *Navajo*
Weaver: Navajo Rugs; P.O. Box 4100, Window Rock, AZ 86515

Michele **Laughing** — *Navajo*
Weaver: Navajo Rugs; P.O. Box 64, Navajo, NM 87328; (505) 266-3255

Mona **Laughing** — *Navajo*
Weaver: Rugs; P.O. Box 64, Navajo, NM 87328; (505) 266-3255

Chavez **LaValdo** — *Navajo*
Jewelry; P.O. Box 531, Shiprock, NM 87420

Albert **Lee** — *Navajo*
Jewelry; P.O. Box 945, Shiprock, NM 87420; (505) 368-5349

Allison **Lee** — *Navajo*
Jewelry; 3332 Stanford Dr. NE, Albuquerque, NM 87107; (505) 884-2090

Cecelia **Lee** — *Navajo*
Jewelry; 4405 Pacific St., Farmington, NM 87402;
(505) 327-5340

Cherie **Lee** — *Navajo*
Jewelry; P.O. Box 4512, Yah Ta Hey, NM 87375;
(505) 735-2338

Clarence **Lee** — *Navajo*
Jewelry; P.O. Box 539, Gallup, NM 87305; (505) 735-2268

Clinton **Lee** — *Navajo*
Jewelry; P.O. Box 4512, Yah Ta Hey, NM 87375;
(505) 735-2338

Daniel **Lee** — *Navajo*
Jewelry; P.O. Box 2420, Shiprock, NM 87420

Emma R. **Lee** — *Navajo*
Seamstress: Broomstick skirts; Star Route 4, Gallup, NM
87305

Harry **Lee** — *Navajo*
Crafts: Ceramics, earrings +; P.O. Box 121, Shiprock, NM
87420

Joey **Lee** — *Navajo*
Jewelry; 2323 Kathryn SE #490, Albuquerque, NM 87106;
(505) 255-1734

Marcelia **Lee** — *Navajo*
Jewelry; 2323 Kathryn SE #490, Albuquerque, NM 87106;
(505) 255-1734

Mary **Lee** — *Navajo*
Crafts: Ceramics, earrings +; P.O. Box 121, Shiprock, NM
87420

Peggy **Lee** — *Navajo*
Jewelry; P.O. Box 1047, Fruitland, NM

Stanley **Lee** — *Navajo*
Jewelry; P.O. Box 309, Winslow, AZ 86047

Tony **Lee** — *Navajo*
Jewelry; P.O. Box 15601, Santa Fe, NM 87506; (505) 465-2915

Leland L. **Leonard** — *Navajo*
Crafts: Key Chains, Etc.; P.O. Box 52, Lukachukai, AZ 86507

Nelson **Leslie** — *Navajo*
Photography: Artist; Ft. Defiance, AZ 86504; (520) 729-5308

Joe **Lester** — *Navajo*
Welder: Silhouette Art (Custom orders); P.O. Box 153, Indian Wells, AZ 86031; (520) 654-3289

Melinda **Leuppe** — *Navajo*
Pottery: Sandpainted; P.O. Box 2007, Shiprock, NM 87420

Lorenzo E. **LeValdo** — *Navajo*
Ceramic Crafts; P.O. Box 162, Crownpoint, NM 87313; (505) 786-5860

Jane Y. **Lewis** — *Navajo*
Jewelry; 240 E. Ruth #205, Phoenix, AZ 8020; (602) 943-2790

Judy **Lewis** — *Navajo*
Jewelry & Sand Art; P.O. Box 1346, Winslow, AZ 86047

Nelson **Lewis** — *Navajo*
Jewelry & Sand Art; P.O. Box 1346, Winslow, AZ 86047

Timm **Lewis** — *Navajo*
Jewelry; P.O. Box 318, St. Michaels, AZ 86511; (520) 871-4461

Rinna R. **Leyba** — *Navajo*
Jewelry; 712 Prospect Ave. NW, Albuquerque, NM 87102; (505) 242-4396

Bernadine **Liston** — *Navajo*
Kachinas; P.O. Box 687, Shiprock, NM 87420

Joey **Liston** — *Navajo*
Kachinas; P.O. Box 687, Shiprock, NM 87420

Larry **Liston** — *Navajo*
Sandpainter; P.O. Box 1505, Sheep Springs, NM 87364

Barry **Litson** — *Navajo*
Kachinas; P.O. Box 1725, Shiprock, NM 87420;
(505) 368-4116

Malvina **Litson** — *Navajo*
Kachinas; P.O. Box 1725, Shiprock, NM 87420;
(505) 368-4116

James **Little** — *Navajo*
Jewelry; P.O. Box 8292, Scottsdale, AZ 85252;
(602) 451-4169

Jasper **Littletree** — *Navajo*
Artist; P.O. Box 764, Kirtland, NM 87417; (505) 598-5614

Jake I. **Livingston** — *Navajo*
Jewelry: Silver & Gold; P.O. Box 252, Houck, AZ 86506;
(520) 688-2369

Rose **Long** — *Navajo*
Clothing: Seamstress (Custom Orders); P.O. Box 310246,
Mexican Hat, UT 84531; (801) 739-4348

Virgil **Loretto** — *Navajo*
Artist: Watercolors, Pencil; P.O. Box 519, Window Rock,
AZ 86515

Eva **Mace** — *Navajo*
Jewelry; 9109 Copper Ave., NE #1, Albuquerque, NM
87123; (505) 323-9469

Harvey **Mace** — *Navajo*
Jewelry; 9109 Copper Ave., NE #1, Albuquerque, NM
87123; (505) 323-9469

Lenora **Mace** — *Navajo*
Jewelry & Food Concession; 10017 Pilar SW,
Albuquerque, NM 87121; (505) 831-6948

Ted **Mace** — *Navajo*
Jewelry & Food Concession; 10017 Pilar SW,
Albuquerque, NM 87121; (505) 831-6948

Arnold **Maloney** — *Navajo*
Jewelry; P.O. Box 301, Gamerco, NM 87317;
(505) 735-2276

Leonard **Maloney** — *Navajo*
Jewelry; P.O. Box 301, Gamerco, NM 87317;
(505) 870-2173

Ron **Maloney** — *Navajo*
Jewelry; P.O. Box 301, Gamerco, NM 87317;
(505) 735-2276 (Messages)

Lula **Mann** — *Navajo*
Pottery: Navajo Designs; P.O. Box 1545, Kaibeto, AZ 86053

Betty **Manygoats** — *Navajo*
Pottery; P.O. Box 519, Tonalea, AZ 86044

Laverna **Manygoats** — *Navajo*
Beadwork Artist; P.O. Box 57, Navajo, NM 87328

Andy **Marion** — *Navajo*
Jewelry; P.O. Box 92873, Albuquerque, NM 87199;
(505) 858-0304

Alvin **Marshall** — *Navajo*
Sculptor; P.O. Box 856, Kirtland, NM 87417;
(505) 598-5919

Bobby **Martin** — *Navajo*
Artist: Computer Graphics +; P.O. Box 1865, Window Rock, AZ 86515

Anette **Martinez** — *Navajo*
Jewelry; P.O. Box 782, Keams Canyon, AZ 86034

Bronco **Martinez** — *Navajo*
Artist: Cowboy clown +; P.O. Box 792, Thoreau, NM 87323; (505) 869-7288

Calvin **Martinez** — *Navajo*
Jewelry; P.O. Box 2967, Gallup, NM 87305; (505) 778-5559

Herman **Martinez** — *Navajo*
Clothing; 412 General Hodges NE, Albuquerque, NM 87123; (505) 293-1608

Leon **Martinez** — *Navajo*
Jewelry; P.O. Box 782, Keams Canyon, AZ 86034

Sally **Martinez** — *Navajo*
Weaver: Navajo Rugs, Etc.; Navajo National Monument, Tonalea, AZ 86044

Velma **Martinez** — *Navajo-Pima*
Food Vendor; 103 S. Gower Rd. Box #7, Farmington, NM 87401; (505) 325-5862

Yvonne **Martinez** — *Navajo*
Jewelry; P.O. Box 62, Prewitt, NM 87045; (505) 735-2275

Andrew **McCabe** — *Navajo*
Jewelry; CPO Box 5113, Leupp, AZ 86035

Cheryl **McCabe** — *Navajo*
Jewelry; CPO Box 5113, Leupp, AZ 86035

Christopher **McCabe** — *Navajo*
Fetishes; P.O. Box 235, Brimhall, NM 87310; (505) 735-2335

Joe N. **McCabe** — *Navajo*
Jewelry; 1109 Paseo Del Flag, Flagstaff, AZ 86001

Herman **McCray** — *Navajo*
Jewelry; P.O. Box 365, Crownpoint, NM 87313;
(505) 786-5109

Ronald **McCray** — *Navajo*
Jewelry; P.O. Box 365, Crownpoint, NM 87313;
(505) 786-5109

Christine **McHorse** — *Navajo*
Pottery; P.O. Box 8638, Santa Fe, NM 87504; (505) 989-7716

Joel **McHorse** — *Navajo*
Sculptor; 2101 Coal Pl. SE, Albuquerque, NM 87106;
(505) 765-5583

Cecilia **McKelvey** — *Navajo*
Pottery; 620 N. Jordan, Bloomfield, NM 87413;
(505) 632-1686

Celeste **McKelvey** — *Navajo*
Pottery; 620 N. Jordan, Bloomfield, NM 87413;
(505) 632-1686

Celinda **McKelvey** — *Navajo*
Pottery; 620 N. Jordan, Bloomfield, NM 87413;
(505) 632-1686

Lucy L. **McKelvey** — *Navajo*
Pottery; 620 N. Jordan, Bloomfield, NM 87413;
(505) 632-1686

Bill **McKinley** — *Navajo*
Jewelry: Trad. & Contemp.; P.O. Box 2796, Window Rock,
AZ 86515; (520) 871-5100

Jonathan **Mike** — *Navajo*
Jewelry; P.O. Box 764, Keams Canyon, AZ 86034;
(602) 203-6696

Ruth **Mike** — *Navajo*
Weaver: Navajo Rugs, Jewelry; P.O. Box 353, Gamerco, NM 87317

Erwyn **Milford** — *Navajo*
Jewelry; P.O. Box 4595, Window Rock, AZ 86515; (520) 729-2499

Elsie **Mitchell** — *Navajo*
Sandpainter; P.O. Box 174, Aneth, UT 84510

Mary **Mitchell** — *Navajo*
Sculptures: Clay Dolls (women); P.O. Box 127, Chinle, AZ 86503

Toney **Mitchell** — *Navajo*
Artist; 1710 North W. St., Flagstaff, AZ 86004; (520) 774-2839

Jesse Lee **Monongye** — *Navajo*
Jewelry; Scottsdale, AZ; (602) 991-8159

Jason **Morgan** — *Navajo*
Jewelry; 610 West Mesa, Gallup, NM 87301

Larry **Morgan** — *Navajo*
Jewelry; P.O. Box 1842, Crownpoint, NM 87313

Malena **Morgan** — *Navajo*
Jewelry; P.O. Box 1842, Crownpoint, NM 87313

Manuel **Morgan** — *Navajo*
Jewelry; P.O. Box 248, Aneth, UT 84510

Yanua **Morgan** — *Navajo*
Jewelry; P.O. Box 248, Aneth, UT 84510

Arnold A. **Morris** — *Navajo*
Jewelry & Sculptor; P.O. Box 26, Tohatchi, NM 87325; (505) 733-2285

Calvin **Morris** — *Navajo*
Jewelry: Sandcast; P.O. Box 632, Keams Canyon, AZ 86034

Carol **Morris** — *Navajo*
Crafts: Leather Pouches, Etc.; Naschitti Trading Post, Tohatchi, NM 87325

William **Murphy** — *Navajo*
Artist: Oils-Traditional Scenes; P.O. Box 201, Crownpoint, NM 87313; (505) 786-5378

Ella **Myers** — *Navajo*
Weaving: Dye charts; P.O. Box 4404, Yah Ta Hey, NM 87375; (505) 722-5170

Bernice J. **Nakai** — *Navajo*
Jewelry; 300 Vanden Bosch, Gallup, NM 87301

Naveek — *Navajo*
Jewelry; P.O. Box 3034, Taos, NM 87571; (505) 758-0749

Albert **Nelson** — *Navajo*
Sandpainter & Wood Carver; P.O. Box 1757, Sheep Springs, NM 87364

Angie **Nelson** — *Navajo*
Crafts: Ceramics; P.O. Box 2091, Shiprock, NM 87420

Arkie **Nelson** — *Navajo*
Jewelry; 122 General Marshall NE #20, Albuquerque, NM 87123; (505) 323-5099

Ben **Nelson** — *Navajo*
Artist; 1013 Virginia NE, Albuquerque, NM 87110; (505) 265-8191, (505) 298-2099

Bennie **Nelson** — *Navajo*
Artist: Sculptor; 4701 Brenda NE, Albuquerque, NM 87109; (505) 298-2099

Diane **Nelson** — *Navajo*
Kachinas & Wood Carver; P.O. Box 1537, Sheep Springs, NM 87364

Jasper **Nelson** — *Navajo*
Jewelry; P.O. Box 1336, Gallup, NM 87301

Jerry **Nelson** — *Navajo*
Jewelry; 125 E. Water St. #43, Santa Fe, NM 87501

L.Eugene **Nelson** — *Navajo*
Jewelry; 1704 Richmond Dr. NE, Albuquerque, NM
87106; (505) 265-4496

Laberta **Nelson** — *Navajo*
Sandpainter & Wood Carver; P.O. Box 1757, Sheep
Springs, NM 87364

Peter **Nelson** — *Navajo*
Jewelry; P.O. Box 3449, Indian Wells, AZ 86031;
(520) 714-0451

Roger **Nelson** — *Navajo*
Jewelry; 222 W. 66 Ave., Gallup, NM 87301; (505) 722-7497

Tonya **Nelson** — *Navajo*
Jewelry; 122 General Marshall NE #20, Albuquerque, NM
87123; (505) 323-5099

Anthony **Nez** — *Navajo*
Sandpainter, Baskets & Pottery; P.O. Box 1907, Sheep
Springs, NM 87364

Arlene **Nez** — *Navajo*
Jewelry; P.O. Box 1575, Shiprock, NM 87420

Darlene **Nez** — *Navajo*
Beadwork; P.O. Box 336, Navajo, NM 87328; (505) 777-1436

David C. **Nez** — *Navajo*
Artist; 9100 9th St. North #407, St. Petersburg, FL 33702;
(813) 578-8452

Delbert **Nez** — *Navajo*
Jewelry: Flat Beads; P.O. Box 157, Rehoboth, NM 87322;
(505) 786-7259

Ethel **Nez** — *Navajo*
Weaver: Natural/Vegetable; P.O. Box 987, Sanders, AZ
86512; (520) 688-2369

Gibson **Nez** — *Navajo-Apache*
Jewelry: Trad. & Contemp.; 100 Sandoval St., Santa Fe,
NM 87501; (505) 984-0932

Gilbert **Nez** — *Navajo*
Beadwork: Beaded Dr.eam Catcher; P.O. Box 652,
Kykotsmovi, AZ 86039

Jonathan **Nez** — *Navajo*
Woodwork & Wall Hangings; P.O. Box 100103, Aneth,
UT 84510

Leona R. **Nez** — *Navajo*
Weaver: Rugs, Pillows, Etc.; P.O. Box 3440, Indian Wells,
AZ 86031

Michael **Nez** — *Navajo*
Jewelry; 612 Suffolk Ct. SW, Albuquerque, NM 87121;
(505) 833-5038

Phillip A. **Nez** — *Navajo*
Jewelry; P.O. Box 2720, Shiprock, NM 87420

Redwing **Nez** — *Navajo*
Artist: Oils, Etc.hings, Etc.; P.O. Box 3300, IndianWells,
AZ 86031; (520) 654-3393

Rick **Nez** — *Navajo*
Sculptor; 33 Rd. 6211, Kirtland, NM 87417; (505) 598-9458

Rita **Nez** — *Navajo*
Jewelry; 612 Suffolk Ct. SW, Albuquerque, NM 87121;
(505) 833-5038

Sidney **Nez** — *Navajo*
Jewelry; P.O. Box 1575, Shiprock, NM 87420

Virgil J. **Nez** — *Navajo*
Artist; P.O. Box 346, Pinon, AZ 86510

Wallace **Nez, Jr** — *Navajo*
Pottery; 6240 N. 63rd Ave. #259, Glendale, AZ 85301;
(602) 931-4403, (602) 370-7872

Bobby **Nofchissey** — *Navajo*
Jewelry; 54-1/2 E. San Francisco St., Santa Fe, NM 87501;
(505) 820-1080

Elise **Oliver** — *Navajo*
Jewelry; P.O. Box 2915, Shiprock, NM 87420

Barbara JT **Ornelas** — *Navajo*
Weaver: Rugs; 4802 E. Copper St., Tucson, AZ 85712;
(520) 327-3852

Lester **Ortiz** — *Navajo*
Jewelry; P.O. Box 3054, Gallup, NM 87305; (505) 722-7624

William **Ortiz** — *Navajo*
Jewelry; P.O. Box 633, Gallup, NM 87305; (505) 863-4003

Mary S. **Owens** — *Navajo*
Weaver: Natural/Vegetable; P.O. Box 987, Sanders, AZ
86512; (520) 688-2369

Leslie **Pablo** — *Navajo*
Sculptor; P.O. Box 1018, Kirtland, NM 87417

Lula **Palmer** — *Navajo*
Pottery: Ceramic; P.O. Box 982, Teec Nos Pos, AZ 86514

Lonn **Parker** — *Navajo*
Jewelry: Contemporary; P.O. Box 491, St. Michaels, AZ
86511; (520) 871-3650

Stanley **Parker** — *Navajo*
P.O. Box 279, Ft. Defiance, AZ 86504

Albert **Parrish** — *Navajo*
Jewelry: Liquid Silver Necklace; P.O. Box 2667, Gallup, NM 87305; (505) 778-5468

Marlene **Perry** — *Navajo*
Jewelry; P.O. Box 7220, Nazlini, AZ 86540; (520) 755-5900, (520) 755-3474 Messages

Michael **Perry** — *Navajo*
Jewelry; P.O. Box 7220, Nazlini, AZ 86540; (520) 755-5900, (520) 755-3474 Messages

Davis **Peshlakai** — *Navajo*
Jewelry; P.O. Box 1491, Tohatchi, NM 87325

Linda M. **Peshlakai** — *Navajo*
Jewelry; P.O. Box 176, Ft. Wingate, NM 87316; (505) 488-5649

Norbert **Peshlakai** — *Navajo*
Jewelry; P.O. Box 176, Ft. Wingate, NM 87316; (505) 488-5649

Geneva A. **Pete** — *Navajo*
Seamstress: Quilts, Pillows, Etc.; P.O. Box 1514, Chinle, AZ 86503; (520) 674-8361

David **Peters** — *Navajo*
Sandpainter; P.O. Box 7371, Newcomb, NM 87455

Juanito **Peters** — *Navajo*
Sandpainter; P.O. Box 7371, Newcomb, NM 87455

Raymond **Pettigrew** — *Navajo*
Sculptor; P.O. Box 2681, Kirtland, NM 87417; (505) 598-5919

Terry **Pettigrew** — *Navajo*
Carvings: Alabaster; P.O. Box 1321, Fruitland, NM 87416

Melinda G. **Piaso** — *Navajo*
Jewelry; P.O. Box 1963, Chinle, AZ 86503; (520) 674-5651

Thompson **Piaso** — *Navajo*
Jewelry: Traditional; P.O. Box 7154, Albuquerque, NM 87194; (505) 831-5001

Joe **Piaso Jr.** — *Navajo*
Jewelry; P.O. Box 1963, Chinle, AZ 86503; (520) 674-5651

Dennis **Pioche** — *Navajo*
Folk Art; P.O. Box 5967, Farmington, NM 87499; (505) 327-1610

Charlene **Platero** — *Navajo*
Jewelry; P.O. Box 5902, Canoncito, NM 87026; (505) 831-6401

Curtis **Platero** — *Navajo*
Jewelry; P.O. Box 5902, Canoncito, NM 87026; (505) 831-6401

Fannie **Platero** — *Navajo*
Jewelry; P.O. Box 216, Canoncito, NM 87026

Jimmie **Poncey-Homer** — *Navajo*
Wood Carver & Beadwork; P.O. Box 50, Marble Canyon, AZ 86036

Sally **Poncey-Homer** — *Navajo*
Wood Carver & Beadwork; P.O. Box 50, Marble Canyon, AZ 86036

Ronald **Portley** — *Navajo*
Fetishes & Carvings; General Delivery, Gamerco, NM 87317; (505) 726-8180

Ronald **Portley** — *Navajo-Apache*
Fetishes & Carvings; General Delivery, Gamerco, NM 87317; (505) 726-8180

Brian **Preston** — *Navajo*
Artist: Desktop pub., Etc.; 910 S. Gary Dr. #108, Tempe, AZ 85281; (602) 966-2963

Sylvia B. **Radcliffe** — *Navajo*
Jewelry; P.O. Box 686, Window Rock, AZ 86515;
(520) 871-4481

Dennis T. **Ramone** — *Navajo*
Jewelry; P.O. Box 625, Algodones, NM 87001;
(505) 867-6353

Jennifer C. **Redhorse** — *Navajo*
Jewelry; Santa Fe, NM; (505) 820-2401

Daniel **Reeves** — *Navajo*
Jewelry; P.O. Box 80771, Albuquerque, NM 87198;
(505) 255-4175, (505) 255-7845

Reuben **Richard** — *Navajo*
Artist; P.O. Box 2004, Tuba City, AZ 86045; (520) 283-5688

Kay B. **Rogers** — *Navajo*
Jewelry; P.O. Box 5271, Durango, CO 81301; (970) 385-4408

Gary **Runnels** — *Navajo*
Jewelry; 32A Corral Blanco Way, Santa Fe, NM 87505;
(505) 424-6194

Jennifer **Runnels** — *Navajo*
Jewelry; 32A Corral Blanco Way, Santa Fe, NM 87505;
(505) 424-6194

Ben **Sam** — *Navajo*
Sandpainter: Natural-color Sand; P.O. Box 1911, Cuba,
NM 87013

Fannie **Sam** — *Navajo*
Jewelry; P.O. Box 571, Mentmore, NM 87319

Mike **Sam** — *Navajo*
Crafts: Jewelry; P.O. Box 1159, Chinle, AZ 87313

Pauline **Sam** — *Navajo*
Sandpainter: Natural-color Sand; P.O. Box 1911, Cuba,
NM 87013

Sherry **Sam** — *Navajo*
 Crafts: Jewelry; P.O. Box 1159, Chinle, AZ 87313

Lorenzo **Sandman** — *Navajo*
 Sandpainter; P.O. Box 1617, Sheep Springs, NM 87364

Lynda **Sandman** — *Navajo*
 Sandpainter; P.O. Box 1617, Sheep Springs, NM 87364

Casey **Sandoval** — *Navajo*
 Jewelry; Canoncito, NM 87026; (505) 220-1039,
 (505) 460-4086 Pager

Mary B. **Sandoval** — *Navajo*
 Weaver: Navajo Rugs; P.O. Box 334, Crownpoint, NM
 87313

Patricea **Sandoval** — *Navajo-Cherokee*
 Beadwork; P.O. Box 3544, Farmington, NM 87401;
 (505) 324-8764

Raye C. **Sandoval** — *Navajo*
 Sculptor: Welding; P.O. Box 334, Crownpoint, NM 87313

Marilou **Schultz** — *Navajo*
 Weaver; 844 E. 8th Pl., Mesa, AZ 85203; (602) 834-3791

Marie **Scott** — *Navajo*
 Crafts: Cross Stitching, Etc.; P.O. Box 765, St. Michaels,
 AZ 86511

Patrick **Scott** — *Navajo*
 Sculptor, Beadwork, Fans; P.O. Box 3018, Tuba City, AZ
 86045; (520) 283-5629

Quenby **Scott** — *Navajo*
 Crafts: Cross Stitching, Etc.; P.O. Box 765, St. Michaels,
 AZ 86511

Cindy **Shepherd** — *Navajo*
 Crafts: Wood Spindles, Etc.; General Delivery, Sanders,
 AZ 86512; (520) 688-3273

Doug **Shepherd** — *Navajo*
Crafts: Wood Spindles, Etc.; General Delivery, Sanders, AZ 86512; (520) 688-3273

Rosabelle **Shepherd** — *Navajo*
Weaver; 8635 Jupiter Dr., Flagstaff, AZ 86004; (520) 526-8749

Genevieve **Shirley** — *Navajo*
Jewelry & Basket Designs; P.O. Box 147, Ganado, AZ 86505

Irma J. **Shirley** — *Navajo*
Weaver: Navajo Rugs; P.O. Box 1262, Ganado, AZ 86505

Ambrose L. **Shorty** — *Navajo*
Crafts: Leather, Wallets, Etc.; P.O. Box 942, Ganado, AZ 86505

Ben D. **Shorty** — *Navajo*
Artist & Silversmith; P.O. Box 454, Tesuque, NM 87575; (505) 820-2052

Eddy **Shorty** — *Navajo*
Sculptor; P.O. Box 145, Abiquiu, NM 87510; (505) 685-4419

Walter **Shurley** — *Navajo*
Artist: Jewelry; 141 Cochise Dr., Winslow, AZ 87323; (602) 289-3213

Laura G. **Shurley-Olivas** — *Navajo*
Clothing: Sewing; 12411 Osborne St., #139, Pacoima, CA 91331; (818) 890-1165

Deborah **Silversmith** — *Navajo*
Jewelry: Canyon; SteamBoat Shore #253, Steamboat C., AZ 86505

Mark **Silversmith** — *Navajo*
Artist; P.O. Box 5295, Farmington, NM 87499; (505) 324-8101, (505) 326-6854

Samuel **Simpson** — *Navajo*
Artist: Woodburning; P.O. Box 5318, Page, AZ 86040; (520) 353-4404; E-mail: jwurth@page.az.net

Penny **Singer** — *Navajo*
Clothing: Trad. & Contemp.; 4209 San Pedro NE #272, Albuquerque, NM 87109; (505) 875-1585

Lucinda **Slick** — *Navajo*
Pottery; P.O. Box 7328, Shonto, AZ 86054

Grace **Slim** — *Navajo*
Drums & Jewelry; P.O. Box 560, Ft. Wingate, NM 87316; (505) 298-5191

Marvin **Slim** — *Navajo*
Jewelry; Albuquerque, NM; (505) 271-9821

Michael **Slim** — *Navajo*
Jewelry; P.O. Box 53583, Albuquerque, NM 87153; (505) 298-5191

Michelle **Slim** — *Navajo*
Jewelry; Albuquerque, NM 87123; (505) 271-8299

Victoria **Slim** — *Navajo*
Jewelry; P.O. Box 53583, Albuquerque, NM 87153; (505) 298-5191

Jarvis **Sloan** — *Navajo*
T Shirts: Indian Designs; P.O. Box 2184, Tuba City, AZ 86045

Daniel **Smith** — *Navajo*
Sandpainter; P.O. Box 2804, Shiprock, NM 87420

Hanson **Smith** — *Navajo*
Jewelry; P.O. Box 1975, Chinle, AZ 86503; (520) 674-4869

Harold R. **Smith** — *Navajo*
Artist: Sculptor; P.O. Box 1987, Bloomfield, NM 87413

Jack **Smith** — *Navajo*
Jewelry; P.O. Box 145, Holbrook, AZ 86025

Jimmy **Smith** — *Navajo*
Artist; P.O. Box 1198, Thoreau, NM 87323

Lorraine **Smith** — *Navajo*
Jewelry; P.O. Box 145, Holbrook, AZ 86025

Lucille **Smith** — *Navajo*
Weaver: Navajo Rugs; P.O. Box 21, Lupton, AZ 86508;
(520) 688-2107

Patrick **Smith** — *Navajo*
Jewelry; P.O. Box 117, Flagstaff, AZ 86002; (520) 774-5488

Stan **Smith** — *Navajo*
Jewelry; P.O. Box 5396, Leupp, AZ 86035

Daniel R. **Smith, Sr.** — *Navajo*
Sandpainter: Custom orders; P.O. Box 2804, Shiprock,
NM 87420

Alicia **Spencer** — *Navajo*
Jewelry: Liquid Silver Necklace; P.O. Box 38, Rehoboth,
NM 87322

Julie **Spencer** — *Navajo*
Pottery: Clay statues; P.O. Box 1695, Chinle, AZ 86503

Sadie **Spencer** — *Navajo*
Crafts; P.O. Box 2404, Gallup, NM 87305; (505) 863-9970

Virginia N. **Standing Elk** — *Navajo*
Jewelry; 521 Airport Rd., Sp. #188, Santa Fe, NM 87505;
(505) 424-0124

Sanford **Storer** — *Navajo*
Jewelry; 51 CR 3004, Aztec, NM 87410; (505) 334-3716

Lola **Sullivan** — *Navajo*
Weaver: Navajo Rugs (Custom orders); P.O. Box 1856,
Kayenta, AZ 86033

Rose **Swett** — *Navajo*
Jewelry; 310 Bortot St., Sp #3, Gallup, NM 87301;
(505) 863-7990

Fannie **Tabaha** — *Navajo*
Crafts: Yarn Wedding Baskets; P.O. Box 141, St. Michaels,
AZ 86511

Zane **Tahe** — *Navajo*
Jewelry; P.O. Box 601, Thoreau, NM 87323

Blanche **Taho** — *Navajo*
Clothing: Ribbon shirts, Etc.; P.O. Box 313, Tuba City, AZ
86045

Mark **Taho** — *Navajo-Hopi*
Crafts; P.O. Box 313, Tuba City, AZ 86045; (602) 283-5864

Carrie A. **Tahy** — *Navajo*
Jewelry; P.O. Box 1331, Tohatchi, NM 87325

Alice **Taliman** — *Navajo*
Ceramics: Wall Hangings; P.O. Box 1146, Window Rock,
AZ 86515

Helen **Tallman** — *Navajo*
Weaver: Navajo Rugs; P.O. Box 851, Teec Nos Pos, AZ
86514; (505) 320-7719

Marie S. **Tasyatwho** — *Navajo*
Weavings & Beadwork; P.O. Box 311, LaPlata, NM 87418;
(505) 326-3769

Lillie T. **Taylor** — *Navajo*
Weaver: Rugs; P.O. Box 67, Indian Wells, AZ 86031;
(602) 898-1147 (Messages)

Mary **Taylor** — *Navajo*
Jewelry; P.O. Box 2183, Flagstaff, AZ 86003; (520) 526-8171

Tsosie **Taylor** — *Navajo*
Jewelry; P.O. Box 2183, Flagstaff, AZ 86003; (520) 526-8171

Ambrose **Teasyatwho** — *Navajo*
Sculptor & Carver; P.O. Box 81, La Plata, NM 87418

Cherileen **Teasyatwho** — *Navajo*
Weaver: Navajo Rugs; P.O. Box 81, La Plata, NM 87418

Elnora **Teasyatwho** — *Navajo*
Weaver: Navajo Rugs; P.O. Box 81, La Plata, NM 87418

D. **Teller** — *Navajo*
Seamstress: Pendleton coats; 1432 Tory Ave., Farmington, NM 87401; (505) 325-6532

Everett **Teller** — *Navajo*
Jewelry; P.O. Box 1675, Lukachukai, AZ 86507; (602) 787-2264

M. **Teller** — *Navajo*
Seamstress: Pendleton coats; 1432 Tory Ave., Farmington, NM 87401; (505) 325-6532

Mary C. **Teller** — *Navajo*
Jewelry; P.O. Box 1675, Lukachukai, AZ 86507; (602) 787-2264

Teresa **Tenorio** — *Navajo*
Beadwork; 608 S. Mesa Verde, Farmington, NM 87401; (505) 326-5209

Martha **Terry** — *Navajo*
Weaver: Navajo Rugs; P.O. Box 1281, Window Rock, AZ 86515

Eleanor **Thomas** — *Navajo*
Weaver: Navajo Rugs; P.O. Box 173, Ft. Defiance, AZ 86504

Gilbert **Thomas** — *Navajo*
Jewelry; P.O. Box 3054, Indian Wells, AZ 86031; (520) 654-3289

Paulson **Thomas** — *Navajo*
Jewelry; P.O. Box 3848, Canoncito, NM 87026; (505) 836-1481

Vernon **Thomas** — *Navajo*
Sandpainter, Nameplates, Etc.; P.O. Box 1580, Tohatchi, NM 87325

Betsy **Thompson** — *Navajo*
Seamstress: Buckskin clothing; P.O. Box 626, Ft. Wingate, NM 87316; (520) 755-2825

Herb **Thompson** — *Navajo*
Jewelry; P.O. Box 1764, Kirtland, NM 87417; (505) 598-6460

Mae M. **Thompson** — *Navajo*
Clothing: Seamstress; P.O. Box 862, Crystal, NM 87328

Marlene **Thompson** — *Navajo*
Craft: Crochet Plant Holder; P.O. Box 399, Chambers, AZ 86502

Michael **Thompson** — *Navajo*
Handbags: Pouches, Purses, Etc.; HC63, Box 260C, Winslow, AZ 86047; (520) 657-3330

Paul **Thompson** — *Navajo*
Flutes; P.O. Box 837, Albuquerque, NM 87103; (505) 275-8466

Veronica **Thompson** — *Navajo*
Jewelry; P.O. Box 1764, Kirtland, NM 87417; (505) 598-6460

Willie **Thompson** — *Navajo*
Seamstress: Buckskin clothing; P.O. Box 626, Ft. Wingate, NM 87316; (520) 755-2825 (Messages)

Deanna **Todachine** — *Navajo*
Weaver: Navajo Rugs; P.O. Box 1438, Kayenta, AZ 86033; (520) 674-2058 (Messages)

Irving **Toddy** — *Navajo*
Artist: Illustrator; P.O. Box 430, Houck, AZ 86596; (520) 871-4302

Paul C. **Tohlakai** — *Navajo*
Artist; P.O. Box 425, Pinon, AZ 86510

Eva **Toledo** — *Navajo*
Jewelry; 1299 Vegas Verdes #46, Santa Fe, NM 87505;
(505) 473-0093, (505) 699-0412

Everette **Toledo** — *Navajo*
Jewelry; 1299 Vegas Verdes #46, Santa Fe, NM 87505;
(505) 473-0093, (505) 699-0412

Helen **Toledo** — *Navajo*
Weaving & & Sewing; 3409 Iles Ave., Farmington, NM
87402; (505) 327-9334

Herbert **Toledo** — *Navajo*
Jewelry; P.O. Box 80321, Albuquerque, NM 87198;
(505) 294-9165

Minnie **Toledo** — *Navajo*
Jewelry; P.O. Box 26294, Albuquerque, NM 87125;
(505) 343-8503

Toney **Toledo** — *Navajo*
Jewelry; 1299 Vegas Verdes #46, Santa Fe, NM 87505;
(505) 473-0093, (505) 699-0412

Sam **Tolth** — *Navajo*
Jewelry; P.O. Box 2814, Gallup, NM 87305; (505) 863-4144

Harold **Tom** — *Navajo*
Jewelry: Artist; HCR 5079, Box 310, Gallup, NM 87301;
(505) 863-5049

Jack **Tom** — *Navajo*
Jewelry; HCR 63, Box 6064, Winslow, AZ 86047;
(520) 657-3305

Leroy **Tom** — *Navajo*
Artist: Oils, Ceramic Pottery; P.O. Box 1637, Shiprock,
NM 87420; (505) 368-4524

Louis **Tom** — *Navajo*
Jewelry: Artist; P.O. Box 226, St. Michaels, AZ 86515

Mary **Tom** — *Navajo*
Jewelry; HCR 63, Box 6064, Winslow, AZ 86047;
(520) 657-3305

Terrance **Tom** — *Navajo*
Craft: Screen Printing, Embroidery; P.O. Box 145,
Blanding, UT 84511; (801) 678-3536

Bessie **Tome** — *Navajo*
Jewelry: Nickel Earrings, Beads; P.O. Box 904, Teec Nos
Pos, AZ 86514

Jasper **Tome** — *Navajo*
Crafts: Wall Hangings; P.O. Box 173, Rehoboth, NM
87322; (505) 863-3797

Angeline **Touchine** — *Navajo*
Jewelry; P.O. Box 104, Churchrock, NM 87311;
(505) 488-5214

Ben **Touchine** — *Navajo*
Jewelry; P.O. Box 104, Churchrock, NM 87311;
(505) 488-5214

Loretta **Towne** — *Navajo*
Jewelry; Albuquerque, NM; (505) 856-5685

Ray **Tracey** — *Navajo*
Jewelry; 135 W. Palace Ave., Santa Fe, NM 87501;
(505) 989-3430, (800) 336-8782

Cecil **Tracy** — *Navajo*
Jewelry; P.O. Box 2794, Window Rock, AZ 86515;
(520) 871-2015

Robert **Tree** — *Navajo*
Artist: Oils, Acrylics, Etc.; P.O. Box 3014, Kayenta, AZ
86033; (520) 697-3792

Evelyn **Tsinijinnie** — *Navajo*
Fashion: Beadwork & Jewelry; Denver, CO 80221;
(303) 439-2139

Felix **Tsinijinnie** — *Navajo*
Jewelry: Overlay/Beaded; HC63, Box 521, Winslow, AZ
86047; (520) 657-3200

Joanne L. **Tsinijinnie** — *Navajo*
Jewelry: Overlay/Beaded; HC63, Box 521, Winslow, AZ
86047; (520) 657-3200

Orville **Tsinnie** — *Navajo*
Jewelry; P.O. Box 537, Shiprock, NM 87420;
(505) 368-4240, (505) 368-5936

Brian **Tso** — *Navajo*
Jewelry: Silver & Gold; P.O. Box 1175, Winslow, AZ
86047; (520) 699-7187

Ervin Dee **Tso** — *Navajo*
Jewelry; P.O. Box 3422, Flagstaff, AZ 86003;
(520) 607-2347

Evelyn **Tso** — *Navajo*
Craft: Wall Hangings; P.O. Box 859, Navajo, NM 87328

Faye B. **Tso** — *Navajo*
Pottery & Weaving; P.O. Box 583, Tuba City, AZ 86045

Geraldine **Tso** — *Navajo*
Artist: Oils & Quilts; P.O. Box 965, Taos, NM 87571

Justin **Tso** — *Navajo*
Artist; P.O. Box 881, Navajo, NM 87328; (520) 674-5678,
(520) 674-3737

Lavern **Tso** — *Navajo*
Jewelry; P.O. Box 3422, Flagstaff, AZ 86993;
(602) 699-7187

Marie **Tso** — *Navajo*
Craft: Cross Stitching; P.O. Box 316, St. Michaels, AZ 86511

Susie **Tso** — *Navajo*
Weaver: Navajo Rugs; P.O. Box 2144, Window Rock, AZ 86515

Tommie M. **Tso** — *Navajo*
Jewelry; P.O. Box 262, Tohatchi, NM 87325; (505) 735-2432

Calvin **Tsosie** — *Navajo*
Craft: Ceramic Lamps; P.O. Box 1494, Shiprock, NM 87420

Danny R. **Tsosie** — *Navajo*
Artist & Jewelry; P.O. Box 915, Taylor, AZ 85939; (602) 536-7782

Ervin **Tsosie** — *Navajo*
Jewelry: Inlay; P.O. Box 75, Mexican Springs, NM 87320; (505) 733-2498

Gloria **Tsosie** — *Navajo*
Seamstress: Glitter-designer; P.O. Box 4063, Yah Ta Hey, NM 87375; (505) 735-2358

Jennifer E. **Tsosie** — *Navajo*
Clothing; P.O. Box 2701, Flagstaff, AZ 86003; (520) 779-6222

Lyndon B. **Tsosie** — *Navajo*
Jewelry; P.O. Box 877, Chinle, AZ 86503; (520) 674-3730

Marie **Tsosie** — *Navajo*
Craft: Ceramic Clocks; P.O. Box 1494, Shiprock, NM 87420

Nelson **Tsosie** — *Navajo*
Sculptor & Pastel Artist; P.O. Box 23285, Santa Fe, NM 87502; (505) 474-4480

Robert D. **Tsosie** — *Navajo-Picuris*
Sculptor; P.O. Box 88, San Jose, NM 87565; (505) 421-2986

Ben **Turquoise** — *Navajo*
Jewelry; 6005 Burnet Rd., Austin, TX 78757;
(512) 280-8763, (888) 887-7864

Geri **Vail** — *Navajo*
Pottery; 1005 Geis St., Grants, NM 87020; (505) 285-4136

Skeeter **Vail** — *Navajo*
Pottery; 1005 Geis St., Grants, NM 87020; (505) 285-4136

Nellie **Vandever** — *Navajo*
Jewelry; P.O. Box 211, SD Pueblo, NM 87052; (505) 465-0514

Karole W. **Vaughn** — *Navajo*
Weaver: Navajo Rugs, Beadwork; P.O. Box 126, Sanostee,
NM 87461

Otta **Vicente, Sr.** — *Navajo*
Wood Carver: Miniature Kachinas; P.O. Box 3523,
Shiprock, NM 87420

Elizabeth **W-Benally** — *Navajo*
Artist: Paintings, Jewelry; P.O. Box 73, Pinehill, NM
87357; (505) 775-3665

Darrell L. **Wallace** — *Navajo*
Leatherwork: Saddle Repairs, Etc.; P.O. Box 976, St.
Michaels, AZ 86511; (520) 871-5558

Daniel A. **Walters** — *Navajo-Pawnee*
Artist: Acrylics; P.O. Box 3194, Canoncito, NM 87026;
(505) 836-0828

Roy M. **Walters** — *Navajo*
Sculptor; P.O. Box 1074, Tuba City, AZ 86045;
(520) 283-4704

Tim **Washburn** — *Navajo*
Sculptor; P.O. Box 466, Kirtland, NM 87417; (505) 598-9728

Judy **Watts** — *Navajo*
Weaver: Sash Belts; P.O. Box 480, Ft. Defiance, AZ 86504

Lorraine **Wayne** — *Navajo*
Seamstress: Clothing Designer; P.O. Box 14, Ramah, NM 87321; (520) 783-4236

Sharon **Weahkee** — *Navajo*
Jewelry: Walrus/Elk Ivory; 190 CR Rd. 4800, Bloomfield, NM 87413; (505) 632-5543

Alberta **Wero** — *Navajo*
Jewelry: Artist/Potter; 505 Indiana SE #4, Albuquerque, NM 87102

Amos **White** — *Navajo*
Jewelry: Storyteller Jewelry; P.O. Box 2667, Gallup, NM 87301; (505) 778-5468

Irene **White** — *Navajo*
Pottery: Trad. Ceremonial; P.O. Box 1032, Teec Nos Pos, AZ 86514

Kathy **White** — *Navajo*
Weaver: Navajo Rugs (Custom orders); P.O. Box 2434, Window Rock, AZ 86515

Kenneth **White** — *Navajo*
Pottery: Trad. Ceremonial; P.O. Box 1032, Teec Nos Pos, AZ 86514

Kenneth T. **White** — *Navajo*
Artist: Beadwork, Etc.; 31877 Del Obispo, Ste. 206, San Juan Capistrano, CA 92675; (714) 248-1999

Geraldine **Whitehorne** — *Navajo*
Beadwork: Beaded Pens w/lids; P.O. Box 83, Chambers, AZ 86502

Jerome **Whitehorse** — *Navajo*
Jewelry; P.O. Box 298, Ft. Wingate, NM 87316; (505) 863-4843

John **Whiterock Jr.** — *Navajo*
Pottery: Sand Paintings; P.O. Box 154, Tonalea, AZ 86044

Baje **Whitethorne** — *Navajo*
Artist; 7695 Nell Dr., Flagstaff, AZ 86004; (520) 526-0063

Ed **Whitethorne** — *Navajo*
Artist: Watercolors; P.O. Box 3315, Tuba City, AZ 86045;
(520) 283-4215

Hank **Whitethorne** — *Navajo*
Jewelry; P.O. Box 7474, Shonto, AZ 86054

Olivia **Whitethorne** — *Navajo*
Jewelry; P.O. Box 7474, Shonto, AZ 86054

Arlene N. **Williams** — *Navajo*
Entertainer: Poet, Composer, Etc.; 344 N. 1170 W., Provo,
UT 84601; (801) 375-1323

Clara **Williams** — *Navajo*
Jewelry; P.O. Box 3064, Kayenta, AZ 86033; (520) 524-6765

Helen **Williams** — *Navajo*
Jewelry & Beadwork; P.O. Box 1197, Ganado, AZ 86505

Lorraine **Williams** — *Navajo*
Pottery; 405 W. 7th St., Sp. # 7, Cortez, CO 81321;
(970) 564-9639, (970) 564-9704

Robert **Williams** — *Navajo*
Jewelry; P.O. Box 3064, Kayenta, AZ 86033; (520) 524-6765

Rose **Williams** — *Navajo*
Pottery; Cow Springs Trading Post, Tonalea, AZ 86044

Rosie **Williams** — *Navajo*
Jewelry & Seamstress; 8160 E. April Dr., Flagstaff, AZ
86004; (520) 526-1874

Roger **Willie** — *Navajo*
Artist; 3402 NC Hwy. 711, Lumberton, NC 28358;
(910) 618-9367, (910) 521-8763

Valorie **Willie** — *Navajo*
 Beadwork: Breast Plates; P.O. Box 1853, Bloomfield, NM 87143

Harrison **Willie, Jr.** — *Navajo*
 Jewelry: Artist; P.O. Box 4083, Yah Ta Hey, NM 87375

Clara **Wilson** — *Navajo*
 Pottery; HC61, Box 70, Winslow, AZ 86047

Harrison **Wilson** — *Navajo*
 Jewelry; P.O. Box 3162, Canoncito, NM 87026;
 (505) 831-3196

Jimmy **Wilson** — *Navajo*
 Pottery; HC61, Box 70, Winslow, AZ 86047

Les **Wilson** — *Navajo*
 Weaver: Navajo Rugs; Two Grey Hills Trading Post,
 Tohatchi, NM 87325; (505) 789-3270

Rita **Wilson** — *Navajo*
 Jewelry; P.O. Box 3162, Canoncito, NM 87026;
 (505) 831-3196

Bonnie **Woodie** — *Navajo*
 Clothing: Trad. & Contemp.; P.O. Box 397, Ganado, AZ
 86505; (520) 736-2443

Dolly **Woodie** — *Navajo*
 Weaver; #197-86558, Ganado, AZ 86505; (520) 736-2443

Lucita **Woodis** — *Navajo*
 Artist; P.O. Box 868, Shiprock, NM 87420; (505) 368-5476

Agnes **Woods** — *Navajo*
 Pottery & Navajo Rugs; P.O. Box 354, Tohatchi, NM 87325

Ben **Woody, Jr.** — *Navajo*
 Sculptor; P.O. Box 1824, Bloomfield, NM 87413

James K. **Woolenshirt** — *Navajo*
Artist: Oils, Acrylics, Etc.; P.O. Box 3755, Shiprock, NM 87420; (505) 368-4601

Harry E. **Yabeny** — *Navajo*
Jewelry; P.O. Box 938, Shiprock, NM 87420

Ben **Yazzen** — *Navajo*
Drums & Jewelry; P.O. Box 560, Ft. Wingate, NM 87316; (505) 298-5191

Alice **Yazzie** — *Navajo*
Artist: Paintings; 1221 Truman St. SE, Albuquerque, NM 87108; (505) 260-0309; Web: www.rt66.com/swaia/ayazzie.html

Carl **Yazzie** — *Navajo*
Jewelry; P.O. Box 771, Tuba City, AZ 86045; (520) 283-6313, (520) 204-2700

Darlene **Yazzie** — *Navajo*
Seamstress: Pillow Cases, Etc.; P.O. Box 204, Bluff, UT 84512; (801) 672-2411

Darrell **Yazzie** — *Navajo*
Jewelry; P.O. Box 325, Lukachukai, AZ 86507

Douglas **Yazzie** — *Navajo*
Artist: Watercolors; P.O. Box 1813, Chinle, AZ 86503; (520) 674-5334

Ed **Yazzie** — *Navajo*
Sculptor; P.O. Box 281, Rock Point, AZ 86545; (520) 659-4205

Elmer **Yazzie** — *Navajo*
Artist: Yucca Brush Paintings; P.O. Box 2 (03 Pill Hill), Rehoboth, NM 87322; (505) 722-6935

Evelyn **Yazzie** — *Navajo*
Jewelry; P.O. Box 771, Tuba City, AZ 86045; (520) 283-6313, (520) 204-2700

Gary **Yazzie** — *Navajo*
Artist; 2550 W. Wilshire, Oklahoma City, OK 73116;
(405) 842-6413

Herman **Yazzie** — *Navajo*
Woodwork: Arts & Crafts; P.O. Box 936, Navajo, NM 87328

Jimmy J. **Yazzie** — *Navajo*
Jewelry; P.O. Box 2274, Kayenta, AZ 86033;
(520) 697-8677

John **Yazzie** — *Navajo*
Moccasins: Traditional Navajo (Custom orders); 10080
Palamino Rd., Flagstaff, AZ 86004; (520) 526-4847

John **Yazzie** — *Navajo*
Jewelry; P.O. Box 204, Bluff, UT 84512; (801) 672-2411

Kathy **Yazzie** — *Navajo*
Artist; Tucson, AZ; (520) 298-6431

Larry **Yazzie** — *Navajo*
Sculptor; P.O. Box 1305, Tuba City, AZ 86045;
(602) 283-6637

Leo L. **Yazzie** — *Navajo*
Jewelry; 3525 N. Wayman St., Flagstaff, AZ 86004;
(520) 526-8247

Loretta **Yazzie** — *Navajo*
Beadwork & Navajo Rug Looms; P.O. Box 7201, Nazlini,
AZ 86540

Louis **Yazzie** — *Navajo*
Crafts: Sash Belts, Key Chain; P.O. Box 2222, Kirtland,
NM 87416

Lynda T. **Yazzie** — *Navajo*
Woodwork: Arts & Crafts; P.O. Box 936, Navajo, NM 87328

Raymond **Yazzie** — *Navajo*
Jewelry; P.O. Box 5166, Gallup, NM 87305; (505) 726-8272

Rose **Yazzie** — *Navajo*
Crafts: Sash Belts, Key Chain; P.O. Box 2222, Kirtland,
NM 87416

Sharon **Yazzie** — *Navajo*
Artist; P.O. Box 2 (03 Pill Hill), Rehoboth, NM 87322;
(505) 722-6935

Sharon C. **Yazzie** — *Navajo*
Seamstress: Clothing Designer; P.O. Box 2924, Window
Rock, AZ 86515; (520) 729-2436

Shirley **Yazzie** — *Navajo*
Jewelry; P.O. Box 1465, Shiprock, NM 87420

Susan **Yazzie** — *Navajo*
Jewelry; P.O. Box 2274, Kayenta, AZ 86033

Venaya J. **Yazzie** — *Navajo*
Artist; 1505 Bluffview Ave., Farmington, NM 87401;
(505) 325-8898

Wil **Yazzie** — *Navajo*
Jewelry; P.O. Box 3551, Canoncito, NM 87026; (505) 839-2805

Kee **Yazzie, Jr.** — *Navajo*
Jewelry; P.O. Box 1377, Winslow, AZ 86047; (505) 753-6359

Louis **Yazzie, Jr.** — *Navajo*
Weaver: Sash Belts, Etc.; P.O. Box 291, Lukachukai, AZ
86507; (520) 787-2282

Yellowhair — *Navajo*
Jewelry & Clothing; 3390 N. Hwy. 89, Prescott, AZ
86301; (520) 541-7739, (520) 899-1714

Anita **Yellowhair** — *Navajo*
Clothing & Jewelry; Mesa, AZ; (602) 838-1549, (602) 945-2635

Manuel **Yellowhair** — *Navajo*
Pottery: Handcarved; P.O. Box 602, Keams Canyon, AZ
86034; (505) 722-6921

Rosie **Yellowhair** — *Navajo*
Sandpainter; P.O. Box 1104, Fruitland, NM 87416;
(505) 598-3170

Alvin **Yellowhorse** — *Navajo*
Jewelry; P.O. Box 316, Lupton, AZ 86508; (520) 688-3199

Artie **Yellowhorse** — *Navajo*
Jewelry; 4314 Silver SE, Albuquerque, NM 87108;
(505) 266-0600

Ben **Yellowhorse** — *Navajo*
Jewelry; P.O. Box 28, New Laguna, NM 87038;
(505) 552-9705

Betty **Yellowhorse** — *Navajo*
Jewelry: Coin Jewelry/Clothing; 128 Cynthia Lp. NW,
Albuquerque, NM 87114; (505) 292-8406, (505) 897-0614

Elsie **Yellowhorse** — *Navajo*
Jewelry; P.O. Box 401, Lupton, AZ 86508; (520) 688-2427,
(520) 688-2990

Lynol **Yellowhorse** — *Navajo*
Jewelry; 706 Daybreak Rd., Rio Rancho, NM 87124;
(505) 891-0317

Robert **Yellowhorse** — *Navajo*
Jewelry; 128 Cynthia Lp. NW, Albuquerque, NM 87114;
(505) 897-0614

Juan **Yellowman** — *Navajo*
Carvings: Navajo Folk Art; P.O. Box 4483, Window Rock,
Az 86515; (505) 871-3296

Darrell **Yonnie** — *Navajo*
Jewelry; P.O. Box 340, Ste. 1048, Sanders, AZ 86512

Ida **Zohnie** — *Navajo*
Weaver: Navajo Rugs, Etc.; P.O. Box 1252, Fruitland, NM
87416; (505) 598-9632

San Felipe

You'll find San Felipe easily by making a quick 30 to 40 minute drive north from Albuquerque or south from Santa Fe. Your first stop may be at Casino Hollywood for lunch, then out to see a few artists.

One of the most unusual items you will find in San Felipe is a unique art form created by Joe Ortiz. He incorporates a traditional San Felipe pot into a work with a base of what appears to be driftwood - very attractive and quite unusual!

There are a number of embroidery artists here who do their work on traditional clothing that can be worn or displayed in an attractive manner. Mary and Nicholas Candelaria can assist you.

Look for pottery by Valencia Montano or Ricardo Ortiz and moccasins by Nat Valencia.

Fernando Padillo is a nationally recognized artist, but you won't find him at the Pueblo - try Oklahoma City.

In the early fall San Felipe Pueblo holds an arts and crafts fair at the Pueblo. And occasional art events have been held on the property adjacent to the casino.

San Felipe

Mary **Candelaria** — *San Felipe*
Weaving, Embroidery, Sashes; San Felipe, NM 87001;
(505) 867-6702

Nicholas **Candelaria** — *San Felipe*
Weaving, Embroidery, Sashes; San Felipe, NM 87001;
(505) 867-6702

Roger **Candelaria** — *San Felipe*
Pottery: Storytellers, Etc.; P.O. Box 837, Algodones, NM
87001; (505) 867-8097

Hubert **Candelario** — *San Felipe*
Pottery: Contemporary; P.O. Box 602, Algodones, NM
87001; (505) 867-0673

Charles **Chavez** — *San Felipe*
Clothing: Traditional; P.O. Box 766, Algodones, NM
87001; (505) 867-8414

Leonora **Chavez** — *San Felipe*
Clothing: Traditional; P.O. Box 766, Algodones, NM
87001; (505) 867-8414

Valencia **Montano** — *San Felipe*
Pottery & Jewelry; P.O. Box 280, Algodones, NM 87001;
(505) 867-8781, (505) 867-2887

Ben **Ortiz** — *San Felipe*
Belts & Moccasins; P.O. Box 4256, San Felipe, NM 87001

Joe **Ortiz** — *San Felipe*
Artist: Pottery on Wood; P.O. Box 4016, San Felipe, NM
87001; (505) 867-8793

Luana **Ortiz** — *San Felipe*
Jewelry; Albuquerque, NM; (505) 271-9821

Ricardo **Ortiz** — *San Felipe*
Pottery & Jewelry; P.O. Box 280, Algodones, NM 87001;
(505) 867-8781, (505) 867-2887

Santana **Ortiz** — *San Felipe*
Clothing: Ribbon Shirts/Dress; P.O. Box 4218, San Felipe,
NM 87001; (505) 867-8793

Stella M. **Ortiz** — *San Felipe*
Jewelry; P.O. Box 4016, San Felipe, NM 87001

Fernando **Padilla, Jr.** — *San Felipe*
Artist; P.O. Box 55781, OklahomaCity, Ok 73155;
(405) 947-0556, (405) 848-1472

Charlene **Reano** — *San Felipe*
P.O. Box 4055, San Felipe, NM 87001; (505) 867-2525

Frank **Reano** — *San Felipe*
P.O. Box 4055, San Felipe, NM 87001; (505) 867-2525

Albert L. **Sanchez** — *San Felipe*
Beadwork; P.O. Box 4340, San Felipe, NM 87001

Simon **Small** — *San Felipe*
Pottery: Gray Glaze; P.O. Box 348, Jemez Pueblo, NM
87024; (505) 834-7773

R. **Twinhorse** — *San Felipe*
Jewelry; P.O. Box 4317, San Felipe, NM 87001;
(505) 867-6645

Kenneth **Valencia** — *San Felipe*
Silversmith; P.O. Box 692, Algodones, NM 87001;
(505) 867-1015

Nat **Valencia** — *San Felipe*
Moccasins: Handmade; P.O. Box 67, San Felipe, NM 87001; (505) 867-6171

Bruce **Velasquez** — *San Felipe*
Paintings & Pottery; P.O. Box 4199, San Felipe, NM 87001; (505) 867-1687

San Ildefonso

San Ildefonso is known for its famous black-on-black style of pottery. If you visit the Pueblo be sure to stop at the museum and see the display which shows how the pottery is made.

Probably the most famous Indian potter known to most of us is Maria Martinez of San Ildefonso, who along with her husband Julian is credited with reviving the black-on-black style.

San Ildefonso is a member of the Eight Northern Indian Pueblos Council. You can receive a brochure that describes the eight pueblos by calling 800-793-4955. Check out their website at IndianPueblos.org.
The brochure gives a brief description of the pueblos and includes articles on a number of artists. There is also a calendar of events and a list of phone numbers for the various pueblos. It's free - so call and get one!

If you can acquire a pot from Barbara Gonzales or Dora Tse Pe you will have an incomparable work of art.

For outstanding embroidery work call on Isabel Gonzales. And if you want a painting find Elvis in the directory and give him a call - believe it or not, he's still around!

San Ildefonso

Martha **Appleleaf** — *San Ildefonso*
Pottery: Trad. & Contemp.; Rt.5, Box 307, Santa Fe, NM
87501; (505) 455-1299, (505) 455-0917

Jo Ann **Glanz** — *San Ildefonso*
Jewelry: Silver; 8306 Roma NE, Albuquerque, NM 87108;
(505) 262-2760

Aaron **Gonzales** — *San Ildefonso*
Pottery; Rt. 5, Box 304-A, Santa Fe, NM 87501;
(505) 455-7202

Barbara **Gonzales** — *San Ildefonso*
Pottery; Rt. 5, Box 304-A, Santa Fe, NM 87501;
(505) 455-7202

Cavan **Gonzales** — *San Ildefonso*
Pottery & Paintings; Rt.5, Box 315-C, Santa Fe, NM
87501; (505) 455-7132

Isabel C. **Gonzales** — *San Ildefonso*
Embroidery: Kilts, Mantas; Rt.5, Box 316, Santa Fe, NM
87501; (505) 455-7716

Jeanne **Gonzales** — *San Ildefonso*
Pottery: Incised & Beadwork; Rt. 5, Box 316, Santa Fe,
NM 87501; (505) 455-2476

Marie **Gonzales-** — *San Ildefonso*
Pottery: Incised; Rt. 5, Box 316, Santa Fe, NM 87501;
(505) 455-2476

Geraldine **Gutierrez** — *San Ildefonso*
Pottery; P.O. Box 247, Espanola, NM 87532;
(505) 753-4648, (505) 753-5538

Rose **Gutierrez** — *San Ildefonso*
Pottery; P.O. Box 247, Espanola, NM 87532;
(505) 753-4648, (505) 753-5538

Becky **Martinez** — *San Ildefonso*
Paintings & Pottery; Rt. 5, Box 305 A., Santa Fe, NM
87501; (505) 455-7167

Carol G. **Naranjo** — *San Ildefonso*
Pottery; P.O. Box 247, Espanola, NM 87532;
(505) 753-4648, (505) 753-5538

Florence **Naranjo** — *San Ildefonso*
Pottery; Rt. 5, Box 318-D, Santa Fe, NM 87501;
(505) 455-7528

Kathy G. **Naranjo** — *San Ildefonso*
Pottery; P.O. Box 247, Espanola, NM 87532;
(505) 753-4648, (505) 753-5538

Louis **Naranjo** — *San Ildefonso*
Pottery; Rt. 5, Box 318-D, Santa Fe, NM 87501;
(505) 455-7528

Gary A. **Roybal** — *San Ildefonso*
Artist & Moccasins; Rt. 5, Box 306, Santa Fe, NM 87501;
(505) 455-2145

Kathy WanPovi **Sanchez** — *San Ildefonso*
Pottery; Rt. 5, Box 442-B, Espanola, NM 87532;
(505) 747-7100

Russell **Sanchez** — *San Ildefonso*
Pottery; Rt. 5, Box 315, Santa Fe, NM 87501

Ernest **Tafoya** — *San Ildefonso*
Jewelry; 8306 Roma NE, Albuquerque, NM 87108;
(505) 262-2760

Juan **Tafoya** — *San Ildefonso*
Pottery; Rt. 5, Box 306 A., Santa Fe, NM 87501;
(505) 455-2649, (505) 455-2418

Dora **Tse Pe** — *San Ildefonso*
Pottery; P.O. Box 3679, Santa Fe, NM 87501;
(505) 455-7560

Elvis **Tsee-PinTorres** — *San Ildefonso*
Paintings & Pottery; Rt. 5, Box 312, Santa Fe, NM 87501;
(505) 455-7547

Than **Tsideh** — *San Ildefonso*
Pottery: Trad. & Contemp.; Rt.5, Box 307, Santa Fe, NM
87501; (505) 455-1299, (505) 455-0917

Charlotte **Vigil** — *San Ildefonso*
Pottery; Rt.5, Box 312-A, Santa Fe, NM 87501;
(505) 455-2525

Doug **Vigil** — *San Ildefonso*
Pottery; Rt.5, Box 312-A, Santa Fe, NM 87501;
(505) 455-2525

Santa Clara

Travel north out of Santa Fe into the town of Espanola. When you see the signs to Santa Clara turn left and drive a few short miles to the Pueblo. Plan to spend a few extra hours here and visit the Puye Cliff Dwellings and Communal House Ruins, a National Historic Landmark.

If you make the trip to Santa Clara you will be rewarded with the opportunity to meet some of the finest and most famous potters of the Southwest. If you call one of the Roller family numbers you'll probably be invited to visit their studio where you'll be overwhelmed with the quality of their work.

Mary Cain and Mida Tafoya, daughters of Christina Naranjo make beautiful pottery at reasonable prices. I knew their deceased mother Christina many years ago when she was an active potter, one of the finest traditional potters of Santa Clara.

Now younger potters like Nancy Youngblood Lugo and Roxanne Swentzel get much of the publicity because of their flawless technique and innovative styles.

One of my favorites will always be Grace Medicine Flower. Grace was one of the top Pueblo potters when I first became involved with Native arts in the late 60's.

Santa Clara

I vividly remember a photo of a group of Native artists taken at the White House when Grace and a number of other artists presented works to the Nixons. These pieces later were placed in the Smithsonian I believe.

I have a wonderful, whimsical etching done by Camilio Sunflower Tafoya, Grace's father. It is a group of field mice and frogs playing leapfrog over toadstools!

Paul and Dorothy Gutierrez are known far and wide for their wonderful figurines. A favorite is a mudhead clown in a variety of postures. Sometimes lying on his back with his legs crossed, sometimes with a six-pack in one hand and a can (of something!) in the other, and always amusing and delightful.

My friend and excellent potter Joe Baca is another of those fine craftsmen who has traveled around the country to do fine art shows. Look for him at major Native events almost anywhere!

Jody Folwell and Jody Naranjo are two more potters you won't want to miss if you get to Santa Clara. And if don't want to call ahead you can drive around the Pueblo and look for signs that say "Pottery For Sale." There's almost always somebody around with some beautiful pots for you to buy and appreciate.

Santa Clara

Evelyn **Aguilar** — *Santa Clara*
Pottery; P.O. Box 1015, Espanola, NM 87532;
(505) 455-3293, (505) 753-2894

Mary E. **Archuleta** — *SantaClara-S.J.*
Pottery; P.O. Box 742, San Juan, NM 87566; (505) 852-4430

Angela **Baca** — *Santa Clara*
Pottery: Black, Incised; P.O. Box 4, Espanola, NM 87532;
(505) 753-3982

Annie **Baca** — *Santa Clara*
Pottery; P.O. Box 1522, Espanola, NM 87532;
(505) 747-1628

David **Baca** — *Santa Clara*
Pottery; P.O. Box 4, Espanola, NM 87532; (505) 753-2849,
(505) 753-3982

Joe **Baca** — *Santa Clara*
Pottery; Rt. 5, Box 472C, Espanola, NM 87532;
(505) 753-9663

Florence **Browning** — *Santa Clara*
Pottery; P.O. Box 1332, Espanola, NM 87532;
(505) 753-7744

Billy **Cain** — *Santa Clara*
Pottery: Traditional; P.O. Box 1494, Espanola, NM 87532;
(505) 753-6238

Mary **Cain** — *Santa Clara*
Pottery: Traditional; P.O. Box 1494, Espanola, NM 87532;
(505) 753-6238

Dave **Chavarria** — *Santa Clara*
Featherwork & Leather; P.O. Box 340, Gamerco, NM
87317; (505) 722-6483

Denise **Chavarria** — *Santa Clara*
Pottery; 033 S. Santa Clara, Espanola, NM 87532;
(505) 753-3289

Loretta **Chavarria** — *Santa Clara*
Pottery; P.O. Box 1134, Espanola, NM 87532

Stella **Chavarria** — *Santa Clara*
Pottery: Black, Carved; P.O. Box 1134, Espanola, NM
87532; (505) 753-7764

Nancy **CroneNaranjo** — *Santa Clara*
Quilts; P.O. Box 4599, Fairview, NM 87533; (505) 753-9239

Tina **Diaz** — *Santa Clara*
Pottery: Black & Red Carved; HC-75, Box 435, Lamy, NM
87540; (505) 466-1669

Debra **Duwyenie** — *Santa Clara*
Clay & Metal; Rt.5, Box 451, Espanola, NM 87532;
(505) 753-5680

Mary **Eckleberry** — *Santa Clara*
Pottery: Black; P.O. Box 1883, Espanola, NM 87532;
(505) 753-6175

Upton **Ethelbah** — *SantaClara-Apa*
Sculptor; P.O. Box 526, Espanola, NM 87532; (505) 747-3165

Hank **Folwell** — *Santa Clara*
Pottery; Rt. 5, Box 453, Espanola, NM 87532; (505) 753-6705

Jody **Folwell** — *Santa Clara*
Pottery; Rt. 5, Box 453, Espanola, NM 87532; (505) 753-6705

Polly **Folwell** — *Santa Clara*
Pottery; Rt. 5, Box 453, Espanola, NM 87532; (505) 753-6705

Susan **Folwell** — *Santa Clara*
Pottery; Rt. 5, Box 453, Espanola, NM 87532; (505) 753-6705

Jason D. **Garcia** — *Santa Clara*
Pottery & Figurines; Rt. 1, Box 471-A, Espanola, NM 87532; (505) 753-2570

Sharon N. **Garcia** — *Santa Clara*
Pottery; P.O. Box 1313, Espanola, NM 87532; (505) 753-9857

Tammy **Garcia** — *Santa Clara*
Pottery: Blue Rain Gallery; 117 S. Plaza, Taos, NM 87571; (800) 414-4893; Web: www.blueraingallery.com

Andrea **Gutierrez** — *Santa Clara*
Pottery: Carved, Black; P.O. Box 1944, Espanola, NM 87532

Dorothy **Gutierrez** — *Santa Clara*
Pottery: Animal Figures; P.O. Box 1441, Espanola, NM 87532; (505) 753-2890

Kristy **Gutierrez** (14 years old) — *Santa Clara*
Pottery; P.O. Box 1944, Espanola, NM 87532

Paul **Gutierrez** — *Santa Clara*
Pottery: Animal Figures; P.O. Box 1441, Espanola, NM 87532; (505) 753-2890

Teresa V. **Gutierrez** — *Santa Clara*
Pottery: Black, Carved; P.O. Box 1, Espanola, NM 87532

Tony **Gutierrez** — *Santa Clara*
Pottery: Carved, Black; P.O. Box 1944, Espanola, NM 87532

Herbert **Hardin** — *Santa Clara*
Sculptor: Metal; 805 Adams NE, Albuquerque, NM 87110; (505) 268-0984

Andrew **Harvier** — *Santa Clara*
Pottery; 021 S. Santa Clara, Espanola, NM 87532; (505) 753-3209

Judith **Harvier** — *Santa Clara*
 Pottery; 021 S. Santa Clara, Espanola, NM 87532;
 (505) 753-3209

Jo-po-vi — *Santa Clara*
 Pottery: Red & Black; P.O. Box 254, Espanola, NM 87532;
 (505) 753-3178

RoseMary **Lewis** — *Santa Clara*
 Pottery & Animal Figures; P.O. Box 621, Espanola, NM
 87532; (505) 753-5121

Travis **Lewis** — *Santa Clara*
 Pottery & Animal Figures; P.O. Box 621, Espanola, NM
 87532; (505) 753-5121

Rosemary **Lonewolf** — *Santa Clara*
 Sculptor & Potter; 333 N. Pennington #4, Chandler, AZ
 85224; (602) 786-5698

Ronnie **Martinez** — *Santa Clara*
 Pottery; P.O. Box 3518, Santa Fe, NM 87501; (505) 455-7797

Grace **MedicineFlower** — *Santa Clara*
 Pottery; P.O. Box 1128, Espanola, NM 87532; (505) 753-2550

Carmen **Michel** — *Santa Clara*
 Pottery; P.O. Box 1660, Espanola, NM 87532; (505) 753-4252

Camille **Moquino** — *Santa Clara*
 Pottery: Black & Red; P.O. Box 10, Espanola, NM 87532

Corn **Moquino** — *Santa Clara*
 Pottery: Black & Red; P.O. Box 1420, Espanola, NM 87532;
 (505) 753-4588

Betty **Naranjo** — *Santa Clara*
 Pottery; P.O. Box 2039, Espanola, NM 87532

Dolly **Naranjo** — *Santa Clara*
 Potter; 135 Estrada Maya, Santa Fe, NM 87501; (505) 983-2633

Dusty **Naranjo** — *Santa Clara*
Pottery; P.O. Box 1896, Espanola, NM 87532; (505) 753-6139

Geri **Naranjo** — *Santa Clara*
Pottery; P.O. Box 195, Espanola, NM 87532; (505) 753-3683

Gracie **Naranjo** — *Santa Clara*
Pottery: Black, Carved; P.O. Box 172, Espanola, NM 87532; (505) 753-7897

Isabel **Naranjo** — *Santa Clara*
Pottery; P.O. Box 1979, Espanola, NM 87532; (505) 753-6230

Jody **Naranjo** — *Santa Clara*
Pottery; P.O. Box 1435, Espanola, NM 87532; (505) 753-8924

Karen **Naranjo** — *Santa Clara*
Pottery; 4350 Airport Rd., Ste. 5-206, Santa Fe, NM 87501; (505) 473-4648

Kevin **Naranjo** — *Santa Clara*
Pottery; P.O. Box 195, Espanola, NM 87532; (505) 753-3683

Maria I. **Naranjo** — *Santa Clara*
Pottery, Figurines, Nativity, Etc.; P.O. Box 976, Espanola, NM 87532

Reycita **Naranjo** — *Santa Clara*
Pottery: Black, Carved; P.O. Box 273, Espanola, NM 87532; (505) 753-7056

Robert **Naranjo** — *Santa Clara*
Pottery; P.O. Box 2039, Espanola, NM 87532

Robert **Naranjo** — *Santa Clara*
Pottery: Traditional; P.O. Box 4599, Fairview, NM 87533; (505) 753-9239

Andy **Padilla** — *Santa Clara*
Pot Designs: Black; P.O. Box 932, Espanola, NM 87532; (505) 753-2819

Marcia **Padilla** — *Santa Clara*
Pottery: Black; P.O. Box 932, Espanola, NM 87532;
(505) 753-2819

Cliff **Roller** — *Santa Clara*
Pottery; P.O. Box 171, Espanola, NM 87532; (505) 753-3003

Jeff **Roller** — *Santa Clara*
Pottery; P.O. Box 46, Espanola, NM 87532; (505) 753-1665

Susan **Roller** — *Santa Clara*
Pottery; 1005B S. Prince Dr., Espanola, NM 87532;
(505) 753-7212, (505) 753-3003

Toni **Roller** — *Santa Clara*
Pottery: Trad. Black Carved; P.O. Box 171, Espanola, NM
87532; (505) 753-3003

Marian **Rose (Naranjo)** — *Santa Clara*
Pottery; Rt. 5, Box 474, Espanola, NM 87532;
(505) 753-2021

Mary **Singer** — *Santa Clara*
Pottery: Black, Carved; Rt.5, Box 472, Espanola, NM
87532; (505) 753-7237

Anita L. **Suazo** — *Santa Clara*
Pottery: Black & Red; P.O. Box 389, Espanola, NM 87532;
(505) 753-2724

Candelaria **Suazo** — *Santa Clara*
Pottery: Red/Black Scraffiti; P.O. Box 272, Espanola, NM
87532

Joseph **Suazo** — *Santa Clara*
Pottery: Black & Red Carved; P.O. Box 389, Espanola, NM
87532; (505) 753-2724

Marie **Suazo** — *Santa Clara*
Pottery: Red & Black; P.O. Box 284, Espanola, NM 87532;
(505) 747-3803

LaHoma **SunFlower** — *Santa Clara*
 Pottery; P.O. Box 4602, Espanola, NM 87532

Celes **Tafoya** — *Santa Clara*
 Pottery; P.O. Box 1015, Espanola, NM 87532;
 (505) 455-3293, (505) 753-2894

Cresencia **Tafoya** — *Santa Clara*
 Pottery; P.O. Box 612, Espanola, NM 87532; (505) 753-4868

Emily **Tafoya** — *Santa Clara*
 Pottery; P.O. Box 3803, Espanola, NM 87532; (505) 753-8295

Forrest **Tafoya** — *Santa Clara*
 Pottery; P.O. Box 1037, Espanola, NM 87532; (505) 753-8225

Harriet **Tafoya** — *Santa Clara*
 Pottery; P.O. Box 1532, Espanola, NM 87532

Jennifer **Tafoya** — *Santa Clara*
 Pottery; P.O. Box 3803, Fairview, NM 87533; (505) 753-8888

Judy **Tafoya** — *Santa Clara*
 Pottery: Etched & Carved; 018 S. Santa Clara, Espanola,
 NM 87532; (505) 753-1809

Laura **Tafoya** — *Santa Clara*
 Pottery: Red & Black; P.O. Box 865, Espanola, NM 87532;
 (505) 753-4710

Lincoln **Tafoya** — *Santa Clara*
 Pottery: Etched & Carved; 018 S. Santa Clara, Espanola,
 NM 87532; (505) 753-1809

Linette **Tafoya** (Age 8, Grade 4) — *Santa Clara*
 Pottery: Etched & Carved; 018 S. Santa Clara, Espanola,
 NM 87532; (505) 753-1809

Lu Ann **Tafoya** — *Santa Clara*
 Pottery: Traditional; P.O. Box 1763, Espanola, NM 87532;
 (505) 753-7074

Michelle T. **Tafoya** — *Santa Clara*
Pottery; P.O. Box 2112, Espanola, NM 87532; (505) 753-3368

Mida **Tafoya** — *Santa Clara*
Pottery: Traditional; P.O. Box 534, Espanola, NM 87532;
(505) 753-6996

Quincy **Tafoya** — *Santa Clara*
Pottery; P.O. Box 1037, Espanola, NM 87532; (505) 753-8225

Robert M. **Tafoya** — *Santa Clara*
Pottery; P.O. Box 534, Espanola, NM 87532; (505) 753-6996

Wanda J. **Tafoya** — *Santa Clara*
Pottery: Traditional; Rt. 1, Box 116, Santa Fe, NM 87501

Frank **Tapia** — *Santa Clara*
Pottery: Red/Black Etc.hing; P.O. Box 1386, Espanola,
NM 87532

Mae **Tapia** — *Santa Clara*
Pottery: Red/Black Etc.hing; P.O. Box 1386, Espanola,
NM 87532

Ramona **Tapia** — *Santa Clara*
Pottery; P.O. Box 2112, Espanola, NM 87532; (505) 753-3368

Doris E. **Tenorio** — *Santa Clara*
Pottery: Red/Black Carved; P.O. Box 1, Espanola, NM 87532

Jenifer **Tse-PeSisneros** — *Santa Clara*
Pottery; 957 S. Santa Clara, Espanola, NM 87532;
(505) 753-0123

Carol **Velarde** — *Santa Clara*
Pottery: Carved Black Incised Minis; P.O. Box 1,
Espanola, NM 87532

Pablita **Velarde** — *Santa Clara*
Artist; (505) 989-6645

Sandra **Velarde** — *Santa Clara*
 Pottery: Micaceous; 9 S. Santa Clara, Espanola, NM
 87532; (505) 753-8485

Tricia **Velarde** — *Santa Clara*
 Pottery; P.O. Box 1957, Espanola, NM 87532

Yolanda **Velarde** — *Santa Clara*
 Pottery: Black & Red; P.O. Box 85, Espanola, NM 87532

Ethel **Vigil** — *Santa Clara*
 Pottery: Red/Black Carved; P.O. Box 1252, Espanola, NM
 87532; (505) 753-2873

Jason **WhiteEagle** — *Santa Clara*
 Pottery: Black & Red, Carved; P.O. Box 4602, Espanola,
 NM 87532

Nancy **Youngblood Lugo** — *Santa Clara*
 Pottery; P.O. Box 188, Santa Fe, NM 87505; (505) 466-1690;
 Web: Members.aol.com/NYLugoinc/webpage

Santo Domingo

North of San Felipe Pueblo between Albuquerque and Santa Fe you will find Santo Domingo. It's easy to find. Just follow the signs from I-25 for a few miles and you'll be there!

The Santo Domingo artists are known for their fine workmanship with turquoise and shell. This is the place to get a really nice heishe necklace, possibly made of olive shell. I remember in the early 70's when I had a gallery in Florida I used to go diving in the Gulf of Mexico for olive shells before each trip back to New Mexico. I would take a bag of olive and other shells to give to several of the heishe makers that I knew at the time.

There are many excellent craftspeople in Santo Domingo to shop with. Call and make an appointment or ask at the Pueblo when you arrive. And if you can't get out of Albuquerque, call Augustine Lovato and see if he has anything to sell. He may be away at an art fair if you are there on a weekend, but if you're lucky enough to catch him you'll see some great work. And if you speak German, he'll enjoy the chance to practice one of his several languages.

You might find a Santo Domingo potter as well – check out the list that follows.

Santo Domingo

Tonita C. **Abeita** — *Santo Domingo*
Jewelry: Heishi & Inlay; P.O. Box 104, SD Pueblo, NM 87052; (505) 465-1108

Harvey Ross **Abeyta** — *Santo Domingo*
Jewelry: Traditional; P.O. Box 573, SD Pueblo, NM 87052; (505) 465-2473

David **Aguilar** — *Santo Domingo*
Jewelry: Inlay; P.O. Box 528, SD Pueblo, NM 87052; (505) 465-0023

Esther **Aguilar** — *Santo Domingo*
Jewelry: Inlay; P.O. Box 528, SD Pueblo, NM 87052; (505) 465-0023

Kenneth **Aguilar** — *Santo Domingo*
Jewelry; P.O. Box 1489, Pena Blanca, NM 87041; (505) 465-0817

Luther **Aguilar** — *Santo Domingo*
Jewelry: Coral & Turquoise; P.O. Box 417, SD Pueblo, NM 87052; (505) 465-2662

Lynn **Aguilar** — *Santo Domingo*
P.O. Box 220, SD Pueblo, NM 87052; (505) 465-1430

Marie C. **Aguilar** — *Santo Domingo*
Jewelry: Coral & Turquoise; P.O. Box 417, SD Pueblo, NM 87052; (505) 465-2662

Rafaelita **Aguilar** — *Santo Domingo*
Pottery & Jewelry; P.O. Box 13, SD Pueblo, NM 87052; (505) 465-2783

Raymond **Aguilar** — *Santo Domingo*
P.O. Box 220, SD Pueblo, NM 87052; (505) 465-1430

Tony **Aguilar, Jr.** — *Santo Domingo*
Jewelry; P.O. Box 68, SD Pueblo, NM 87052; (505) 465-2862

Frank **Atencio** — *Santo Domingo*
Jewelry: Silversmith, Storyteller; P.O. Box 225, SD Pueblo, NM 87052; (505) 465-2743

Juanita **Atencio** — *Santo Domingo*
Jewelry; P.O. Box 24, SD Pueblo, NM 87052; (505) 465-2755

Clarence **Bailon** — *Santo Domingo*
Jewelry: Cut Out Designs; P.O. Box 560, SD Pueblo, NM 87052; (505) 465-2460

Eleanor **Bailon** — *Santo Domingo*
Jewelry: Cut Out Designs; P.O. Box 560, SD Pueblo, NM 87052; (505) 465-2460

Florentino **Bailon** — *Santo Domingo*
Jewelry; P.O. Box 223, SD Pueblo, NM 87052; (505) 465-2553

Ralph **Bailon** — *Santo Domingo*
Storytellers & Xmas Ornaments; P.O. Box 226, SD Pueblo, NM 87052; (505) 465-1043

Joeba **Benavidez** — *Santo Domingo*
Jewelry & Pottery; P.O. Box 397, SD Pueblo, NM 87052; (505) 465-2947

Mary S. **Benavidez** — *Santo Domingo*
Jewelry & Pottery; P.O. Box 397, SD Pueblo, NM 87052; (505) 465-2947

Gloria A. **Bird** — *Santo Domingo*
Beadwork; 5121 Grande Dr. NW, Albuquerque, NM 87107; (505) 248-7149, (505) 248-7266

Gloria C. **Bird** — *Santo Domingo*
P.O. Box 213, SD Pueblo, NM 87052; (505) 465-2340

Jolene **Bird** — *Santo Domingo*
Jewelry: Trad. & Contemp.; P.O. Box 37, SD Pueblo, NM 87052; (505) 465-0340

Alfred **Calabaza** — *Santo Domingo*
Jewelry: Custom design; P.O. Box 362, SD Pueblo, NM 87052; (505) 465-2810

Elsie A. **Calabaza** — *Santo Domingo*
Jewelry: Heishi; P.O. Box 346, SD Pueblo, NM 87052; (505) 465-2724

Eva **Calabaza** — *Santo Domingo*
Jewelry: Custom design; P.O. Box 362, SD Pueblo, NM 87052; (505) 465-2810

Jimmy **Calabaza** — *Santo Domingo*
Jewelry; P.O. Box 396, SD Pueblo, NM 87052; (505) 465-2832

Joe **Calabaza** — *Santo Domingo*
Jewelry: Fine Heishi; P.O. Box 215, SD Pueblo, NM 87052; (505) 465-2680

Mary Ann **Calabaza** — *Santo Domingo*
Jewelry: Fine Heishi; P.O. Box 215, SD Pueblo, NM 87052; (505) 465-2680

Donna O. **Carey** — *Santo Domingo*
Jewelry; P.O. Box 226, Eureka, MT 59917; (406) 296-0609

Arvin **Cate** — *Santo Domingo*
Jewelry; P.O. Box 454, SD Pueblo, NM 87052

Irma **Cate** — *Santo Domingo*
Jewelry: Fetishes, Heishi; P.O. Box 203, SD Pueblo, NM 87052; (505) 465-0140

Joe **Cate** — *Santo Domingo*
Jewelry: Shells/Mosaic/Turq; P.O. Box 454, SD Pueblo, NM 87052

Lorraine **Cate** — *Santo Domingo*
Jewelry: Fetishes, Heishi; P.O. Box 203, SD Pueblo, NM 87052; (505) 465-0140

Rosey **Cate** — *Santo Domingo*
Jewelry: Shells/Mosaic/Turq; P.O. Box 454, SD Pueblo, NM 87052

Alfred **Chavez** — *Santo Domingo*
Jewelry; P.O. Box 334, SD Pueblo, NM 87052; (505) 465-0627

Avelino **Chavez** — *Santo Domingo*
Jewelry; P.O. Box 334, SD Pueblo, NM 87052; (505) 465-0627

Clara **Chavez** — *Santo Domingo*
Jewelry; P.O. Box 334, SD Pueblo, NM 87052; (505) 465-0627

Edward **Chavez** — *Santo Domingo*
Jewelry; P.O. Box 334, SD Pueblo, NM 87052; (505) 465-0627

Eliza **Chavez** — *Santo Domingo*
Jewelry: Heishi/Shell; P.O. Box 254, SD Pueblo, NM 87052; (505) 465-2901

Harvey **Chavez** — *Santo Domingo*
Jewelry; P.O. Box 134, SD Pueblo, NM 87052; (505) 465-2677

Janie **Chavez** — *Santo Domingo*
Jewelry; P.O. Box 134, SD Pueblo, NM 87052; (505) 465-2677

Joe **Chavez** — *Santo Domingo*
Jewelry: Heishi/Shell; P.O. Box 254, SD Pueblo, NM 87052; (505) 465-2901

Joe **Chavez** — *Santo Domingo*
Jewelry & Beadwork; P.O. Box 31, SD Pueblo, NM 87052; (505) 465-2992

LeJeune **Chavez** — *Santo Domingo*
Jewelry & Beadwork; P.O. Box 31, SD Pueblo, NM 87052; (505) 465-2992

Neomi **Chavez** — *Santo Domingo*
Jewelry; P.O. Box 334, SD Pueblo, NM 87052; (505) 465-0627

Toby **Chavez** — *Santo Domingo*
Beadwork; 6205 Bellamah NE, Albuquerque, NM;
(505) 266-6113

Alonzo J. **Coriz** — *Santo Domingo*
Jewelry; P.O. Box 189, SD Pueblo, NM 87052

Angel **Coriz** — *Santo Domingo*
Storytellers & Xmas Ornaments; P.O. Box 226, SD
Pueblo, NM 87052; (505) 465-1043

Brenda **Coriz** — *Santo Domingo*
Jewelry: Shell Inlay; P.O. Box 135, SD Pueblo, NM 87052;
(505) 465-1525

Fabian **Coriz** — *Santo Domingo*
Jewelry: Shell Inlay; P.O. Box 135, SD Pueblo, NM 87052;
(505) 465-1525

Helen M. **Coriz** — *Santo Domingo*
Jewelry: Trad. & Contemp.; P.O. Box 27, SD Pueblo, NM
87052; (505) 465-2564

Ione **Coriz** — *Santo Domingo*
Pottery: Piglets/Birdheads; P.O. Box 549, SD Pueblo, NM
87052; (505) 465-1504

Irvin **Coriz** — *Santo Domingo*
Drum Maker; P.O. Box 571, SD Pueblo, NM 87052;
(505) 465-2266

Joseph **Coriz** — *Santo Domingo*
Jewelry: S.T. Overlay Gold; P.O. Box 133, SD Pueblo, NM
87052; (505) 465-2732

Joseph **Coriz** — *Santo Domingo*
Jewelry: Trad. & Contemp.; P.O. Box 27, SD Pueblo, NM
87052; (505) 465-2564

Julian **Coriz** — *Santo Domingo*
Jewelry; P.O. Box 204, SD Pueblo, NM 87052; (505) 465-0902

Lorenzo B. **Coriz** — *Santo Domingo*
Jewelry; SD Pueblo, NM 87052

Louise **Coriz** — *Santo Domingo*
Jewelry: Heishi, Weaving; P.O. Box 15535, Santa Fe, NM
87506; (505) 685-4506

Marie **Coriz** — *Santo Domingo*
Jewelry: Shell Inlay; P.O. Box 135, SD Pueblo, NM 87052;
(505) 465-1525

Marie A. **Coriz** — *Santo Domingo*
Jewelry; P.O. Box 204, SD Pueblo, NM 87052; (505) 465-0902

Mary C. **Coriz** — *Santo Domingo*
Jewelry; P.O. Box 524, SD Pueblo, NM 87052; (505) 465-0240

Mary R. **Coriz** — *Santo Domingo*
Jewelry; P.O. Box 324, SD Pueblo, NM 87052; (505) 465-2398

Matthew **Coriz** — *Santo Domingo*
Jewelry: Silver; P.O. Box 156, SD Pueblo, NM 87052;
(505) 465-2283

Nestoria P. **Coriz** — *Santo Domingo*
Jewelry: Handmade Beads; P.O. Box 113, SD Pueblo, NM
87052; (505) 465-2595

Pam **Coriz** — *Santo Domingo*
Jewelry & Pottery: Polish & Repair; P.O. Box 22, SD
Pueblo, NM 87052; (505) 465-9922

Rudy **Coriz** — *Santo Domingo*
Jewelry; P.O. Box 324, SD Pueblo, NM 87052; (505) 465-2398

Tom **Coriz** — *Santo Domingo*
Jewelry & Pottery: Polish & Repair; P.O. Box 22, SD
Pueblo, NM 87052; (505) 465-9922

Tonita **Coriz** — *Santo Domingo*
Jewelry; P.O. Box 572, SD Pueblo, NM 87052; (505) 465-9961

Angie **Crespin** — *Santo Domingo*
Jewelry; P.O. Box 1489, Pena Blanca, NM 87041;
(505) 465-0817

Don **Crespin** — *Santo Domingo*
Jewelry; P.O. Box 253, SD Pueblo, NM 87052; (505) 465-2698

Nancy **Crespin** — *Santo Domingo*
Jewelry; P.O. Box 253, SD Pueblo, NM 87052; (505) 465-2698

Barbara C. **Garcia** — *Santo Domingo*
Jewelry; P.O. Box 221, SD Pueblo, NM 87052; (505) 465-0219

David **Garcia** — *Santo Domingo*
Jewelry; P.O. Box 211, SD Pueblo, NM 87052; (505) 465-0514

Dennis **Garcia** — *Santo Domingo*
Jewelry; P.O. Box 66, SD Pueblo, NM 87052

Gail **Garcia** — *Santo Domingo*
Jewelry; P.O. Box 221, SD Pueblo, NM 87052; (505) 465-0219

Gregory **Garcia** — *Santo Domingo*
Jewelry; P.O. Box 211, SD Pueblo, NM 87052; (505) 465-0514

Helen **Garcia** — *Santo Domingo*
Pottery; 108 Morenci St., SD Pueblo, NM 87052;
(505) 465-2603

Juan **Garcia** — *Santo Domingo*
Jewelry; P.O. Box 42, SD Pueblo, NM 87052; (505) 465-2605

Juanita **Garcia** — *Santo Domingo*
Jewelry; P.O. Box 66, SD Pueblo, NM 87052

Judith **Garcia** — *Santo Domingo*
Jewelry; P.O. Box 221, SD Pueblo, NM 87052; (505) 465-0219

Lillian **Garcia** — *Santo Domingo*
Jewelry; P.O. Box 211, SD Pueblo, NM 87052; (505) 465-0514

Lloyd **Garcia** — *Santo Domingo*
Pottery; 108 Morenci St., SD Pueblo, NM 87052; (505) 465-2603

Lorencita **Garcia** — *Santo Domingo*
Jewelry: Shell/Turq/Beads; P.O. Box 302, SD Pueblo, NM 87052; (505) 465-2709

Madeline **Garcia** — *Santo Domingo*
P.O. Box 1384, Pena Blanca, NM 87041

Mavis **Garcia** — *Santo Domingo*
Jewelry: Heishi/Fetishes; P.O. Box 337, SD Pueblo, NM 87052; (505) 465-0539

Nick **Garcia** — *Santo Domingo*
Jewelry: Heishi & Silver; Star Route Box 58, Algodones, NM 87001; (505) 465-2386

Petra **Garcia** — *Santo Domingo*
Jewelry; P.O. Box 42, SD Pueblo, NM 87052; (505) 465-2605

Ramon C. **Garcia** — *Santo Domingo*
Jewelry: Shell/Turq/Beads; P.O. Box 302, SD Pueblo, NM 87052; (505) 465-2709

Ray **Garcia** — *Santo Domingo*
Drums; P.O. Box 70, SD Pueblo, NM 87052; (505) 967-5221

Raymond **Garcia** — *Santo Domingo*
Jewelry; P.O. Box 221, SD Pueblo, NM 87052; (505) 465-0219

Reyes M. **Garcia** — *Santo Domingo*
Jewelry: Heshi & Turquoise; P.O. Box 178, SD Pueblo, NM 87052; (505) 465-2750

Sammy **Garcia** — *Santo Domingo*
Jewelry: Silversmith; P.O. Box 337, SD Pueblo, NM 87052; (505) 465-0539

Samuel **Garcia** — *Santo Domingo*
Jewelry; P.O. Box 221, SD Pueblo, NM 87052; (505) 465-0219

Anthony **Lovato** — *Santo Domingo*
Jewelry: Silver/Gold Turq.; P.O. Box 242, Pena Blanca, NM 87041; (505) 465-1-46

Augustine **Lovato** — *Santo Domingo*
Jewelry: Traditional; 2141 Isleta Blvd. SW, Albuquerque, NM 87105; (505) 877-6835

Calvin **Lovato** — *Santo Domingo*
Jewelry: Heishi; P.O. Box 98, SD Pueblo, NM 87052; (505) 465-2469

Eldra **Lovato** — *Santo Domingo*
Jewelry; P.O. Box 70, SD Pueblo, NM 87052; (505) 967-5221

Julian **Lovato** — *Santo Domingo*
Jewelry: Silversmith; P.O. Box 67, SD Pueblo, NM 87052; (505) 465-2697

Maria S. **Lovato** — *Santo Domingo*
Jewelry; P.O. Box 73, SD Pueblo, NM 87052

Marie **Lovato** — *Santo Domingo*
Jewelry; P.O. Box 67, SD Pueblo, NM 87052; (505) 465-2697

Mary C. **Lovato** — *Santo Domingo*
Jewelry: Mosaic Inlay, Trad.; P.O. Box 1242, Pena Blanca, NM 87041; (505) 465-1046

Pilar **Lovato** — *Santo Domingo*
Jewelry: Heishi; P.O. Box 98, SD Pueblo, NM 87052; (505) 465-2469

Ray **Lovato** — *Santo Domingo*
Jewelry; P.O. Box 58, SD Pueblo, NM 87052; (505) 465-2718

Felix **Lovato, Jr.** — *Santo Domingo*
Pottery, Beadwork, Etc.; P.O. Box 733, Algodones, NM 87001; (505) 867-8793

Crucita **Melchor** — *Santo Domingo*
Jewelry; P.O. Box 384, SD Pueblo, NM 87052; (505) 465-2814

Marlene **Melchor** — *Santo Domingo*
Jewelry; P.O. Box 384, SD Pueblo, NM 87052; (505) 465-2814

Tom **Moquino** — *Santo Domingo*
Jewelry; P.O. Box 296, SD Pueblo, NM 87052; (505) 465-0420

Andrew **Pacheco** — *Santo Domingo*
Jewelry; P.O. Box 284, SD Pueblo, NM 87052

Domingo **Pacheco** — *Santo Domingo*
Jewelry: Repair; P.O. Box 112, SD Pueblo, NM 87052

Eddie **Pacheco** — *Santo Domingo*
Jewelry; P.O. Box 394, SD Pueblo, NM 87052

Gilbert **Pacheco** — *Santo Domingo*
Pottery: Traditional SDP; P.O. Box 411, SD Pueblo, NM 87052; (505) 465-2456

Gladys **Pacheco** — *Santo Domingo*
Jewelry; P.O. Box 284, SD Pueblo, NM 87052

Joe E. **Pacheco** — *Santo Domingo*
Jewelry; P.O. Box 565, SD Pueblo, NM 87052

Larry **Pacheco** — *Santo Domingo*
Jewelry: Silver & Gold; P.O. Box 205, SD Pueblo, NM 87052; (505) 465-2233

Marilyn **Pacheco** — *Santo Domingo*
Jewelry; P.O. Box 565, SD Pueblo, NM 87052

Nelson **Pacheco** — *Santo Domingo*
Jewelry; P.O. Box 587, SD Pueblo, NM 87052; (505) 465-2568

Paulita T. **Pacheco** — *Santo Domingo*
Jewelry: Traditional SDP; P.O. Box 411, SD Pueblo, NM 87052; (505) 465-2456

Sallie **Pacheco** — *Santo Domingo*
Jewelry: Repair; P.O. Box 112, SD Pueblo, NM 87052

Teresa L. **Pacheco** (Age 10 in 1998) — *Santo Domingo*
Pottery; P.O. Box 565, SD Pueblo, NM 87052

Ramos **Pacheco jr.** — *Santo Domingo*
Jewelry: Silver & Turq.; P.O. Box 242, SD Pueblo, NM
87052; (505) 465-2813

Venencia **Pacheco jr.** — *Santo Domingo*
Jewelry: Silver & Turq.; P.O. Box 242, SD Pueblo, NM
87052; (505) 465-2813

Florence **Pajarito** — *Santo Domingo*
Jewelry & Pottery; SD Pueblo, NM 87052; (505) 465-2802

Joe **Pajarito** — *Santo Domingo*
Jewelry: Hand-Carved Leaves; SD Pueblo, NM 87052;
(505) 465-2802

Mary **Pajarito** — *Santo Domingo*
Jewelry: Hand-Carved Leaves; SD Pueblo, NM 87052;
(505) 465-2802

Albert **Quintana** — *Santo Domingo*
Jewelry: Trad. & Contemp.; P.O. Box 22, SD Pueblo, NM
87052; (505) 465-1239

Cris **Quintana** — *Santo Domingo*
Jewelry: Trad. & Contemp.; P.O. Box 22, SD Pueblo, NM
87052; (505) 465-1239

Shelly **Quintana** — *Santo Domingo*
Jewelry: Trad. & Contemp.; P.O. Box 22, SD Pueblo, NM
87052; (505) 465-1239

Angie **Reano** — *Santo Domingo*
Jewelry; P.O. Box 314, SD Pueblo, NM 87052; (505) 465-2448

Charlene L. **Reano** — *Santo Domingo*
Jewelry; 935 Buena Vista SE #E104, Albuquerque, NM
87106; (505) 764-9892, (505) 465-2496

Charlotte **Reano** — *Santo Domingo*
Jewelry; P.O. Box 315, SD Pueblo, NM 87052; (505) 465-2668

Dena **Reano** — *Santo Domingo*
Jewelry; P.O. Box 315, SD Pueblo, NM 87052; (505) 465-2668

Denise **Reano** — *Santo Domingo*
Jewelry; P.O. Box 315, SD Pueblo, NM 87052; (505) 465-2668

Irene **Reano** — *Santo Domingo*
Jewelry: Fetish Necklaces; General Delivery, Gamerco,
NM 87317; (505) 726-8180

Joe L. **Reano** — *Santo Domingo*
Jewelry; P.O. Box 314, SD Pueblo, NM 87052; (505) 465-2448

Percy **Reano** — *Santo Domingo*
Jewelry; P.O. Box 315, SD Pueblo, NM 87052; (505) 465-2668

Rose **Reano** — *Santo Domingo*
Jewelry; P.O. Box 196, SD Pueblo, NM 87052; (505) 465-2462

Jessie **Rosetta** — *Santo Domingo*
P.O. Box 32, SD Pueblo, NM 87052; (505) 465-2243

Paul **Rosetta** — *Santo Domingo*
P.O. Box 32, SD Pueblo, NM 87052; (505) 465-2243

Vivian **Sanchez** — *Santo Domingo*
Jewelry; P.O. Box 115, SD Pueblo, NM 87052; (505) 465-2714

Lorenzo **Tafoya** — *Santo Domingo*
Jewelry; P.O. Box 69, SD Pueblo, NM 87052; (505) 465-2793

Mary L. **Tafoya** — *Santo Domingo*
Jewelry; P.O. Box 69, SD Pueblo, NM 87052; (505) 465-2793

Wenona **Tapia** — *Santo Domingo*
Jewelry: Heishi & Silver; Star Route Box 58, SD Pueblo,
NM 87052; (505) 465-2386

Gabby **Tenorio** — *Santo Domingo*
Jewelry: Heishi; P.O. Box 453, SD Pueblo, NM 87052;
(505) 465-2333

Howard **Tenorio** — *Santo Domingo*
Jewelry; P.O. Box 65, SD Pueblo, NM 87052; (505) 465-2820

Margaret **Tenorio** — *Santo Domingo*
Jewelry & Sewing; P.O. Box 558, SD Pueblo, NM 87052; (505) 465-2455

MaryEdna **Tenorio** — *Santo Domingo*
StoryTeller & FirePl.s; P.O. Box 62, SD Pueblo, NM 87052; (505) 465-2609

Raymond **Tenorio** — *Santo Domingo*
Jewelry: Heishi; P.O. Box 453, SD Pueblo, NM 87052; (505) 465-2333

Robert **Tenorio** — *Santo Domingo*
Pottery: Traditional; P.O. Box 62, SD Pueblo, NM 87052; (505) 465-2609

Veronica **Tenorio** — *Santo Domingo*
Jewelry; P.O. Box 65, SD Pueblo, NM 87052; (505) 465-2820

Edward **Tortalita** — *Santo Domingo*
Jewelry: Silversmith; P.O. Box 518, SD Pueblo, NM 87052; (505) 465-1129

Eileen **Tortalita** — *Santo Domingo*
Jewelry; P.O. Box 207, SD Pueblo, NM 87052; (505) 465-2666

Florence **Tortalita** — *Santo Domingo*
Jewelry: Silversmith; P.O. Box 518, SD Pueblo, NM 87052; (505) 465-1129

Lorenzo **Tortalita** — *Santo Domingo*
Jewelry; P.O. Box 207, SD Pueblo, NM 87052; (505) 465-2666

Vickie **Tortalita** — *Santo Domingo*
Jewelry; P.O. Box 207, SD Pueblo, NM 87052; (505) 465-2666

Alois **Wagner** — *Santo Domingo*
Jewelry; 1116 La Poblana Rd. NW, Albuquerque, NM 87107; (505) 342-2078, (505) 764-0129

Tim **Yazzie** — *Santo Domingo*
Jewelry; 347 Tribal Rd. 66, Albuquerque, NM 87105; (505) 869-4722

Sioux

Let me begin this section by explaining and apologizing. There are a number of different groups that fall under the Sioux name for the purposes of this directory. Some of the artists list Lakota, some list Lakota Sioux, some list Rosebud Sioux, some Wahpeton-Sisseton Sioux as well as others. I'm sorry that it is not possible to have a separate listing for each group, but the limitations of this directory just don't allow it. And, as a matter of fact, many of the 100 tribal affiliations in this directory don't get a separate category. They're all listed together in the last section.

This is a very diverse group of artists. Kevin and Valerie Pourier from Scenic, ND carve beautiful images on Buffalo horns that are frequent award winners at shows.

JoAnne Bird from Brookings, SD is often a demonstrator at art events. Ask her to see the special process she has for some of her art work – you'll enjoy the surprise!

Paul and Linda Szabo from Mission, SD turn out some really nice jewelry. They also travel to shows so you may not have to travel to South Dakota to see them.

If you're in Illinois call Jean Bad Moccasin and check out her pottery. Or find Sonja Holy Eagle back in SD and enjoy her terrific drums and hide paintings.

Sioux

Annalisa **Agard** — *Sioux*
Quilts: Family Business; P.O. Box 374, McIntosh, SD 57641; (605) 273-4400, (605) 273-4236

Anthony **Agard** — *Sioux*
Quilts: Family Business; P.O. Box 374, McIntosh, SD 57641; (605) 273-4400, (605) 273-4236

Irene **Agard** — *Sioux*
Quilts: Family Business; P.O. Box 374, McIntosh, SD 57641; (605) 273-4400, (605) 273-4236

Thelma **Amiotte** — *Sioux Rosebud*
Star Quilts, Beadwork, Dance Outfits; P.O. Box 61, Parmelee, SD 57566; (605) 747-5304, (605) 747-2381

Jean **BadMoccasin** — *Sioux*
Pottery; 2722 Rabbit Ct., Spring Grove, IL 60081; (815) 675-6610

JoAnne **Bird** — *Sioux*
Artist; P.O. Box 57006, Brookings, SD 57006; (605) 693-3193

Archie **Blue Thunder** — *Sioux Rosebud*
Beadwork; P.O. Box 565, Rosebud, SD 57570

Buka **Blue Thunder** — *Sioux Rosebud*
Beadwork: Dance Outfits; P.O. Box 291, Mission, SD 57555

Sandra **Brewer** — *Sioux*
A & C.; (520) 402-0107

Sandra **Brewer** — *Sioux*
Beadwork & Dolls; P.O. Box 2453, Globe, AZ 85502; (520) 402-0107

Rex **Carolin** — *Sioux*
Artist: Bone & Horn; 7726 E. Hwy. 287 #61, Coolidge, AZ 85228; (520) 723-5277

Sheryl **Charging Whirlwind** — *Sioux Rosebud*
Dance Outfits: Clothing; P.O. Box 1346, Mission, SD 57555

Bruce **Contway** — *Sioux-Chippewa*
Jewelry, Etc.; P.O. Box 920, Whitehall, MT 59759; (406) 287-5122

Winter **Dawn** — *Sioux*
Sculptor & Leather Handbags; P.O. Box 252, Glen Haven, CO 80532; (970) 586-2863; E-mail: wdawn@aol.com, Web: www.winterdawn.com

Ed **Defender** — *Sioux*
Artist; 301 Tulane SE, Albuquerque, NM 87106; (505) 265-0695

Michael J. **Donohoe** — *Sioux*
Artist; HC 1, Box 14, Ashland, NY 12407; (518) 734-4316

James C. **Dubray** — *Sioux Oglala*
Arts & Crafts: Traditional Lakota; P.O. Box 402, Allen, SD 57714; (605) 455-2692

Thomas **Dubray** — *Sioux Oglala*
Quill Work: Traditional Lakota; P.O. Box 402, Allen, SD 57714

Joyce G.T. **Fogarty** — *Sioux*
Beadwork & Quillwork; 23040 Pleasant Valley, N. San Juan, CA 95960

Scott **Frazier** — *Sioux-Crow*
Dolls: Beadwork; 266 Bear Canyon, Bozeman, MT 59715; (406) 586-7091, (406) 587-7606

Imogene **Goodshot** — *Sioux*
Dolls; 203 Quapaw, Santa Fe, NM 87501; (505) 984-0388

Linda **Haukaas** — *Sioux*
Dolls & Ledger Drawings; 610N.CascadeAve., Studio 21, Colorado Springs, CO 80903; (719) 634-5021

Tom **Haukaas** — *Sioux*
Beadwork & Lakota Art; (813) 886-9020

Sonja **Holy Eagle** — *Sioux*
Drums & Hide Painting; P.O. Box 75, Rapid City, SD 57709; (605) 348-2421

Margaret **Hosie** — *Sioux*
Quilts: Family Business; P.O. Box 374, McIntosh, SD 57641; (605) 273-4400, (605) 273-4236

Donna **JumpingEagle** — *Sioux-Oglala*
Beadwork; AZ; (520) 289-0598

Vernal **Kills In Sight** — *Sioux Rosebud*
Beadwork: Leather, Sculptor; General Delivery, St. Francis, SD 57572; (605) 747-5548

Lester **Kills The Enemy** — *Sioux Rosebud*
Speaking & Singing Engagements; P.O. Box 363, Parmelee, SD 57566

Ivan **Knife** — *Sioux Rosebud*
Quillwork, Moccasins & Pipe Bags; General Delivery, White River, SD 57579

Beverly **Larvie** — *Sioux Rosebud*
Speaking & Singing; General Delivery, Mission, SD 57555; (605) 856-2558

Nick **Leading Fighter** — *Sioux Rosebud*
Beadwork; P.O. Box 484, Mission, SD 57555

Reginald **Little Brave** — *Sioux Rosebud*
Feathers: Beadwork, Etc.; P.O. Box 979, Mission, SD 57555

Dorothy **Little Elk** — *Sioux Rosebud*
Cradleboards, Purses, Etc.; P.O. Box 274, Parmelee, SD
57566; (605) 747-2923

Donroy **Makes Room** — *Sioux Rosebud*
Feathers, Speaking, Singing, Etc.; General Delivery,
Mission, SD 57555

Lindolfo **Martinez** — *Sioux Oglala*
Beadwork: Moccasins, Dr.ums, Etc.; P.O. Box 356, Allen,
SD 57714

Ray **McKeown** — *Sioux*
Beadwork & Quillwork; 196 Barclay St., Ste. 403,
Vancouver, BC V6G 1L4; (604) 687-8209

Charles C. **McLaughlin** — *Sioux*
Carving: Wood, stone, Etc.; P.O. Box 295, Selfridge, ND
58568; (701) 422-3706

Julius **Not Afraid** — *Sioux Oglala*
Beadwork: Clothing, Outfits; P.O. Box 544, Allen, SD
57714; (605) 455-2375

George **Omaha Boy** — *Sioux Rosebud*
Beadwork: Moccasins, Clothing; P.O. Box 138, Rosebud,
SD 57570

Philomine **Omaha Boy** — *Sioux Rosebud*
Beadwork: Keychains, pens; P.O. Box 138, Rosebud, SD
57570

Anabelle **One Star** — *Sioux Rosebud*
P.O. Box 188, St. Francis, SD 57572

Marion **One Star** — *Sioux Rosebud*
Beadwork: Dance Outfits, Trad.Food; P.O. Box 400,
Rosebud, SD 57570; (605) 747-2231

Darlene **Poor Bear** — *Sioux Oglala*
Quilts, Ribbon Shirts, Etc.; P.O. Box 384, Allen, SD 57714; (605) 455-1173

Elaine **Poor Bear Martinez** — *Sioux Oglala*
Quilts: Handmade, Crib-size; P.O. Box 356, Allen, SD 57714

Kevin **Pourier** — *Sioux*
Carvings: Buffalo Horn; HC 36, Box 5, Scenic, ND 57780; (605) 433-5555

Valerie **Pourier** — *Sioux*
Carvings: Buffalo Horn; HC 36, Box 5, Scenic, ND 57780; (605) 433-5555

Andrew **Red Bird** — *Sioux Rosebud*
Beadwork; P.O. Box 482, St. Francis, SD 57572

Vida **Red Bird** — *Sioux Rosebud*
Beadwork; P.O. Box 482, St. Francis, SD 57572

Woody **Richards** — *Sioux*
P.O. Box 735, Fairview, NC 28730; (704) 628-0003

Jean **Roach** — *Sioux*
Jewelry; 324 Doolittle St., Rapid City, SD 57701; (605) 388-9220

J. **Rousseau** — *Sioux*
Artist; 3514 W. 8th Ct., Lawrence, KS 66049; (785) 865-1538

Wambli **Sapa** — *Sioux*
Artist: N. Plains Tribal Art; 7726 E. Hwy. 287 #61, Coolidge, AZ 85228; (520) 723-5277 (602) 819-3450

Sal **Serbin** — *Sioux-Assini.*
Misc.; 320 Donrich Dr., Carrolton, GA 30117; (770) 830-5591

Jock **Sheirbeck** — *Sioux Rosebud*
Sculptor: Bone, stone, Etc.; P.O. Box 411, Mission, SD 57555; (605) 856-4622

Joe **Shields** — *Sioux Rosebud*
Hat Pins, Earrings, Bracelets; P.O. Box 467, Mission, SD 57555

Roger **Shields** — *Sioux Rosebud*
Quillwork; General Delivery, Mission, SD 57555

Raymond **Shot** — *Sioux Rosebud*
Flutes: Traditional; P.O. Box 1603, Vermillion, SD 57609

Gloria Black **Spotted Horse** — *Sioux Rosebud*
Dance Outfits: Purses, Etc.; General Delivery, St. Francis, SD 57572; (605) 747-2843

Diana **Stone** — *Sioux Rosebud*
Quilts: Star Quilts; General Delivery, Parmelee, SD 57566; (605) 747-5206

Linda **Stone** — *Sioux Rosebud*
Beadwork & Quillwork; P.O. Box 126, Rosebud, SD 57570

Roy **Stone, Jr.** — *Sioux Rosebud*
Quilts: Star Quilts; General Delivery, Parmelee, SD 57566; (605) 747-5206

Suzanna **Swallow** — *Sioux Rosebud*
Beadwork: Earrings, Etc.; P.O. Box 416, Rosebud, SD 57570

Linda T. **Szabo** — *Sioux Lakota*
Jewelry; P.O. Box 906, Mission, SD 57555; (605) 856-4548

Paul **Szabo** — *Sioux Lakota*
Jewelry; P.O. Box 906, Mission, SD 57555; (605) 856-4548

Don **Tenoso** — *Sioux*
Doll Maker; P.O. Box 1036, Corrales, NM 87048

Carla **Thompson** — *Sioux Rosebud*
Quilts: Star Quilts; Norris, SD 57560; (605) 747-5206

Lena Jo **Toledo** — *Sioux Rosebud*
Beadwork & Quillwork; P.O. Box 565, Rosebud, SD 57570

Sonny **Tuttle** — *Sioux-Arapaho*
Artist: Hide Paintings; P.O. Box 388, Lander, WY 82520; (307) 332-2134

Carol **Two Eagle** — *Sioux Rosebud*
Sculptor: Bone, Stone, Etc.; P.O. Box 341, Parmelee, SD 57566; (605) 747-2132

Lonnie **Two Eagle** — *Sioux Rosebud*
Sculptor: Bone, Stone, Etc.; P.O. Box 341, Parmelee, SD 57566; (605) 747-2132

Judy **White Buffalo** — *Sioux Rosebud*
Beadwork: Dance Outfits; P.O. Box 700, Mission, SD 57555

Felice **Witt** — *Sioux Oglala*
Beadwork & Seamstress; P.O. Box 481, Allen, SD 57714; (605) 455-2692

Santee **Witt** — *Sioux Oglala*
Artist: Paintings; P.O. Box 481, Allen, SD 57714; (605) 455-2692

Gerald **Wright** — *Sioux Rosebud*
Dance Outfits; P.O. Box 498, St. Francis, SD 57572; (605) 747-5731

Francis J. **Yellow** — *Sioux*
Artist; 2917 29th Ave. S., Minneapolis, MN 55406; (612) 728-0440

Jim **Yellowhawk** — *Sioux-Iroquois*
Artist: Mixed media; 23213 Black Forest Pl., Rapid City, SD 57702; (605) 574-2165; E-mail: kfyellowhk.aol.com

Mitchell **Zephier** — *Sioux*
Jewelry: Gold & Silver; 909 E. St. Patrick #16, Rapid City, SD 57701; (605) 343-0603

Zuni

Zuni, about 30 miles south of Gallup, NM is home to some of the finest jewelers in the country. Known the world over for their fine needlepoint turquoise and inlay jewelry Zuni artists have long been famous for their exceptionally high quality stone cutting work.

Many Zuni artists are also known for their stone carvings, notably in the fetish carvings by famous family names like Quandalacy and Quam.

There are also outstanding contemporary silversmiths and jewelers like Veronica Poblano and Carolyn Bobelu, a former Indian Arts & Crafts Association Artist of the Year. And Veronica has taught her children to carry on her tradition of excellent craftsmanship.

You'll enjoy the work of 2-D artist Chris Natachu and sculptor Keith Paywa. Keith lives in Pecos, NM, and you can see his work when you get to the Santa Fe area.

You'll enjoy the pottery of Berdel Soseeah, miniatures with lizards and frogs. Also, potters Noreen Simplico and Agnes Peynetsa are worth a visit.

If you can get to Zuni in late November or early December try to attend the Shalako ceremony. Call 505-782-4481 to get the exact date - you'll love it!

Zuní

Carolyn **Bobelu** — *Zuni-Navajo*
Jewelry; 731 Kevin Ct., Gallup, NM 87301; (505) 722-4939

Lisa **Bobelu** — *Zuni*
Fetishes; P.O. Box 963, Zuni, NM 87327

Lena L. **Boone** — *Zuni*
Fetishes; P.O. Box 217, Zuni, NM 87327; (505) 782-4524,
(505) 294-8836

Marilyn **Chuyate** — *Zuni*
Fetishes; P.O. Box 1014, Zuni, NM 87327

Phyllis **Coonsis** — *Zuni*
Jewelry: Clusterwork; P.O. Box 796, Zuni, NM 87327;
(505) 782-2374

Patty **Edaakie** — *Zuni*
Jewelry: Inlay; P.O. Box 824, Zuni, NM 87327;
(505) 782-5827, (505) 782-5686

Raylan **Edaakie** — *Zuni*
Jewelry: Inlay; P.O. Box 824, Zuni, NM 87327;
(505) 782-5827, (505) 782-5686

Sheryl **Edaakie** — *Zuni*
Jewelry: Silver & Inlay; P.O. Box 885, Zuni, NM 87327;
(505) 782-4159

Strallie **Edaakie** — *Zuni*
Jewelry: Silver & Inlay; P.O. Box 885, Zuni, NM 87327;
(505) 782-4159

Ola **Eriacho** — *Zuni*
Jewelry; P.O. Box 912, Zuni, NM 87327; (505) 782-2122

Tony **Eriacho** — *Zuni*
Jewelry; P.O. Box 912, Zuni, NM 87327; (505) 782-2122

Bobbie **Esalalio** — *Zuni*
 Jewelry & Art; P.O. Box 1581, Zuni, NM 87327;
 (505) 782-4729, (505) 782-5892

Christina A. **Eustace** — *Zuni-Cochiti*
 Jewelry; P.O. Box 10196, Santa Fe, NM 87504;
 (505) 989-3986

James B. **Eustace** — *Zuni-Cochiti*
 Artist; P.O. Box 11, Cochiti, NM 87072; (505) 465-0328

Kiera **Eustace** — *Zuni-Cochiti*
 Jewelry; Brigitta Str. 31, Essen, Germany, 45130

Jolene **Eustace-Hanelt** — *Zuni-Cochiti*
 Jewelry; Brigitta Str. 31, Essen, Germany, 45130

Eric **Eustace-Othole** — *Zuni-Cochiti*
 Jewelry; P.O. Box 15483, Santa Fe, NM 87501;
 (505) 989-8503

Dinah **Gaspar** — *Zuni*
 Fetishes & Carvings; P.O. Box 2, Zuni, NM 87327;
 (505) 782-4976

Duran **Gaspar** — *Zuni*
 Jewelry; P.O. Box 1004, Zuni, NM 87327; (505) 782-2788

Peter **Gaspar** — *Zuni*
 Fetishes & Carvings; P.O. Box 2, Zuni, NM 87327;
 (505) 782-4976

Bart **Gasper** — *Zuni*
 Kachinas; P.O. Box 285, Zuni, NM 87327

Jolynn B. **Gasper** — *Zuni*
 Jewelry; P.O. Box 1004, Zuni, NM 87327; (505) 782-2788

Margia **Ghahate** — *Zuni*
 Beadwork; P.O. Box 411, Zuni, NM 87327; (505) 782-5605

Rosanne **Ghahate** — *Zuni*
Fetishes & Pottery; P.O. Box 789, Zuni, NM 87327;
(505) 782-4946

Ferdinand **Hooee** — *Zuni*
Jewelry: Silver & Gold; P.O. Box 682, Zuni, NM 87327;
(505) 782-2490

Sylvia **Hooee** — *Zuni*
Jewelry: Silver & Gold; P.O. Box 682, Zuni, NM 87327;
(505) 782-2490

Charles **Hustito** — *Zuni*
Jewelry; Zuni, NM 87327; (505) 782-4702

Clive J. **Hustito** — *Zuni*
Fetishes & Sculpture; P.O. Box 692, Zuni, NM 87327;
(505) 782-2494

Rosalie **Hustito** — *Zuni*
Jewelry; Zuni, NM 87327; (505) 782-4702

Carlton **Jamon** — *Zuni*
Jewelry; P.O. Drawer F., Zuni, NM 87327; (505) 782-2869

Julie **Jamon** — *Zuni*
Jewelry; P.O. Drawer F., Zuni, NM 87327; (505) 782-2869

Marvin **Jamon** — *Zuni*
Jewelry: Trad. & Contemp.; P.O. Box 731, Bernalillo, NM
87004; (505) 867-4663

Ricky **Laahty** — *Zuni*
Fetishes: Frogs; P.O. Box 274, Zuni, NM 87327;
(505) 782-4791

Yolanda **Laate** — *Zuni*
Jewelry; P.O. Box 682, Zuni, NM 87327; (505) 782-2454,
(505) 782-2766

Filmer L. **Lalio** — *Zuni*
Jewelry: Inlay & Needlepoint; 5546 W. Desert Cove, Glendale, AZ 85304; (602) 486-1905

Lydia V. **Lalio** — *Zuni*
Jewelry: Inlay & Needlepoint; 5546 W. Desert Cove, Glendale, AZ 85304; (602) 486-1905

Reynold **Lunasee** — *Zuni*
Fetishes; P.O. Box 1066, Zuni, NM 87327; (505) 782-4535

Josephine **Nahohai** — *Zuni*
Pottery: Contemp & Trad.; P.O. Box 416, Zuni, NM 87327; (505) 782-2163

Milford **Nahohai** — *Zuni*
Pottery: Contemp & Trad.; P.O. Box 416, Zuni, NM 87327; (505) 782-2163

Randy **Nahohai** — *Zuni*
Pottery: Contemp & Trad.; P.O. Box 416, Zuni, NM 87327; (505) 782-2163

Rowena **Nahohai** — *Zuni*
Pottery: Contemp & Trad.; P.O. Box 416, Zuni, NM 87327; (505) 782-2163

Chris **Natachu** — *Zuni*
Artist; P.O. Box 795, Zuni, NM 87327; (505) 782-4632

Emery **Ohmsatte** — *Zuni*
Jewelry: Contemporary; P.O. Box 1, Overgaard, AZ 85933; (520) 535-4884

Gibbs **Othole** — *Zuni*
Jewelry & Art; P.O. Box 1581, Zuni, NM 87327; (505) 782-4729, (505) 782-5892

Loren **Panteah** — *Zuni*
Jewelry; P.O. Box 682, Zuni, NM 87327; (505) 782-2454, (505) 782-2766

Myron **Panteah** — *Zuni*
Jewelry; P.O. Box 28112, Santa Fe, NM 87592;
(505) 920-3161

Allen R. **Paquin** — *Zuni-Apache*
Jewelry: Inlaid Lizard; 95 Lynwood Dr. SE, Rio Rancho,
NM 87124; (505) 892-4031

Geraldine **Paquin** — *Zuni-Laguna*
Jewelry; P.O. Box 35, New Laguna, NM 87038

Leonard **Paquin** — *Zuni-Laguna*
Jewelry; P.O. Box 35, New Laguna, NM 87038

Keith **Paywa** — *Zuni*
Sculptor; P.O. Box 516, Pecos, NM 87552; (505) 774-5968

Agnes **Peynetsa** — *Zuni*
Pottery: Mini/Lizards-Frogs; P.O. Box 252, Zuni, NM
87327; (505) 782-2981

Marvin **Pinto** — *Zuni*
Fetishes & Pottery; P.O. Box 789, Zuni, NM 87327;
(505) 782-4946

Dylan **Poblano** — *Zuni*
Jewelry: Contemporary; P.O. Box 1087, Zuni, NM 87327;
(505) 782-2156

Jovanna **Poblano** — *Zuni*
Beadwork: Contemporary; P.O. Box 1087, Zuni, NM
87327; (505) 782-2156

Veronica **Poblano** — *Zuni*
Jewelry: Gold/Silver Contem; P.O. Box 1087, Zuni, NM
87327; (505) 782-2156

Andrew **Quam** — *Zuni*
Fetishes; 224 Paseo del Volcan SW #939, Albuquerque,
NM 87121; (505) 833-3904

Eldred **Quam** — *Zuni*
Fetishes; P.O. Box 1014, Zuni, NM 87327

Georgette **Quam** — *Zuni*
Fetishes; P.O. Box 1066, Zuni, NM 87327; (505) 782-4535

Jayne **Quam** — *Zuni*
Jewelry & Carvings; P.O. Box 583, Zuni, NM 87327;
(505) 782-2881

Laura **Quam** — *Zuni*
Fetishes; 224 Paseo del Volcan SW #939, Albuquerque,
NM 87121; (505) 833-3904

Lynn **Quam** — *Zuni*
Jewelry & Carvings; P.O. Box 583, Zuni, NM 87327;
(505) 782-2881

Charlotte **Seoutewa** — *Zuni*
Jewelry: Inlay; P.O. Box 1262, Zuni, NM 87327;
(505) 782-4842

Eldrick **Seoutewa** — *Zuni*
Jewelry: Inlay; P.O. Box 1262, Zuni, NM 87327;
(505) 782-4842

Noreen **Simplico** — *Zuni*
Pottery; P.O. Box 324, Zuni, NM 87327; (505) 782-2543

Berdel **Soseeah** — *Zuni*
Pottery: Mini/Lizards-Frogs; P.O. Box 252, Zuni, NM
87327; (505) 782-2981

Edith **Tsabetsaye** — *Zuni*
Jewelry; P.O. Box 285, Zuni, NM 87327

Tiffany **Tsabetsaye** — *Zuni*
Kachinas; P.O. Box 285, Zuni, NM 87327

Fabian **Tsethlikai** — *Zuni*
Fetishes; P.O. Box 963, Zuni, NM 87327

Carlos **Tsipa** — *Zuni*
Jewelry; P.O. Box 1399, Zuni, NM 87327; (505) 782-2814

Ron **Upshaw** — *Zuni-Navajo*
Fetishes & Carvings, Etc.; 4113 Hermosa NE,
Albuquerque, NM 87110; (505) 884-6476

Ed **Vicenti** — *Zuni*
Jewelry: Gold & Silver; P.O. Drawer 610, Zuni, NM
87327; (505) 782-4696, (520) 299-4543

Jennie **Vicenti** — *Zuni*
Jewelry: Gold & Silver; P.O. Drawer 610, Zuni, NM
87327; (505) 782-4696, (520) 299-4543

Nelson **Vicenti** — *Zuni*
Pottery: Traditional; P.O. Box 1192, Zuni, NM 87327;
(505) 782-2329

Daniel I. **Weahkee** — *Zuni-Navajo*
Carver: Fetishes, Etc.; 190 CR Rd. 4800, Bloomfield, NM
87413; (505) 632-5543

Angie **Westika** — *Zuni*
Fetishes & Pottery; P.O. Box 799, Zuni, NM 87327;
(505) 782-4744

Nancy **Westika** — *Zuni*
Jewelry: Silver & Gold; P.O. Box 799, Zuni, NM 87327;
(505) 782-4744

Sheldon **Westika** — *Zuni*
Jewelry: Silver & Gold; P.O. Box 799, Zuni, NM 87327;
(505) 782-4744

Todd **Westika** — *Zuni*
Fetishes & Pottery; P.O. Box 799, Zuni, NM 87327;
(505) 782-4744

Mike **Yatsayte** — *Zuni*
Fetishes & Jewelry; P.O. Box 2422, Gallup, NM 87305;
(505) 778-5487, (505) 870-1005

Other Tribes

Abenaki
Aleut
Anishinabeck
Arapaho
Arikara
Assiniboine/Aleut
Aztec
Beausoleil
Bishop reservation CA
Blackfeet
Cattaraugus
Cayuse
Chehalis
Cheyenne
Chickasaw
Chippewa
Choctaw
Coast Salish
Colville
Comanche
Coushatta
Cree
Creek
Crow
Delaware
Gitxkan

Gros Ventre
Guianbiano
Haida
Ho-Chunk
Hualapai
Huron-Wendat
Ihunktawon
Inupiaq
Iowa
Karok
Kickapoo
Kiowa
Klamath
Kutenai
Kwagiutl
Kwanlin Dun
Kwautil/Cherokee
Laguna
LaJolla Band
Lower Cayuga
Lumbee
Makah
Mandan Hidatsa
Menominee
Meskwaki
Miccosukee

Mi'kmaq
Miwok
Mohave
Mohawk
Muscogee
Nambe
Nanticoke
Nisga'a
Nisqually
Northern Tuchone
Northwest Coast
Ojibwa
Oneida
Osage
Ottawa
Paiute
Pawnee
Pembina
Penobscot
Picuris
Pima
Pojoaque
Ponca
Potawatomi
Quinalt
Salish-Kootenai
Sallawish
San Juan
Sandia

Santa Ana
Seminole
Seneca
Shawnee
Shoshone
Shoshone-Bannock
Skokomish
Southern Arapahoe
Southern Cheyenne
Southern Ute
Spokane
Squamish
Sugpiaq
Tahitan
Taos
Teseque
Tewa
Tlingit
Tohono O'Odham
Tsimshian
Umatilla/Walla Walla
Ute
Waywayseecappo
Winnebago
Yakama
Yaqui
Yu'pik
Yurok
Zia

Other Tribes

Other Tribes

Karen L. **Abeita** — *Tewa-Isleta*
Pottery; P.O. Box 696, Polacca, AZ 86042; (520) 737-2610

Brenda P. **Ackerman** — *Meskwaki*
Clothing: Trad. & Contemp.; 2409 Melrose Ave., Ames, IA 50010; (515) 232-9039

Ivan "Q'we'ens" **Adams** — *Haida*
Jewelry: Overlay & Repousse'; Comp.18 Site. 19 R.R. #3, Terrace, BC V8G 4R6; (250) 638-7226; E-mail: Craftyindian@kermode.net

Angelique **Adamson** — *Salish-Kootenai*
Beadwork, Dr.ums, Pipes & Shield; P.O. Box 432, Pablo, MT 59855; (406) 675-0135

Karen **Ahtone** — *Kiowa-Apache*
Buckskin: Beadwork; Rt. 3, Box 167-B, Anadarko, OK 73005; (580) 588-5066

Ronnee **Ahtone** — *Kiowa-Apache*
Buckskin: Beadwork; Rt. 3, Box 167-B, Anadarko, OK 73005; (580) 588-5066

Richard **Aitson** — *Kiowa*
Beadwork; 9922 Heffner Village, Oklahoma City, OK 73162; (405) 722-3138

Rose **All Runner** — *Picuris*
Pottery; P.O. Box 403, Penasco, NM 87533; (505) 587-2646

Dennis **Allen** — *Skokomish*
Drums & Box es; N. 500 Ress Rd., Shelton, WA 98584; (360) 427-9462

Ron **Alphonse** — *Northwest Coast*
Carver; 323 NE 90th, Seattle, WA 98115; (206) 525-6876

Marcus **Ammerman** — *Choctaw*
Beadwork: Photo-realistic images; P.O. Box 22701, Santa Fe, NM 87502; (505) 995-9637

Tatiana **Andrews** — *Yupik*
Dance: Nunamta; P.O. Box 186, Dillingham, AK 99576

Linda **Anfuso** — *Mohawk*
Artist: Beadwork; 56 Forest Rd., Wilton, NH 3086; (603) 654-2949

Annie **Antone** — *Tohono O'Odham*
Baskets; P.O. Box 85, Gila Bend, AZ 85337; (520) 683-6429

Leona **Antone** — *Tohono O'Odham*
Baskets; 8100 S. Oidak Wo:g, Tucson, AZ 85746; (520) 295-3774

Norma **Antone** — *Tohono O'Odham*
Baskets; P.O. Box 10105, Casa Grande, AZ 85230

Leslie **Aragon** — *Zia*
Pottery: Contemporary; 013 Northeast Dr., Zia Pueblo, NM 87053; (505) 867-3112

Ralph **Aragon** — *Zia*
Pottery & Petroglyph Art; 013 Northeast Dr., Zia Pueblo, NM 87053; (505) 867-3112

Margaret **Archuleta** — *Picuris*
Pottery & Embroidery; P.O. Box 17, Penasco, NM 87533; (505) 587-2116

Sharynn J. **Baker** — *Chippewa*
Jewelry; RR #1, Box 199, Collins, MO 64738; (417) 275-4493

Jean E. **Bales** — *Iowa*
Artist: Miniatures; P.O. Box 193, Cookson, OK 74427; (918) 457-4003

Rocky **Barstad** — *Tsuutina*
Artist: Oils, Pastels, sculptor; 153 MacLeod Tr., High River, AB T1V 1M6; (403) 652-1024; E-mail: rbarstad@rbarstad.com, Web: www.rbarstad.com

George **Beach** — *Chickasaw*
Sculpture & Wood Carvings; HC 30, Box 1772, Lawton, OK 73501; (405) 246-3360

Matthew **Bearden** — *Potawatomi*
Artist; (918) 885-6488

Amos **Beaver** — *Cheyenne*
Artist; Clinton, OK; (405) 323-9231

Richard M. **Bell** — *Coharie*
Sculptor; P.O. Box 720481, Norman, Ok 73070; (405) 360-1558

Robert W. **Bellows** — *Chippewa*
13819 Palmer House Way, Silver Spring, MD 20904; (301) 890-5320

Nancy F. **Bemis** — *Potowatomi*
Drums & Weavings; 909 Broken Wheel Ct., Cheyenne, WY 82007; (307) 638-2482

Donna **Bennett** — *Hualapai*
Jewelry; 5517 E. Waverly St., Tucson, AZ 85712; (520) 298-3772

George O. **Bennett** — *Hualapai*
Jewelry; 5517 E. Waverly St., Tucson, AZ 85712; (520) 298-3772

Les **Berryhill** — *Creek*
Beadwork & Cultural Artifacts; 1800 Bunting Ln., Edmond, OK 73034; (405) 330-2951, (405) 733-7350

Stan **Bevan** — *Tsimshian-Tlingit*
Sculptor: Wood, Masks, Etc.; 1517 Kulspai Dr., Kitselas Village, Terrace, BC V8G 4P5; (250) 638-0028

Susie **Bevins** — *Inupiat*
Sculptor; Point Barrow, AK

Mars **Biggoose** — *Ponca*
Artist; P.O. Box 691578, Tulsa, OK 74169; (918) 663-1259

Diane O. **Billie** — *Seminole*
Beadwork: Clothing, Etc.; P.O. Box 2800, Ochopee, FL
33943; (305) 553-0282

DennisT. **Bird** — *San Juan-SDP*
Jewelry; P.O. Box 1982, Park City, UT 84060;
(801) 583-0400, (801) 649-1111

Gordon **Bird** — *Mandan-Hidatsa*
Musician; P.O. Box 57006, Brookings, SD 57006;
(605) 693-3193

Evelyn **Bird-Quintana** — *San Juan*
Embroidery: Pueblo; 11709 Lexington NE, Albuquerque,
NM 87112; (505) 294-4100

Shawn **Bluejacket** — *Shawnee*
Jewelry; 125 E. Palace Ave. #31, Santa Fe, NM 87501;
(505) 992-4963

Floyd **Bluejay** — *Comanche*
Rainsticks & Gourds, Etc.; 1720 Lakeview Blvd., N. Ft.
Myers, FL 33903; (941) 997-8066

Cliff **Bolton** — *Tsimshian*
Carver: Jade, birchwood, Etc.; P.O. Box 873, Terrace, BC
V8G 4R1; (250) 635-9309

Rena Point **Bolton** — *Tsimshian*
Baskets: Traditional; P.O. Box 873, Terrace, BC V8G4R1;
(250) 635-9309

Debra K. **Box** — *Southern Ute*
Beadwork & Painted Hides; P.O. Box 62477, Colorado
Springs, CO 80962; (719) 495-4236

Edward B. **Box, Sr.** — *Southern Ute*
Jewelry; P.O. Box 224, Ignacio, CO 81137; (970) 563-4128

David **Boxley** — *Tsimshian*
Carver; 34589 Hansville Hwy., Kingston, WA 98346;
(360) 638-1748

Mitchell **Boyiddle** — *Kiowa*
Artist: etc.; P.O. Box 73606, Houston, TX 77273;
(713) 583-7523

Parker **Boyiddle** — *Kiowa*
Artist & Sculptor; 334 Phantom Rd., Westcliffe, CO
81252; (719) 783-2590

Jay **Brabant** — *Cree*
Carver: Wood carvings; 11695 84th Ave., North Delta, BC
V4C ZMZ; (604) 597-1873

Shirley M. **Brauker** — *Ottawa*
Pottery; 1048 Silver Rd., Coldwater, MI 49036;
(517) 238-5833

Aaron **Brokeshoulder** — *Choctaw-Shawnee*
Jewelry; 1702 Old Town Rd. NW, Albuquerque, NM
87104; (505) 842-9356; E-mail: Brksholdr1@aol.com

Ginger E. **Brown** — *Choctaw*
Artist; 11407 W. 155th Terrace, Overland Park, KS 66221;
(913) 897-4873

Pat **Bruderer** — *Cree*
Birchbark: Biting; General Delivery, Moose Lake, Man
ROB OYO; (204) 678-2087

Leonda Fast **Buffalohorse** — *Blackfeet*
Parfleche & Other Crafts; P.O. Box 373, Browning, MT
59417; (406) 338-3158

Quanah **Burgess** — *Comanche*
Artist: Acrylics, W.C., Etc.; 197 NE 1st, Anadarko, OK
73005; (405) 247-4883

Marie **Calabaza** — *San Juan*
Jewelry; P.O. Box 1224, San Juan Pueblo, NM 87566;
(505) 753-5787

Mitchell **Calabaza** — *San Juan*
Jewelry; P.O. Box 1224, San Juan Pueblo, NM 87566;
(505) 753-5787

Ben NightHorse **Campbell** — *Cheyenne*
Jewelry; P.O. Box 639, Ignacio, CO 81137; (970) 563-4623

H. Geoffry **Campbell** — *Tlingit*
Carver: Totems, Etc.; 3722 S. 170th St., Seatac, WA 98188;
(206) 242-6394

Franklin A. **Carillo'** — *Laguna-Choctaw*
Jewelry: Gold, Inlaid; 215 Prospect Ave. NE,
Albuquerque, NM 87102; (505) 243-9736

Diane **Chaat Smith** — *Comanche*
Beadwork: Buckskin, Wearable; 2429 NW 34th St.,
Oklahoma City, OK 73112; (405) 948-4356

Chebon — *Creek-Choctaw*
Artist: Watercolors; 1285 Chasm, Estes Park, CO 80517;
(970) 586-5838

Michael **Chiago Sr.** — *Tohono O'Odham*
Artist: Watercolors, Etc.; P.O. Box 1122, Phoenix, AZ
85001; (520) 361-2474

Randall **Chitto** — *Choctaw*
Pottery: Lumbre; 68 Camino Cabo, Santa Fe, NM 87505;
(505) 466-6858

ShonaBear **Clark** — *Creek*
Parfleche; P.O.Box22212, 1035 Hickox, Santa Fe, NM
87502; (505) 988-2572

Ruth **Cole** — *Creek*
Gourds, Dolls, Beadwork, Etc.; Rt. 2, Box 386, Wagoner,
OK 74467; (918) 485-5100

Gwen **Coleman** — *Choctaw*
Artist: Colored Pencil Draw; Norman, OK; (405) 850-1764

Lois Jean **Conner** — *Miwok*
51500 Rd. 200, O'Neals, CA 93645; (209) 868-3413

Margaret S. **Conover** — *Osage-Sioux*
Beadwork & Weaving; 20568 Slate Gap Rd. East,
Garfield, AR 72732; (501) 359-3947

Beverley **Conrad** — *Mohawk*
Artist: Beadwork, Etc.; Salem Swamp RR1, Box 159,
Selinsgrove, PA 17870; (717) 374-2647

Bruce A. **Cook III** — *Haida-Arapahoe*
Carver: Artist; P.O. Box 338, Haidaburg, AK 99922;
(907) 285-3264

Knee-Know **Corpuz** — *Squamish*
Artist: oils, serigraphs, Etc.; 7068 New Brooklyn Rd. NE,
Bainbridge Island, WA 98110; (206) 842-5460

John **Cruz** — *San Juan*
Gourds & Rattles; San Juan Pueblo, NM 87566;
(505) 988-9821, (505) 852-2053

Donna S. **Cummings** — *Arapaho*
Dolls: Traditional Buckskin; P.O. Box 15393, Santa Fe,
NM 87506; (505) 424-8441; Web: www.indianmarket.net./
shakespeare.html

Arlene **Dahl** — *Menominee*
Dolls; 4506-1/2 Main St., Vancouver, WA 98663;
(206) 695-8543

Sue **Dailey** — *Laguna-Zuni*
Weaver: Traditional Sash; P.O. Box 1353, Paguate, NM
87040; (505) 552-6433

Dawn **Dark Mountain** — *Oneida*
Artist: Watercolors; 107 River Pl., Monona, WI 53716;
(608) 223-0353

Betty **David** — *Spokane*
Clothing: Handpainted Shearling; 105 S. Main St., Ste.
325, Seattle, WA 98104; (206) 624-7666; E-mail:
BDavid7948 (website)

Alex F. **Davis** — *Seneca-Cayauga*
Artist; 1930 E. 8th #2, Joplin, MO 64801; (417) 624-7238

Ralph **Davis** — *Choctaw-Navajo*
Mandelas: Wall Hangings; 335 62nd St. NW,
Albuquerque, NM 87105; (505) 831-2408

Anselm G. **Davis, Jr.** — *Choctaw-Navajo*
Mandelas: Wall Hangings; 335 62nd St. NW,
Albuquerque, NM 87105; (505) 831-2408

Nancy **Dawson** — *Kwagiutl*
Jewelry: Tsawataineuk; 113-1492 Admirals Way, Victoria,
BC V9A 2R1; (250) 598-5324

Ben **Della** — *Makah*
Carvings & Dr.ums; 126 Columbine Dr., Salinas, CA
93906; (408) 422-1159

Troy **DeRoche** — *Blackfeet*
Flutes: Ethnographic Artifact; P.O. Box 490, Chimacum,
WA 98325; (360) 732-4279

Larry J. **DesJarlais** — *Chippewa*
Sculptor & Paintings; P.O. Box 15311, Santa Fe, NM
87506; (505) 473-5426

Robert K. **Deutsawe Jr.** — *Laguna-Zuni*
Jewelry; P.O. Box 953, Paguate, NM 87040

Lawrence **Dili** — *San Juan*
Pottery: Red on Red; P.O. Box 934, San Juan Pueblo, NM
87566; (505) 753-5345

Charlene **Dodson** — *Choctaw*
Clothing & Crafts; 3701 Plains Blvd. #103, Amarillo, TX
79102; (806) 359-8241

Clay **Dodson** — *Choctaw*
Clothing & Crafts; 3701 Plains Blvd. #103, Amarillo, TX
79102; (806) 359-8241

Eula **Doonkeen** — *Seminole*
Artist: Sewing; 1012 N46, Oklahoma City, OK 73118; (405) 521-8505

Argus **Dowdy** — *Choctaw*
Pipes; HC 67, Box 40, Skiatook, OK 74070; (918) 396-2432

Pueblo **Drums** — *Taos*
Drums; 121 N. Plaza #E, Taos, NM 87571; (505) 758-7929, (505) 758-9642

Guy **Du Sault** — *Huron-Wendat*
Clothing; 630 Atironta, Wendake, Qc G0A 4VO; (418) 847-3332

Adeline K. **DuBoise** — *Potawatomi*
Clothing; Rt. 2, Box 169, Tecumseh, OK 74873; (405) 598-2088

Joe **Duran** — *San Juan*
Drums; P.O. Box 972, San Juan Pueblo, NM 87566; (505) 753-5280

Linda **Duran** — *Choctaw-Apache*
Dolls; P.O. Box 2381, Palmer, AK 88645; (907) 745-8497

Anthony J. **Durand** — *Picuris*
Pottery: Micaceous; P.O. Box 254, Penasco, NM 87553; (505) 587-0010

Cora **Durand** — *Picuris*
Pottery: Micaceous; P.O. Box 254, Penasco, NM 87553; (505) 587-0010

Lance A. **Dyea** — *Laguna*
Jewelry; P.O. Box 825, Laguna, NM 87026; (505) 552-6439

Black **Eagle** — *Shoshone-Yokut*
Shields: Breastplates, Etc.; P.O. Box 621, Copperopolis, CA 95228; (209) 785-5259; Web: www.warriorart.com

Lone **Eagle** — *Chippewa*
Mixed-Media; P.O. Box 286, Mt. Pleasant, MI 48804;
(517) 775-7598

Bertha **Early** — *Laguna-Cochiti*
Pottery: Trad. Cochiti/Laguna; P.O. Box 1405, Paguate,
NM 87040; (505) 552-7466

Max **Early** — *Laguna-Cochiti*
Pottery: Trad. Cochiti/Laguna; P.O. Box 1405, Paguate,
NM 87040; (505) 552-7466

Ken **Edwards** — *Colville*
Artist; Rt. 2, Box 72 S., Omak, WA 98841; (509) 826-4744

Fred "Koshon" **Edzerza** — *Tahitan*
Carvings: Horn , Jewelry; 704 Strickland St., Whitehorse,
YK Y1A 2K8; (867) 668-1833

Dorothy **Emery** — *Chippewa-Jemz*
A & C.; 7002 Loma Larga Rd., Corrales, NM 87048;
(505) 890-0419

Terry **Emery** — *Chippewa-Jemz*
A & C.; 7002 Loma Larga Rd., Corrales, NM 87048;
(505) 890-0419

Sam **English** — *Chippewa*
Artist; Albuquerque, NM

Vickie Tunyu **Era** — *Alutiq*
Baskets: Cedar Bark; 2744 173rd Ave. SW, Rochester, WA
98579; (360) 273-5216

Patty **Fawn** — *Kwaitul-Chero.*
Jewelry; 165 Merwin Village Rd., Ariel, WA 98603;
(360) 225-9735, (360) 225-8828

Roger **Fernandes** — *Lower Elwha S-Klallam*
Cut paper: Salish designs; P.O. Box 46294, Seattle, WA
98145; (425) 557-4638

Anita **Fields** — *Osage*
Ribbonwork & works in Clay; 1001 S. Walnut, Stillwater, OK 74074; (405) 743-2782

Joseph **FireCrow, Jr.** — *Cheyenne*
Flutes: Recordings, Maker; (860) 379-6007

George **Flett** — *Spokane*
Artist; P.O. Box 197, Wellpinit, WA; (509) 258-4454, (509) 258-7846

Karen **Floan** — *Ojibwe*
Beadwork: Clothing; 1535 Willard Ave., Detroit Lakes, MN 56501; (218) 846-9911

Jerry **Floresca** — *Colville*
Drums: Buckskins; P.O. Box 471, Nespelem, WA 99155; (509) 634-8703

Adam **FortunateEagle** — *Chippewa*
Pipes & Sculptor; 7133 Stillwater Rd., Fallon, NV 89406; (702) 423-6663

Leonard **Fourhawks** — *Mohawk-Chey.*
Bonework: Breastplates, Etc.; P.O. Box 60337, Florence, MA 01060; (413) 586-6948, (413) 586-5131

Rikki **Francisco** — *Pima*
Baskets; P.O. Box 812, Sacaton, AZ 85247; (520) 315-1753

Martin **Funmaker** — *Ho-Chunk*
Flutes, Clothing, Arts; P.O. Box 4731, Ft. Smith, AR 72914

Andrew **Gallegos** — *Santa Ana*
Gourds: Hand Painted; Santa Ana Pueblo, NM 87004

Retha W. **Gambaro** — *Muscogee (Creek)*
Weaving & Sculptor; 74 Dishpan Ln., P.O.Box 1117, Stafford, VA 22554; (540) 659-0130

Michael D. **Garcia** — *Yaqui*
Jewelry; Rt. 1, Box 125, Santa Fe, NM 87501;
(505) 455-2093; Web: www.westernguide.com

Myra **Garcia** — *San Juan*
P.O. Box 903, San Juan Pueblo, NM 87566; (505) 852-2620

Reycita A. **Garcia** — *San Juan*
Pottery: Storytellers, Figurine; P.O. Box 934, San Juan,
NM 87566; (505) 852-2301

Connie T. **Gaussoin** — *Picuris-Navajo*
Jewelry; P.O. Box 2491, Santa Fe, NM 87504; (505) 471-4335

R. W. **Geionety** — *Kiowa*
Artist; 403 W. Mississippi, Anadarko, OK 73005;
(405) 247-6037

Glenn **Gomez** — *Pojoaque*
Pottery; Rt. 11, Box 71-CC, Santa Fe, NM 87501;
(505) 455-3284

Henrietta **Gomez** — *Taos*
Pottery: Traditional; P.O. Box 292, El Prado, NM 87529;
(505) 758-3052

Terry **Gomez** — *Comanche*
Artist; Santa Fe, NM; (505) 424-6070, (505) 471-3831

Sandra M. **Good** — *Coast Salish*
Clothing & Other Arts; 90 Front St., Unit 6, Nanaimo, BC
V9R 5B8; (250) 754-0074

William **Good** — *Coast Salish*
Clothing & Other Arts; 90 Front St., Unit 6, Nanaimo, BC
V9R 5B8; (250) 754-0074, (250) 755-1722

Chandler **Good Strike** — *Gros Ventre*
Parfleche: Painted Hides; P.O. Box 1038, Hays, MT 59527;
(406) 353-2659; E-mail: goodstrike@hotmail.com

John "Nytom" **Goodwin** — *Makah*
 Clothing; P.O. Box 135, Neah Bay, WA 98357;
 (360) 645-2109; E-mail: nytom@olypen.com,
 web:www.nytomn.com

Connie **Gowen** — *Seminole*
 Crafts: Beadwork, Dolls, Etc.; 6481 James E. Billie Dr.,
 Hollywood, FL 33024; (305) 962-1972

Rollie A. **Grandbois** — *Chippewa-Cree*
 Sculptor: Stone, Bronze; 099 Grandbois Dr., P.O.Box 84,
 Jemez Springs, NM 87025; (505) 829-3588

Dorothy **Grant** — *Haida*
 Clothing: Fashion Designer; 250-757 W. Hastings St.,
 Vancouver, BC V6C 1A1; (604) 681-0201

Gina **Gray** — *Osage*
 Artist; 211 E. Brooks, Norman, OK 73069; (405) 329-8854

Yvonne **Grayson** — *Zia-Acoma*
 Pottery: Trad. & Contemp.; P.O. Box 469, New Laguna,
 NM 87038; (505) 552-9515

Teri **Greeves** — *Kiowa*
 Beadwork; Rt. 8, Box 296-A, Santa Fe, NM 87505;
 (505) 438-8398

Brenda K. **Grummer** — *Potawatomi*
 Artist; 11105 Coachman's Rd., Yukon, OK 73099;
 (405) 373-2894

Paul **Hacker** — *Choctaw*
 Knives & Flutes; 6513 NW 20th Dr., Oklahoma City, OK
 73008; (405) 787-8600, (405) 789-2300

Dow **Hadaway** — *Shawnee*
 Drums, Etc.; 11047 Fenway St., Sun Valley, CA 91352;
 (818) 768-0622

June **Hadaway** — *Shawnee*
Beadwork; 11047 Fenway St., Sun Valley, CA 91352;
(818) 768-0622

Patrice **Hall-Walters** — *Umatilla-WallaWal*
Photograpy; 405 NW Despain, Pendleton, OR 97801;
(541) 278-0115; E-mail: walters@ucinet.com

Victoria A. **Hamlett** — *Cheyenne*
Jewelry; P.O. Box 36, Sun River, MT 59483; (406) 264-5205

Dona **Haney** — *Seminole*
P.O. Box 72, Seminole, OK 74868; (405) 382-3369

Enoch K. **Haney** — *Seminole*
Artist; P.O. Box 72, Seminole, OK 74868; (405) 382-3369

Mary C. **Hanna** — *Paiute-Blackfeet*
Dolls: Northern Traditional; P.O. Box 3493, Pagosa
Springs, CO 81147; (970) 264-2556

Sharron A. **Harjo** — *Kiowa*
Artist; Oklahoma City, OK; (405) 751-7939

Benjamin **Harjo Jr.** — *Shawnee-Seminole*
Artist: Gouache, Etc.; 1516 NW 35th St., Oklahoma City,
OK 73118; (402) 521-0246

Delores **Harragarra** — *Kiowa*
Dolls & Crafts; P.O. Box 828, Carnegie, OK 73015;
(405) 654-2037

Terry "Tuka" **Hartman** — *Yaqui*
Artist: Blanket Design; P.O. Box 22452, Milwaukie, OR
97269; (503) 659-5589

Denny **Haskew** — *Potawatomi*
Sculptor: Bronze; 540 North Grant, Loveland, CO 80537;
(970) 663-6375

Leonard J. **Hawk** — *Yakima*
Jewelry; P.O. Box 329, Second Mesa, AZ 86043; (520) 734-9353

Gus D. **Hawzipta** — *Kiowa*
Artist & Jewelry; HC 69, Box 45, Park Hill, OK 74451;
(918) 456-8547

Eva **Heffke** — *Inupiaq Eskimo*
Dolls: Eskimo-Museum-quality; 2394 Dawson Rd., North
Pole, AK 99705

Chuck "Ya'Ya" **Heit** — *Gitxsan*
Carver: Totems; #89-K, Hazelton, BC V0J-1Y0;
(250) 842-5142

Jesse W. **Henderson** — *Chippewa-Cree*
Artist: Oil, Acrylic, Watercolors; 4632 Richlie St.,
Missoula, MT 59808; (406) 549-0609

Lonnie **Henderson** — *Comanche*
Artist; 440 N. 102nd, Anadarko, Ok 73005; (405) 247-5144

Valjean M. **Hessing** — *Choctaw*
Artist: Watercolors; 300 S. Ash St., Onarga, IL 60955;
(815) 268-4473

George D. **Hill** — *Spokane*
Sculptor & Paintings; Box 84, Wellpinit, WA 99040;
(509) 258-9200

Tyree **Honga** — *Hualapai*
Artist; 9155 N. 3rd St., Rm. 2282, Phoenix, AZ 85020;
(602) 870-6060, Ext. 3593

Caroline D. **Honyumptewa** — *Picuris*
Pottery; P.O. Box 46, Penasco, NM 87533; (505) 587-0411

Alan **Hood** — *Shoshone-Bannock*
Tanning: Buckskin; 521 7th St., Heyburn, ID 83336;
(208) 678-0791

Daisey F. **Hood** — *Shoshone-Bannock*
Tanning: Buckskin; 521 7th St., Heyburn, ID 83336;
(208) 678-0791

Rusty **Houtz** — *Shoshone-Bannock*
Sculptor; P.O. Box 582, Ft. Hall, ID 83203; (208) 237-9791

Norma **Howard** — *Choctaw-Chicka*
Artist; Rt. 2, Box 1687, Stigler, OK 74462; (918) 967-4314,
(918) 967-0046

Clarissa **Hudson** — *Tlingit*
Clothing: Ceremonial regalia; P.O. Box 2709, Pagosa
Springs, CO 81147; (970) 264-2491

Tom **Huff** — *Seneca-Cayuga*
Sculptor; RD#1, Box 245A, Neddrow, NY 13120;
(315) 492-3750

Jason **Hung** — *Kwa'gulth*
Carver; 403 935 Johnson St., Victoria, BC V8V 3N5;
(250) 216-6646

Troy **Hunter** — *Kutenai*
Photography; S.S.#3, Ste. 15-14, MissionRd., Cranbrook,
BC ViC 6H3; (250) 472-0175

Jerry **Ingram** — *Choctaw-Cher.*
Beadwork & Quillwork; General Delivery, Ilfeld, NM
87538; (505) 421-2611

Jan M. **Jackson** — *Klamath-Modoc*
Sculptor; 7418 SE Reedway, Portland, OR 97206;
(503) 777-6010

Jim **Jackson** — *Klamath-Modoc*
Sculptor; P.O. Box 211, Corbett, OR 97019; (503) 695-2809

Nathan P. **Jackson** — *Tlingit*
Carving & Jewelry; 5972 Roosevelt Dr. S., Ketchikan, AK
99901; (907) 225-3431

Norman G. **Jackson** — *Tlingit*
Carver: Boxes, Etc.; P.O. Box 8241, Ketchikan, AK 99901;
(907) 225-2691

Walter W. **Jacobs, III** — *Nanticoke*
Artist; 217 S. Pine St., Langhorne, PA 19047;
(215) 757-2295

Cedric D. **James** — *Choctaw-Chicka*
Artist: Feathers; 3121 Meadow Ln., Edmond, OK 73013;
(404) 330-1665

Patta LT **Joest** — *Choctaw*
Clothing: Contemporary; 814 N. Jones, Norman, OK
73069; (405) 360-0512

Liz **John** — *Coushatta*
Baskets: Pine Needle; Rt. 3, Box 501, Livingston, TX
77351; (409) 563-4217

Eileen **Johnson** — *Winnebago*
Artist; P.O. Box 45394, Rio Rancho, NM 87174; (505) 994-2246

Katherine **Johnson** — *Ho-Chunk*
Jewelry & Sculpture; P.O. Box 35, Jemez Pueblo, NM
87024; (505) 829-3077

Kenneth **Johnson** — *Muscogee-Sem.*
Jewelry; P.O. Box 23296, Santa Fe, NM 87501;
(505) 831-0643; E-mail: kjohnson@numa.niti.org, Web:
www.kjewelry.com

Terrol Dew **Johnson** — *Tohono O'Odham*
Baskets; P.O. Box 1790, Sells, AZ 85634; (520) 383-4966;
E-mail: tdewj@aol.com

David G. **Jones** — *Choctaw-Chero.*
Pipes: Ceremonial; P.O. Box 11224, Prescott, AZ 86304;
(520) 445-6987

Peter B. **Jones** — *Cattaraugus*
Sculpture & & Pottery; Box 174, Versailles, NY 14168;
(716) 532-5993

Ruthe B. **Jones** — *Delaware Shaw.*
 Artist; 517 S. Woodlawn, Okmulgee, OK 74447;
 (918) 758-0678

Woody **Jones** — *Choctaw*
 Pipes: Chahta; 7602 W. Winnzona, Phoenix, AZ 85033;
 (602) 247-7483

Apanguluk **Kairaiuak** — *Yup'ik*
 Carver: Spirit Masks, Etc.; P.O. Box 3977, Palmer, AK
 99645; (907) 745-8497

Robert **Kaniatobe** — *Choctaw*
 Jewelry, Etc.; 431 W. Tennessee St., Durant, OK 74701;
 (405) 931-9460

Michael **Kanteena** — *Laguna*
 Pottery: Pre-Colum Repros.; P.O. Box 777, New Laguna,
 NM 87038; (505) 833-5968

Randy G. **Kemp** — *Choctaw-Creek*
 Artist; P.O. Box 25071, Phoenix, AZ 85014; (602) 965-1357

John M. **Kessler, Jr.** — *Shawnee*
 Jewelry; 314 Yoctangee, Chillicothe, OH 45601;
 (614) 772-6854

Diana **Klopmeyer** — *Yurok*
 Dolls; Rt. 1, Box 308, Pendleton, OR 97801; (503) 276-1000

Carolyn **Krumanocker** — *Chickasaw*
 Sculptor, Dolls, Etc.; 9617 Harmony, Midwest City, OK
 73130; (405) 733-7165

King **Kuka** — *Blackfeet*
 Artist: Sculptor; 907 Ave. C NW, Great Falls, MT 59404;
 (406) 452-4449

Leon **LaFortune** — *Coast Salish*
 Carving: Masks, Etc.; Comox, BC; (250) 339-4203

Other Tribes

Bruce **LaFountain** — *Chippewa*
Sculptor; 223 N. Guadalupe #144, Santa Fe, NM 87501;
(505) 988-3703, (505) 473-4004

Presley **LaFountain** — *Chippewa*
Sculptor; 208 LaCruz, Santa Fe, NM 87501; (505) 820-7141

Jerry **Laktonen** — *Sugpiaq*
Alutiiq Bird Masks; P.O. Box 635, Carlsborg, WA 98324;
(360) 582-0961

Brian **Larney** — *Seminole-Choctaw*
Artist; 1055 N. Federal Hwy., Ft. Lauderdale, FL 33304;
(214) 943-2445, (214) 943-9616

Henri K. **LaRue** — *Tlingit*
Crafts: Traditional; 37121 Grays Airport Rd., Lady Lake,
FL 32159; (352) 728-8745

Brent **Learned** — *Cheyenne-Arap*
Artist; 2840 N. Grand Blvd., Oklahoma City, OK 73107;
(405) 943-7294

Buddy **Lee** — *Kiowa*
Jewelry; Rt. 5, Box 247-E, Santa Fe, NM 87501; (505) 699-0539

Martha **Leeds** — *Laguna-Pima*
Pottery & Paintings; P.O. Box 271, New Laguna, NM
87038; (505) 552-9567

Laura L. **Leverich** — *Nisqually*
Beadwork: Jewelry, Etc.; 9811 NE 90th Ave., Vancouver,
WA 98662; (360) 254-3227

Lorraine Gala **Lewis** — *Laguna-Taos-Hopi*
Pottery: Storytellers; 4016 Rancho Gusto NW,
Albuquerque, NM 87120; (505) 899-3794

Harold **Littlebird** — *Laguna-SDP*
Pottery & Poet; 6 Buskirk Ln., Peralta, NM 87042;
(505) 869-0149

Day **Lone Wolf** — *Abenaki*
Jewelry: Silver & Gold; 77 N. Main St., Orange, MA 01364; (508) 544-8620

Odin **Lonning** — *Tlingit*
Carving; Spirit House Indian Art School, Seattle, WA

Yvonne E. **Lucas** — *Laguna*
Pottery; 301 Calle Pinon, Gallup, NM 87301; (505) 863-5705, (520) 737-2345

Diana **Lucero** — *Zia*
Pottery: Trad. & Contemp.; P.O. Box 105, San Ysidro, NM 87053; (505) 834-7338

Joanne **Luger** — *Northern Tuchone*
Artist; 1633 Pocatello, Bismarck, ND 58504; (701) 224-1157

Pam **Lujan-Hauer** — *Taos*
Pottery; P.O. Box 17, Taos Pueblo, NM 87571; (505) 888-4465

Tom **Machauty Ware** — *Kiowa-Comanche*
Recording: Artist, MC, Dance; P.O. Box 1771, Anadarko, OK 73005; (405) 247-9494

Duane **Maktima** — *Laguna-Hopi*
Jewelry; P.O. Box 307, Glorieta, NM 87535; (505) 757-6946

Joe **Maktima** — *Laguna-Hopi*
Artist; P.O. Box 22282, Flagstaff, AZ 86002; (520) 779-5030

Alex **Maldonado** — *Yaqui*
Flutes: Flute Player; 5536 E. San Angelo, Guadalupe, AZ 85283; (602) 839-3028

Merced **Maldonado** — *Yaqui*
Drums, Rattles, Dance Sticks; (602) 839-3028, (602) 955-0049

David R. **Maracle** — *Mohawk*
Artist: Mohawk Territory; P.O. Box 323, Tyendinaga, ON KOK 1XO; (613) 396-2397, (613) 396-2767

Philip C. **Martinez** — *Taos*
Drums; 131 Paseo Del Sur, Taos Pueblo, NM 87571; (505) 758-7929

Jane M. **Mauldin** — *Choctaw*
Artist; 5329 E. 27th Pl., Tulsa, OK 74114; (918) 747-6033

Donna B. **McAlester** — *Creek*
Artist: Watercolors; 113 Sierra Madre, Texarkana, TX 75503; (903) 832-6388

Michael **McCullough** — *Choctaw*
Artist; 323 Romero NW #6, Albuquerque, NM 87104; (505) 242-8667

Stephen **McCullough** — *Choctaw*
210 Sunset Terrace, Amarillo, TX 79106; (806) 352-3574

Chuna **McIntyre** — *Yupik*
Dance Group: Nunamta; 917 Dorine Ave., Rohnert Park, CA; (707) 585-8052

Ken **McNeil** — *Tahitan-Tlingit*
Carver: Northwest Designs; P.O. Box 32, Kispiox, BC V0J 1Y0; (250) 842-5011

Marie **Meade** — *Yupik*
Dance: Nunamta; 4342 East 4th, Anchorage, AK 99508

Elizabeth **Medina** — *Zia*
Pottery & Paintings; P.O. Box 172, San Ysidro, NM 87053; (505) 867-3852

Marcellus **Medina** — *Zia*
Pottery & Paintings; P.O. Box 172, San Ysidro, NM 87053; (505) 867-3852

Garry J. **Meeches** — *Ojibway*
Artist: Acrylics; 54-03 Yale Ave., Meridian, CT 06450; (203) 235-2764

Art **Menchego** — *Santa Ana*
Artist: Watercolors, Oils; P.O. Box 68, Santa Ana Pueblo, NM; (505) 867-4485

Walter S. **Mentuck** — *Waywayseecappo*
Jewelry; P.O. Box 130, Waywayseecappo, MB ROJ 150

Jess **Mermejo** — *Picuris*
Pottery; P.O. Box 23, Penasco, NM 87533; (505) 587-0411

Rene **Meshake** — *Ojibway*
Artist & Note Cards; P.O. Box 30105, 2 Quebec St., Guelph, ONT N1H 8J5; (888) 2891278; Web: www.freespace.net/~catfish/

Armenia **Miles** — *Cayuse-Hail*
Tipis, Clothing, Etc.; P.O. Box 78195, Seattle, WA 98178; (206) 772-2795

Cloud Eagle **Mirabal** — *Nambe*
Sculptor: Bronze; Rt. 1, Box 117H, Nambe Pueblo, NM 87501; (505) 455-2662

Frank **Mirabal** — *Taos*
Drums; P.O. Box 1228, Taos Pueblo, NM 87571; (505) 758-1455

Robert **Mirabal** — *Taos*
Flute Player; P.O. Box 641, Taos Pueblo, NM 87571; (505) 751-1143

Gus **Modeste** — *Coast Salish*
Carver: Wood; P.O. Box 1513, Chemainus, BC V0R 1K0; (250) 246-1056

Sandra L. **Monague** — *Beausoleil*
Jewelry; P.O. Box 130, Waywayseecappo, MB ROJ 150

David A. **Montour** — *Potawatomi*
Sculptor: Artist; P.O. Box 13484, Phoenix, AZ 85002; (602) 433-2085, (602) 376-7126

Jen **Moquino** — *Tesuque*
Embroidery; P.O. Box 322, Tesuque, NM 87574; (505) 989-3865

Randy **Moquino** — *Tesuque*
Embroidery; P.O. Box 322, Tesuque, NM 87574; (505) 989-3865

Meridth C. **Morgan** — *Yakama*
Beadwork & Traditional Clothing; 101 Rodeo Dr.,
Yakama Reserv., White Swan, WA 98952; (509) 874-2290

David **Morris** — *Choctaw*
Rock Art; P.O. Box 328, Maricopa, AZ 85239; (602) 983-9609

Gerald **Nailor** — *Picuris*
Artist: Oils, Watercolors; P.O. Box 132, Vadito, NM 87579;
(505) 587-1733

Nakwesee — *Kwautil-Cherok.*
Jewelry; P.O. Box 1450, Woodland, WA 98674;
(360) 225-9735, (360) 225-8828

David **Neel** — *Kwagiutl*
Photographer: Artist; 441 W. 3rd St., N. Vancouver, BC
V7M 1G9; (604) 988-9215; Web: www.neel.org/dneel/

Jennifer **Neptune** — *Penobscot*
Jewelry & Porcupine Quillwork; P.O. Box 195, Old
Town, ME 04468; (207) 827-6117

Martin **Neptune** — *Penobscot*
Quillwork, Jewelry & Crafts; P.O. Box 195, Old Town,
ME 04468; (207) 827-6117

Lean Tate **Nevaquaya** — *Comanche*
Flutes: Flutist; 6916 Laurelhill Ct. N., Ft. Worth, TX 76113;
(817) 294-8514

Tim **Nicola** — *Penobscot*
Sculptor; 359 B. SW Miller Rd., Los Lunas, NM 87031;
(505) 861-0326; E-mail: Nisculpt@Nmol.com

Other Tribes

Nokomis — *Ojibwa*
Artist; 259 Ranch Estates Dr. NW, Calgary, ALB T3G 1K7;
(403) 241-8749

Al **Nordwall** — *Chippewa*
Pipes: Beaded P-Hatband; 401 Anthony, Muskogee, OK
74403; (918) 683-3458

Raymond **Nordwall** — *Pawnee-Chippe*
Artist; 1507 Ridgecrest Dr. SE, Albuquerque, NM 87108;
(505) 265-0636

Jamie **Okuma** — *LaJolla Band*
Beadwork & Dolls; P.O. Box 173, Pauma Valley, CA
92061; (760) 742-3404

Sandra **Okuma** — *LaJolla Band*
Artist; P.O. Box 173, Pauma Valley, CA 92061;
(760) 742-3404

Marvin **Oliver** — *Quinalt-Isleta*
Sculptor; 3501 Fremont Ave. N., Seattle, WA 98103;
(206) 633-2468; Web: www.neel.org/dneel/

Rose **Olney** — *Yakama*
A & C.; P.O. Box 734, Allyn, WA 98524; (360) 275-7464

Meg **Orr** — *Colville*
Misc.; P, O, Box 4188, Omak, WA 98841; (509) 826-0904

Betty L. **Osceola** — *Miccosukee*
Clothing: Patchwork, Etc.; S.R. Box W-4800, Ochopee, FL
34141; (305) 554-7113

Joe Dan **Osceola** — *Seminole*
Clothing: Seminole Patchwork; 5791 S. St. Rd. 7, Ft.
Lauderdale, FL 33314; (954) 581-0416

Virginia **Osceola** — *Seminole*
Clothing: Patchwork Seminole; 5791 S. State Rd. #7, Ft.
Lauderdale, FL 33314; (954) 581-0416

Norman **Pacheco** — *San Juan*
Artist: Paintings, Carvings; P.O. Box 768, San Juan Pueblo, NM 87566; (505) 852-2502, (505) 262-2841

Patricia D. **Pacheco** — *Laguna-Chippewa*
Crafts: Dreamcatchers, Etc.; P.O. Box 62, Laguna, NM 87026; (505) 552-6234

Laurie Grimes **Pahnke** — *Aleut-Unangan*
Artist; HCO2-7730, Palmer, AK 99645; (907) 355-0540

Pahponee — *Kickapoo*
Pottery; 41920 Valley View Ct., Elizabeth, CO 80107; (303) 646-2280

Cheryl J. **Paisano** — *Laguna-Cherok.*
Jewelry & Beadwork; 4113 Hendrix Rd. NE, Albuquerque, NM 87110; (505) 881-4910

Michelle **Paisano** — *Laguna-Acoma*
Pottery: Clay Sculptor; 9385 Perry St., Westminster, CO 80030; (303) 427-8422

Ulysses G. **Paisano** — *Laguna*
Jewelry; 4113 Hendrix Rd. NE, Albuquerque, NM 87110; (505) 881-4910

Lucille **Pakootas** — *Colville*
Drums: Buckskins; P.O. Box 471, Nespelem, WA 99155; (509) 634-8703

Gladys **Paquin** — *Laguna*
Pottery; P.O. Box 517, New Laguna, NM 87038

Glenn **Paquin** — *Laguna-Zuni*
Jewelry; P.O. Box 123, New Laguna, NM 87038; (505) 552-7164

Karen D. **Paquin** — *Laguna*
Jewelry; P.O. Box 953, Paguate, NM 87040

Opal **Paquin** — *Laguna-Zuni*
Jewelry; P.O. Box 123, New Laguna, NM 87038; (505) 552-7164

Amado **Pena** — *Mestizo*
Artist; 235 Don Gaspar #3, Santa Fe, NM 87501; (505) 820-2286

Laura **Pena** — *Santa Ana*
Pottery: Traditional Santa Ana; P.O. Box 731, Bernalillo, NM 87004; (505) 867-4663

Les **Peone** — *Salish-Kootenai*
Jewelry; P.O. Box 105, St. Ignatius, MT 59685; (406) 745-4456

Roger **Perdasofpy** — *C omanche-Kiowa*
Drums & Jewelry; P.O. Box 932, Midlothian, TX 76065; (972) 723-2984

Sharon **Perdasofpy** — *Comanche-Cheyen*
Beadwork, Etc.; P.O. Box 932, Midlothian, TX 76065; (972) 723-2984

Yvonne **Peterson** — *Chehalis*
Baskets: Miniatures; 137 Anderson Rd., Oakville, WA 98568; (360) 273-7274

Pete **Peterson Sr.** — *Skokomish*
Carver: Metalsmith; P.O. Box 487, Hoodsport, WA 98548; (360) 877-9158; E-mail: peterson@hctc.com

Reggie **Peterson, Sr.** — *Tlingit*
Carver: Masks, rattles, Etc.; P.O. Box 2425, Sitka, AK 99835

Patricia **Piche** — *Chippewa-Cree*
Clothing; P.O. Box 89, Bon Accord, ALB TOA OKO; (403) 921-2072

Vicentita S. **Pino** — *Zia*
Pottery; 231 Plaza Lp., Zia Pueblo, NM 87053; (505) 867-3433

Other Tribes

Eleanor **Pino-Griego** — *Zia*
Pottery: Trad. & Contemp.; P.O. Box 112, Corrales, NM 87048; (505) 890-0077

Lillian **Pitt** — *Yakima*
Masks: Raku & Anagama; 11528 SE Lincoln, Portland, OR 97216; (503) 252-1854

Edward **Platero** — *Laguna*
Jewelry; P.O. Box 12, New Laguna, NM 87038

Susan A. **Point** — *Coast Salish*
Sculptor; 1370 Cartwright, St. Granville Isl., Vancouver, BC; (604) 689-9918, (604) 266-7374

Charlie **Pratt** — *Cheyenne-Arap*
Sculptor & Miniatures; 4350 Airport Rd., Ste. 5, Santa Fe, NM 87505; (505) 982-8630

Willie **Preacher** — *Shoshone-Bannock*
Artist: Oils; 500 N. Stout, Blackfoot, ID 83221; (208) 785-3455

Jackie S. **Priore** — *Kiowa*
Beadwork; 630 Nickel St., Los Banos, CA 93635; (209) 827-1298

Bill **Prokopiof** — *Aleut*
Sculptor; 1725 Callejon Emilia, Santa Fe, NM 87501; (505) 982-9361

Tony **Purley** — *Laguna*
Beadwork: Jewelry; 716 Monell NE, Albuquerque, NM 87123; (505) 293-0852

Wilma **Purley** — *Laguna-Hopi*
Beadwork: Jewelry; 716 Monell NE, Albuquerque, NM 87123; (505) 293-0852

Joseph E. **Rael** — *Southern Ute*
Artist: Other; P.O. Box 1309, Bernalillo, NM 87004; (505) 867-9315

Joseph E. **Rael, Sr.** — *Southern Ute*
Artist: Mixed media; P.O. Box 177, Hesperus, CO 81326; (970) 259-2246

J. D. **Rainstorm** — *San Juan-Laguna*
Artist: Acrylics; Route 11, Box 331, Santa Fe, NM 87501

Heidi BigKnife **Rankin** — *Shawnee*
Jewelry & Mixed-Media Art; P.O. Box 1204, Santa Fe, NM 87504; (505) 988-8978

Harvey **Rattey** — *Pembina-Assini*
Sculptor; P.O. Box 1184, Glendive, MT 59330; (406) 365-8505, (800) 552-0970

Austin **Real Rider** — *Pawnee*
Sculptor; P.O. Box 524, Pawnee, OK 74058; (918) 762-2722

Kevin **Red Star** — *Crow*
Artist: Oils; 15 S. Broadway Ave., Box 1377, Red Lodge, MT 59068; (800) 858-2584

Ernest R. **Redbird** — *Kiowa*
Doll Artist; 412 E. Louisiana, Anadarko, OK 73005; (405) 247-9630

Petur S. **Redbird** — *Seminole-Creek*
Artist: Jewelry, Etc.; 1829 E. La Jolla, Tempe, AZ 85282

Robert **Redbird** — *Kiowa*
Artist; 2108 Mountain Rd., Ste. B-1, Albuquerque, NM 87104; (505) 224-9703

Robert Jr. **Redbird** — *Kiowa*
Artist; 2108 Mountain Rd., Ste. B-1, Albuquerque, NM 87104; (505) 224-9703

Steven **Redbird** — *Kiowa*
Artist; 2108 Mountain Rd., Ste. B-1, Albuquerque, NM 87104; (505) 224-9703

Tonia **Redbird** — *Kiowa*
Artist; 2108 Mountain Rd., Ste. B-1, Albuquerque, NM 87104; (505) 224-9703

Tony **Redbird** — *Kiowa*
Artist; 2108 Mountain Rd., Ste. B-1, Albuquerque, NM 87104; (505) 224-9703

Will **Redbird** — *Kiowa*
Artist; 2108 Mountain Rd., Ste. B-1, Albuquerque, NM 87104; (505) 224-9703

Mark **Redfox** — *Arikara-Lakota*
Artist; 814 Columbia #32, Seattle, WA 98104; (206) 340-1934

Steve **Relton** — *Mi'kmaq*
Quillwork; P.O. Box 492, Truro, NS B2N 5C7; (902) 893-7825; E-mail: steve@redcrane.ca

Sharon D. **Reyna** — *Taos*
Bronze & Clay; P.O. Box 3031, Taos Pueblo, NM 87571; (505) 758-3790

Margaret **Rodriguez-C** — *Laguna*
Pottery; P.O. Box 533, Veguita, NM 87062; (505) 861-1890

Alta **Rogers** — *Paiute-Yurok*
Baskets & beadwork; 2563 W. Line St., Bishop, CA 93514

Michael **Rogers** — *Paiute*
Jewelry; 2563 W. Line St., Bishop, CA 93514; (619) 873-6991

Michael R. **Rogers** — *Paiute*
Beadwork: Jewelry; 2563 W. Line St., Bishop, CA 93514; (760) 873-6991

Shawna A. **Romero** — *Paiute-Taos*
Artist; P.O. Box 615, Big Pine, CA 93513; (619) 938-2391

Arthur R. **Rowlodge III** — *Arapaho-Choct.*
Artist: Jewelry, Etc.; 9837 Kilgore Rd., Orlando, FL 32836; (407) 876-7320

Peter A. **Roybal** — *Pojoaque*
Jewelry; 16005 N. 32nd #74-D, Phoenix, AZ 85032;
(602) 971-2344

Paladine **Roye** — *Ponca*
Artist; 1206 N. Kennedy, Enid, OK 73701

W. Keith **Ruminer** — *Seminole-Creek-Choctaw*
Flutemaker; RR 3, Box 303R, Seminole, OK 74868;
(405) 382-0253

Gale **Runningwolf, Sr** — *Blackfeet*
Artist; P.O. Box 1371, Billings, MT 59103; (406) 256-1712

Archie J. **Russell** — *Pima*
Bows/Arrows: Walking Sticks, Etc.; 1911 E. Pecan Rd.,
Phoenix, AZ 85040; (602) 276-6157

Bennie **Salas** — *Zia*
Pottery; 107 Zia Blvd., Zia Pueblo, NM 87053;
(505) 867-3493, (505) 269-5674

Daniel V. **Sam** (8 years old) — *Picuris*
Artist: Colored Pencil Draw; P.O. Box 451, Penasco, NM
87533; (505) 587-1-77

Fern M. **Sanchez** — *Picuris*
Pottery; P.O. Box 383, Penasco, NM 87533; (505) 587-2519
(Message Phone)

Raphael **Sarracino** — *Laguna*
Kachinas; P.O. Box 481, Jemez Pueblo, NM 87024;
(505) 834-7083

Ralph **Sarracino Jr.** — *Laguna*
Kachinas; P.O. Box 408, Jemez Pueblo, NM 87024;
(505) 834-7083

Michelle **Sauceda-Halliday** — *Yaqui*
Clothing: Designer; P.O. Box 2240, Corrales, NM 87048;
(505) 898-0534

Jeff **Savage** — *Chippewa*
 Baskets & Sculptor; 1780 Blue Spruce, Cloquet, MN 55720; (218) 879-0157

Nelda **Schrupp** — *Ihunktewan*
 Jewelry: Horsehair & Antler; Box 232, Lakota, ND 58344; (701) 247-2827

Enilse **Sehuanes-Urbaniak** — *Guianbiano*
 Jewelry: Mini. Pottery Jewelry; P.O. Box 428, Crestone, CO 81131; (719) 256-4473

Gale C. **Self** — *Choctaw*
 Jewelry; 1400 County Rd. 303, Terrell, TX 75160; (214) 563-8624

Jackie **Sevier** — *Arapaho*
 Artist; P.O. Box 86, Seneca, NE 69161; (308) 639-3227

Shirly **Shemayme** — *Picuris*
 Pottery; P.O. Box 472, Penasco, NM 87533; (505) 587-2754 (Message Phone)

Deborah **Sherer** — *Blackfeet*
 P.O. Box 20748, Keizer, OR 97307

Deborah **Sherer** — *Blackfeet*
 Clothing: Plains Warshirts; P.O. Box 20748, Keizer, OR 97307; (503) 390-8042; E-mail: sherer5@open.org

Eusebia **Shije** — *Zia*
 Pottery; 946-A Zia Blvd., Zia Pueblo, NM 87053; (505) 867-3873

Israel **Shotridge** — *Tlingit*
 Carver: Totem poles, Etc.; P.O. Box 2508, Vashon, WA 98070; (206) 463-7677; Web: www.shotridgestudios.com

Howard **Sice** — *Laguna-Hopi*
 Jewelry & Sculptor; P.O. Box 15236, Tucson, AZ 85708; (520) 885-1004

Tammy **Singer** — *San Juan-S.C.*
Arts & Crafts: Indian; P.O. Box 1781, Espanola, NM
87532; (505) 753-7525

Joseph **Skywolf** — *Lumbee-Apache*
Crafts: Cultural Crafts; P.O. Box 746, Austin, TX 78767;
(512) 472-3049

Marylou **Slaughter** — *Duwamish*
Baskets: Birchbark, Cedar; 1445 Flower Ave., Port
Orchard, WA 98366; (360) 876-6271; E-mail:
slaughter@wvin.com

Sierra **Small Bird** — *Shawnee-Paiute*
Boulder, CO 80301; (303) 440-9049

Ann **Smith** — *Kwanlin Dun*
Artist: Misc.; P.O. Box 5891, Whitehorse, YUK Y1A 5L6;
(403) 668-3722

Suzanne **Smoke** — *Ojibway*
Clothing; 86 Jones Ave., Ste. 211, Toronto, ON M4M 2Z8;
(416) 469-3563, (416) 674-7733

Alice **Snow** — *Seminole*
Clothing: Jackets, Vests, Skirts; Rt. 6, Box 671,
Okeechobee, FL 34974; (941) 467-2343

Carol **Snow** — *Seneca*
Artist; P.O. Box 17787, Boulder, CO 80308; (303) 499-4513

Floyd **Solomon** — *Laguna-Zuni*
Artist; 556 Washington Ave., Apt.D., Grants, NM 87020;
(505) 285-6041, (505) 552-9341

Reba J. **Solomon** — *Kiowa-Cheyenne*
Dolls: Clay; 1033 Leslie Ln., Norman, OK 73069;
(405) 364-0308

Verna **Solomon** — *Laguna*
Masks: Contemporary; P.O. Box 534, New Laguna, NM
87038; (505) 552-0329

Other Tribes

Delaine **Spilsbury** — *Shoshone*
Misc.; 2429 Salt Lake St., N. Las Vegas, NV 89030;
(702) 642-6674

Lyndon **Standing Elk** — *Cheyenne*
Jewelry; 521 Airport Rd., Sp. #188, Santa Fe, NM 87505;
(505) 424-0124

Ilona **Stanley** — *Ojibwa*
Birchbark: Biting (Canada); Box 32, Camperville, MB
ROL OJO; (204) 524-2173

Larry **Steffler** — *Sauk*
Woodwork: Cedar; 11930 Hobby St. SE, Yelm, WA 98597;
(360) 458-1146

Larissa **Stepetin** — *Assiniboine-Aleut*
Star Quilts; P.O. Box 990, Harlem, MT 59526; (406) 673-3251

Jacquie **Stevens** — *Winnebago*
Pottery; 2442 Cerrillos Rd., Ste. 303, Santa Fe, NM 87501;
(505) 820-0345

Midge Dean **Stock** — *Seneca*
Baskets; 4111 Humphrey Rd., Great Valley, NY 14741;
(716) 945-4886

Mary Jane **Storm** — *Seminole*
Crafts; 3001 NW 63rd Ave., Hollywood, FL 33024;
(305) 963-1868

David Gary **Suazo** — *Taos*
Artist; P.O. Box 965, Taos Pueblo, NM 87571

Bernice **SuazoNaranjo** — *Taos*
Pottery: Micaceous Pots/Bears; P.O. Box 516, Taos
Pueblo, NM 87732; (505) 387-5658

Joyce **Sundheim** — *Penobscot*
Weavings; 3831 Monica Pkwy., Sarasota, FL 34235;
(941) 366-0023

Alan **Syliboy** — *Mi'kmaq*
Artist; P.O. Box 492, Truro, NS B2N 5C7; (902) 893-7825;
E-mail: redcrane@istar.ca

Isaac **Tait** — *Nisga'a*
Jewelry: Carved gemstones; 12 La Vereda, Santa Fe, NM
87501; (505) 986-9643

Pearl **Talachy** — *Nambe*
Pottery; Rt. 1, Box 114M, Nambe Pueblo, NM 87501;
(505) 455-3429

Sue **Tapia** — *San Juan*
Pottery; P.O. Box 1480, San Juan Pueblo, NM 87566;
(505) 852-9667

Thomas **Tapia** — *Tesuque*
Artist: Watercolors; Rt. 11, Box 65-TP, Santa Fe, NM
87501; (505) 983-7075, (505) 820-7436

Tom **Tapia** — *San Juan*
Pottery; P.O. Box 1480, San Juan Pueblo, NM 87566;
(505) 852-9667

Marnie Lyn **Tarbell** — *Mohawk*
116 Kirk Ave., Syracuseh, NY 13205; (315) 424-6885

Tammy **Tarbell Boehning** — *Mohawk*
Pottery & Dolls; P.O. Box 84, Nedrdow, NY 13120;
(315) 492-9663

Urshel **Taylor** — *Pima-Ute*
Artist; 2901 W. Sahuaro Divide, Tucson, AZ 85742;
(520) 297-4456

Tchin — *Blackfeet-Narragan*
Jewelry & Musician; P.O. Box 350443, Brooklyn, NY
11235; (718) 332-9183

Marilyn **Tenorio** — *SDP-Navajo*
Jewelry & Sculptor; 474 Juniper Hills, SD Pueblo, NM
87052; (505) 867-5272

Roderick **Tenorio** — *SDP-Navajo*
Jewelry & Sculptor; 474 Juniper Hills, Bernalillo, NM 87004; (505) 867-5272

Bobbie **Tewa** — *San Juan-Hopi*
Jewelry; P.O. Box 35, San Juan, NM 87566; (505) 753-6027

Lois Chichinoff **Thadei** — *Aleut, Sealaska*
Baskets: Northwest Coast style; 3430 Pacific Ave. SE #A6327, Olympia, WA 98501; (360) 866-8110; E-mail: aleutwoman@aol.com

Sally **Thielen** — *Chippewa*
Dolls & Paper-handmade; 12112 Davison Rd., Davison, MI 48423; (810) 653-4674

Edward R. **Thomas** — *Chippewa*
Sculptor; P.O. Box 295, Decatur, NE 68020; (402) 349-5545

Joseph **Thomas** — *Laguna-Pima*
Beadwork, Dr.ums & Leather; Albuquerque, NM; (505) 296-2330

Dana **Tiger** — *Muskogee*
Artist; 2110 E. Shawnee, Muskogee, Ok 74403

Jon Mark **Tiger** — *Creek*
Artist: Pencil, W.C., Oils, Etc.; HC 63, Box 212, Eufaula, OK 74432; (918) 689-3654

Bea Duran **Tioux** — *Tesuque*
Pottery & Dr.ums; P.O. Box 652, Tesuque, NM 87574; (505) 989-9656

Jim **Tomeo** — *Colville*
Jewelry & Painting; N. 14221 Rivilla Ln., Spokane, WA 99208; (509) 466-0697

Gordon **Tonips** — *Comanche-Kiowa*
Sculptor: Clay; 6475 Spur 303, Ft. Worh, TX 76112; (817) 654-4550

Beatrice **Torres** — *San Juan*
P.O. Box 983, San Juan Pueblo, NM 87566; (505) 852-4605

Charles **Trujillo** — *Sandia*
Jewelry; P.O. Box 6091, Bernalillo, NM 87004; (505) 867-9837

Pemwah **Tumequah** — *Laguna-Kickapoo*
HC78, Box 9914, Rancho deTaos, NM 87557;
(505) 776-2555

Joanna **Underwood** — *Chickasaw*
Pottery; Davis, OK

Susan T. **Underwood** — *Shawnee*
Artist; Route 1, Box 188 A., Delaware, OK 74027;
(918) 467-3378

Joyce L. **Underwood V.** — *Chickasaw*
Beadwork: Clothing; 330-1/2 W. Main, Anadarko, OK 73005

Daniel **Van Fleet** — *Mohave-Apache*
Sculptor; HC 73 Box 15, San Jose, NM 87565;
(505) 421-2208

Gordon F. **Van Wert** — *Chippewa*
Sculptor; 2501 Vista Larga NE, Albuquerque, NM 87106;
(505) 268-5401

Evelyn **Vanderhoop** — *Haida*
Weaver: Chilkat & NW textiles; 34589 Hansville Hwy.,
Kingston, WA 98346; (360) 638-1748

Nadine **VanMechelen** — *Yurok-Karok-Talowa*
Dolls; 46947 Kirkpatrick Rd., Pendleton, OR 97801;
(541) 276-2566; E-mail: doll@bmi.net, web-site:
www.geocities.com/Heartland/Park/5576

Ruth **Vargas** — *Aztec*
Beadwork; P.O. Box 4665, Albuquerque, NM 87196;
(505) 842-0331

Gordon **Vigil** — *Nambe*
P.O. Box 3441, Santa Fe, NM 87501; (505) 455-3819

Lonnie **Vigil** — *Nambe*
Pottery; Rt. 1, Box 121C, Santa Fe, NM 87501; (505) 455-2871

Linda C. **Vit** — *Karok-Cree*
Baskets, Beadwork & Jewelry; P.O. Box 3317, Eureka, CA 95502; (707) 442-8800

Micah **Vogel** — *Sallawish*
Carvings; P.O. Box 584, Neah Bay, WA 98357; (360) 645-2818

Raymond **Volante** — *Tohono O'Odham*
Baskets; P.O. Box 1254, Oracle, AZ 85623; (520) 896-2901

Pat **Waconda** — *Laguna-Kickapoo*
Dolls; P.O. Box 1440, Paguate, NM 87040; (505) 552-9802

Stephan **Wall** — *Chippewa*
Sculptor; SR 2, Box 1933, Tularosa, NM 88352; (505) 585-4870

Denise H. **Wallace** — *Aleut*
Jewelry: Metalsmith; P.O. Box 5521, Santa Fe, NM 87502; (505) 984-0265

Suzanne **Warlow** — *Yupik Eskimo*
P.O. Box 142368, Anchorage, AK 99514; (907) 563-3760

Dell **Warner** — *Lower Cayuga*
Beadwork; P.O. Box 1915, Niagara Falls, NY 14302

Gloria **Wells-Norlin** — *Chippewa*
Artist: etc.; 431 N. Ida Ave., Bozeman, MT 58715; (406) 586-4755

Jr. **Weryackwe** — *Comanche*
Beadwork: Belts, Hat Bands; P.O. Box 1202, Anadarko, OK 73995; (405) 247-5302

Tillier **Wesley** — *Creek*
Artist; P.O. Box 1534, Weatherford, TX 76086; (817) 599-6002

April **White** — *Haida*
Artist; 4643 Marine Ave., Powell River, BC V8A 2K8; (604) 485-7572; Web: www.windspirit.com

Marlene **White Owl** — *Cayuse-NezPerce*
Beadwork & Sewing; 151 SE 1st St., Pendleton, OR 97801; (541) 966-1191

Maynard **White Owl** — *Cayuse-NezPerce*
Beadwork & Sewing; 151 SE 1st St., Pendleton, OR 97801; (541) 966-1191

Mel **Whitebird** — *Cheyenne*
Jewelry; P.O. Box 1292, El Reno, OK 73036; (405) 396-8303

Heather **WhiteManRunsHim** — *Crow*
Beadwork & Dolls; 1913 Gold Ave. SE, Albuquerque, NM 87106; (505) 244-0154

Ardena **Whiteshield** — *So. Cheyenne*
Beadwork; 1003 W. Wade, El Reno, OK 73036; (405) 631-0590

James C. **Whitman** — *Mandan-Hidatsa*
Artist & Sculptor; AZ; (602) 940-1341; E-mail: nmehart@goodnet.com

Kathy **Whitman** — *Mandan-Hidatsa*
Sculptor & Paintings; 2717 E. Victor Hugo Ave., Phoenix, AZ 865032; (602) 494-2516

George S. **Willis** — *Choctaw*
Jewelry & Sculpture/Carvings; 2050 Laurie Cir., Carlsbad, CA 92008; (760) 729-0743

Angie **Yazzie** — *Taos*
Pottery; P.O. Box 110, Taos Pueblo, NM 87571; (505) 751-4588, (505) 758-8773

Edward W. **Yellowfish** — *Comanche-Otoe*
Jewelry, Woodworking, Etc.; 8905 Tracy Dr., Oklahoma City, OK 73132; (405) 721-0928

Gordon **Yellowman** — *Cheyenne*
Artist; 513 Lynn Dr., El Reno, OK 73036; (405) 422-5004

Povi **Zuni** — *San Juan*
Pottery: Horn Vase; 75 Tribal Rd. #90, Albuquerque, NM 87105; (505) 869-6700;

Conclusion

Thanks for participating in our journey through Indian Country. In closing I would like to offer a few more suggestions.

I have recently found a couple of new books that I think you would enjoy, and, if you're heading West, might help with your adventures. First, a book by Jake & Suzanne Page, A Field Guide to SouthWest Indian Arts and Crafts. This will give you a good general overview and many of the artists mentioned can be found here in this directory. I would recommend anything by Jerry & Lois Jacka – exceptional photography and knowledgeable text. For a feel of Navajo country read a couple of Hillerman novels on your drive out. They're fun and pretty accurate geographically - plus, they'll give you some feel for the Navajo culture. Also, check out Native Roads by Fran Kosik.

There are many excellent books on Indian art and it would be wise to look through a couple of them before making purchases. Not only will it help you make a better choice, but it will enrich the experience if you have some knowledge of what you are seeking.

Thanks again!

Index

Abeita, Andy — Isleta

Abeita, Augustine D. — Isleta-Chippewa

Abeita, Gloria — Isleta

Abeita, Karen L. — Other Tribes-Tewa-Isleta

Abeita, Roberta — Navajo

Abeita, Tamra L. — Acoma

Abeita, Tonita C. — Santo Domingo

Abeita-James, Burgess P. — Acoma

Abeyta, Elizabeth — Navajo

Abeyta, Harvey Ross — Santo Domingo

Abeyta, Pablita — Navajo

Abeyta, Tony — Navajo

Acadiz, Lawrence — Hopi

Ackerman, Brenda P. — Other Tribes-Meskwaki

Acuna, Charles P. — Apache

Adakai, Edgar — Navajo

Adams, Ivan "Q'we'ens" — Other Tribes-Haida

Adams, Sr., Ronald D. — Hopi

Adamson, Angelique — Other Tribes-Salish-Kootenai

Agard, Annalisa — Sioux

Agard, Anthony — Sioux

Agard, Irene — Sioux

Aguilar, David — Santo Domingo

Aguilar, Esther — Santo Domingo

Aguilar, Evelyn — Santa Clara

Aguilar, Kenneth — Santo Domingo

Aguilar, Luther — Santo Domingo

Aguilar, Lynn — Santo Domingo

Aguilar, Marie C. — Santo Domingo

Aguilar, Rafaelita — Santo Domingo

Aguilar, Raymond — Santo Domingo

Aguilar, Sarah M. — Navajo

Aguilar, Jr., Tony — Santo Domingo

Ahtone, Karen — Other Tribes-Kiowa-Apache

Ahtone, Ronnee — Other Tribes-Kiowa-Apache

Aitson, Mary — Cherokee

Aitson, Richard — Other Tribes-Kiowa

Albert, Jerald — Navajo

Albert, Robert S. — Hopi

Alcott, Carol H. — Navajo

Alcott, Michael — Navajo

All Runner, Rose — Other Tribes-Picuris

Allen, Dennis — Other Tribes-Skokomish

Allison, Robert — Hopi

Alphonse, Ron — Other Tribes-Northwest Coast

Alsburg, Lynda — Navajo

Alsburg, Robert — Navajo

Alvarez, Andrew — Apache-Yaqui

Ambrose, Virginia — Navajo

Ami, Ramona — Hopi

Amiotte, Thelma — Sioux - Rosebud

Ammerman, Marcus — Other Tribes-Choctaw

Anderson, Troy — Cherokee

Anderson, Jr., Ricki — Navajo

Andrews, Tatiana — Other Tribes-Yupik

Anfuso, Linda — Other Tribes-Mohawk

Annesley, R.H. Bob — Cherokee

Antone, Annie — Other Tribes-Tohono O'Odham

Antone, Leona — Other Tribes-Tohono O'Odham

Antone, Norma — Other Tribes-Tohono O'Odham

Antonio, Jose — Acoma

Antonio, Melissa — Acoma

Antonio, Mildred — Acoma

Appleleaf, Martha — San Ildefonso

Aragon, Allen — Navajo

Aragon, Clarice — Acoma

Aragon, Leslie — Other Tribes-Zia

Aragon, Nanaba — Navajo

Aragon, Ralph — Other Tribes-Zia

Aragon, Wanda — Acoma

Aragon, Sr., Marvis — Acoma

Archuleta, Margaret — Other Tribes-Picuris

Archuleta, Mary E. — Santa Clara-SantaClara-S.J.

Arnilth, Lawrence — Navajo

Arquero, Dominic — Cochiti

Arquero, Johnnie B. — Cochiti

Arquero, Josephine — Cochiti

Arthur, Able — Navajo

Arviso, Cheryl Ann — Navajo

Ashkie, Larry — Navajo

Atencio, Frank — Santo Domingo

Atencio, Juanita — Santo Domingo

Austin, Betty — Navajo

Baca, Angela — Santa Clara

Baca, Annie — Santa Clara

Baca, David — Santa Clara

Baca, Joe — Santa Clara

BadMoccasin, Jean — Sioux

Bahe, Fidel — Navajo

Bahe, Irene — Navajo

Bahe, Kristyne — Navajo

Bailon, Clarence — Santo Domingo

Bailon, Eleanor — Santo Domingo

Bailon, Florentino — Santo Domingo

Bailon, Ralph — Santo Domingo

Baker, Sharynn J. — Other Tribes-Chippewa

Bales, Jean E. — Other Tribes-Iowa

Ballenger, Virginia Y — Navajo

Balloue, John — Cherokee

Barney, Ben — Navajo

Barney, Vivian — Navajo

Barstad, Rocky — Other Tribes-Tsuutina

Bartlett, Lorena — Navajo

Batala, Art — Hopi

Beach, Diana — Cherokee

Beach, George — Other Tribes-
Chickasaw

Bearden, Matthew — Other
Tribes-
Potawatomi

Beaver, Amos — Other Tribes-
Cheyenne

Becenti, Bobby — Navajo

Becenti, Harrison — Navajo

Becenti, Ida — Navajo

Becenti, Larry B. — Navajo

Becenti, Robert — Navajo

Bedoni, Darrell — Navajo

Bedoni, Pat — Navajo

Bedonie, Ron — Navajo

Begay, Abraham — Navajo

Begay, Alvin — Navajo

Begay, Ambrose — Navajo

Begay, Anna — Navajo

Begay, Annie — Navajo

Begay, Aretha — Navajo

Begay, Aretha — Navajo

Begay, Arlene — Navajo

Begay, Arthur — Navajo

Begay, Betty L. — Navajo

Begay, Bia, Jr. — Navajo

Begay, Bobby — Navajo

Begay, Carlos — Navajo

Begay, Clifford — Navajo

Begay, Donovan — Navajo

Begay, Douglas — Navajo

Begay, Dy — Navajo

Begay, Eddie — Navajo

Begay, Elden — Navajo

Begay, Frances — Navajo

Begay, Frances — Navajo

Begay, Franklin — Navajo

Begay, Fred — Navajo-Ute

Begay, George — Navajo

Begay, Harvey — Navajo

Begay, Harvey — Navajo

Begay, Irene — Navajo

Begay, Jerry — Navajo

Begay, Kary — Navajo

Begay, Larry — Navajo

Begay, Leroy — Navajo

Begay, Lorraine — Navajo

Begay, Lula M. — Navajo

Begay, Mae D. — Navajo

Begay, Nellie S. — Navajo

Begay, Patsy — Navajo

Begay, Paul J. — Navajo

Begay, Phyllis — Navajo

Begay, Rena — Navajo

Begay, Richard — Navajo

Begay, Roberta — Navajo

Begay, Sadie — Navajo

Begay, Sarah P. — Navajo

Begay, Sharon A. — Navajo

Begay, Shirley — Navajo

Begay, Shonto — Navajo

Begay, Steven J. — Navajo

Begay, Tillie — Navajo

Begay, Victor — Navajo

Begay, Wallace — Navajo

Begay, Willie — Navajo

Begay, Wilma — Navajo
Begay, Woody — Navajo
Begay, Zeal J. — Navajo
Begay, Jr., Harrison — Navajo
Begaye, Ben — Navajo
Begaye, Ben — Navajo
Begaye, Jacquelynn — Navajo
Begaye, Rex Al — Navajo
Begaye, Sylvia C. — Navajo
Begaye, Vernon — Navajo
Begody, Grace — Navajo
Bekis, Elouise J. — Navajo
Belen, Alice — Navajo
Belen, Jack — Navajo
Bell, Richard M — Other Tribes-Coharie
Bellows, Robert W. — Other Tribes-Chippewa
Belone, James — Navajo
Bemis, Nancy F. — Other Tribes-Potowatomi
Ben, Arland F. — Navajo
Ben, Sr., Herbert — Navajo
Ben, Sr., Rosabelle — Navajo
Benally, Alice — Navajo
Benally, Annie E. — Navajo
Benally, Arlene — Navajo
Benally, Chester — Navajo
Benally, Christina — Navajo
Benally, Darrell — Navajo
Benally, Donna — Navajo
Benally, Eric — Navajo
Benally, Ernest — Navajo
Benally, Etta — Navajo

Benally, Fernandez — Navajo
Benally, Francis — Navajo
Benally, John — Navajo
Benally, Judy — Navajo
Benally, Leo J. — Navajo
Benally, Nellie G. — Navajo
Benally, Perry — Navajo
Benally, Richard — Navajo
Benally, Sam — Navajo
Benavidez, Francisco — Isleta
Benavidez, Joeba — Santo Domingo
Benavidez, Mary S. — Santo Domingo
Bennett, Donna — Other Tribes-Hualapai
Bennett, George O. — Other Tribes-Hualapai
Berryhill, Les — Other Tribes-Creek
Bert, Dan — Hopi
Betoney, Billy — Navajo
Bevan, Stan — Other Tribes-Tsimshian-Tlingit
Bevins, Susie — Other Tribes-Inupiat
Beyale, Randall — Navajo
Beyale, Wayne Nez — Navajo
Bia, Katherine — Navajo
Bia, Norman — Navajo
Bia, Jr., Sam — Navajo
Bicksler, Carola — Cherokee
Bicksler, Robert L. — Cherokee
Biggoose, Mars — Other Tribes-Ponca
Bill, Leonard — Navajo

Bill, Linda — Navajo

Billie, Diane O. — Other Tribes-
Seminole

Billie, Tommie — Navajo

Billie, Jr., George — Navajo

Billy, Ben — Navajo

Billy, Carmelita — Navajo

Billy, Dennison — Navajo

Billy, Timothy — Navajo

Bird, DennisT. — Other Tribes-
San Juan-SDP

Bird, Gloria A. — Santo Domingo

Bird, Gloria C. — Santo Domingo

Bird, Gordon — Other Tribes-
Mandan-Hidatsa

Bird, JoAnne — Sioux

Bird, Jolene — Santo Domingo

Bird-Quintana, Evelyn — Other
Tribes-San Juan

Bitsilly, Dorothy — Navajo

Black, Darlene — Navajo

Black, Jim — Navajo

Black, Lorraine — Navajo

Black, Rosallez — Navajo

Black, Sally — Navajo

Blackgoat, Alice — Navajo

Blackgoat, Jeanie — Navajo

Blacksheep, Beverly — Navajo

Blue Thunder, Archie — Sioux -
Rosebud

Blue Thunder, Buka — Sioux -
Rosebud

Bluejacket, Shawn — Other
Tribes-Shawnee

Bluejay, Floyd — Other Tribes-
Comanche

Bobelu, Carolyn — Zuni-Navajo

Bobelu, Lisa — Zuni

Bolton, Cliff — Other Tribes-
Tsimshian

Bolton, Rena Point — Other
Tribes-Tsimshian

Bonney, Bernice — Navajo

Boone, Lena L. — Zuni

Boone, Virginia — Navajo

Box, Debra K. — Other Tribes-
Southern Ute

Box, Sr., Edward B. — Other
Tribes-Southern
Ute

Boxley, David — Other Tribes-
Tsimshian

Boy, Allen — Navajo

Boy, Rose — Navajo

Boyd, Allen — Navajo

Boyd, Brenda — Navajo

Boyd, Emma R. — Navajo

Boyd, Leroy — Navajo

Boyd, Mary — Navajo

Boyd, Paula — Navajo

Boyiddle, Mitchell — Other
Tribes-Kiowa

Boyiddle, Parker — Other Tribes-
Kiowa

Brabant, Jay — Other Tribes-Cree

Bradley, Genieve — Navajo

Brady, Roland — Navajo

Brauker, Shirley M. — Other
Tribes-Ottawa

Brennan, Peggy — Cherokee

Brewer, Sandra — Sioux

Brewer, Sandra — Sioux

Brokeshoulder, Aaron — Other Tribes-Choctaw-Shawnee

Broughton, Deanna — Cherokee

Brown, Debbie G. — Acoma

Brown, Diamond — Cherokee

Brown, Ginger E. — Other Tribes-Choctaw

Brown, Winona — Navajo

Brown Bear, Zack — Cherokee

Browning, Florence — Santa Clara

Browning, Nate — Navajo

Bruderer, Pat — Other Tribes-Cree

Brycelea, Clifford — Navajo

Buffalohorse, Leonda Fast — Other Tribes-Blackfeet

Burgess, Quanah — Other Tribes-Comanche

Burnside, Samuel — Navajo

Butler, C. J. — Navajo

Butler, Lorrain — Navajo

Cain, Billy — Santa Clara

Cain, Mary — Santa Clara

Cajero, Aaron — Jemez

Cajero, Anita — Jemez

Cajero, Esther — Jemez

Cajero, Joe — Jemez

Cajero, Jr., Joe — Jemez

Calabaza, Alfred — Santo Domingo

Calabaza, Elsie A. — Santo Domingo

Calabaza, Eva — Santo Domingo

Calabaza, Jimmy — Santo Domingo

Calabaza, Joe — Santo Domingo

Calabaza, Marie — Other Tribes-San Juan

Calabaza, Mary Ann — Santo Domingo

Calabaza, Mitchell — Other Tribes-San Juan

Calnimptewa, Cecil — Hopi

Calnimptewa, Darin — Hopi

Campbell, Ben NightHorse — Other Tribes-Cheyenne

Campbell, H. Geoffry — Other Tribes-Tlingit

Candelaria, Mary — San Felipe

Candelaria, Nicholas — San Felipe

Candelaria, Roger — San Felipe

Candelario, Hubert — San Felipe

Carey, Donna O. — Santo Domingo

Carillo', Franklin A. — Other Tribes-Laguna-Choctaw

Carl, Jr., Kee — Navajo

Carolin, Rex — Sioux

Carpio, Caroline — Isleta

Carviso Jr., Emma — Navajo

Carviso Jr., Wilson — Navajo

Casiquito, Dolores C. — Jemez

Casiquito, Jeronima — Jemez

Casiquito, Regina A. — Jemez

Castillo, Irene — Acoma

Cate, Arvin — Santo Domingo
Cate, Irma — Santo Domingo
Cate, Joe — Santo Domingo
Cate, Lorraine — Santo Domingo
Cate, Rosey — Santo Domingo
Chaat Smith, Diane — Other Tribes-Comanche
Chalan, Marcus — Cochiti
Chalan, Martha — Cochiti
Chalan, Mary O. — Cochiti
Chapo, Ben — Navajo
Chapo, Lena — Navajo
Charging Whirlwind, Sheryl — Sioux - Rosebud
Charley, Blanche — Navajo
Charley, Cecelia — Navajo
Charley, David — Navajo
Charley, Harlan — Navajo
Charley, Karen K. — Hopi
Charley, Robert — Navajo
Charley, Rose — Navajo
Charley, Wilton D — Navajo
Charlie, Ric — Navajo
Chavarria, Dave — Santa Clara
Chavarria, Denise — Santa Clara
Chavarria, Loretta — Santa Clara
Chavarria, Manuel Denet — Hopi
Chavarria, Stella — Santa Clara
Chavez, Albert — Navajo
Chavez, Alfred — Santo Domingo
Chavez, Avelino — Santo Domingo
Chavez, Charles — San Felipe
Chavez, Clara — Santo Domingo

Chavez, Edward — Santo Domingo
Chavez, Eliza — Santo Domingo
Chavez, Evelyn — Navajo
Chavez, Fannie — Navajo
Chavez, Harvey — Santo Domingo
Chavez, Janie — Santo Domingo
Chavez, Joe — Santo Domingo
Chavez, Joe — Santo Domingo
Chavez, John — Navajo
Chavez, Julia — Navajo
Chavez, LeJeune — Santo Domingo
Chavez, Leonora — San Felipe
Chavez, M. Lisa — Isleta
Chavez, Neomi — Santo Domingo
Chavez, Toby — Santo Domingo
Cheatham, Michael A. — Cherokee
Chebon — Other Tribes-Creek-Choctaw
Chee, Al — Navajo
Chee, Bernice — Navajo
Chee, Carlis M. — Navajo
Chee, Donny — Navajo
Chee, Elizabeth — Navajo
Chee, Evelyn — Navajo
Chee, Frank — Navajo
Chee, Herman — Navajo
Chee, Janelle — Navajo
Chee, Norma — Navajo
Chee, Norris M. — Navajo
Chee, Raymond — Navajo

Chee, Ronald — Navajo

Chee/Baldwin, Ernest — Navajo

Chee/Baldwin, Genevieve — Navajo

Chiago Sr., Michael — Other Tribes-Tohono O'Odham

Chiaz — Navajo

Chimerica, Forrest — Hopi

Chinana, Angela — Jemez

Chinana, Donald — Jemez

Chinana, Leo — Jemez

Chinana, Lorraine — Jemez

Chinana, Lydia B. — Jemez

Chino, Darrell — Acoma

Chino, Diana — Acoma

Chino, Donna — Acoma

Chino, Emil — Acoma

Chino, Velma — Acoma

Chino-Charlie, Carrie — Acoma

Chiquito, Pearlena — Navajo

Chitto, Randall — Other Tribes-Choctaw

Christie, Laura — Navajo

Chuyate, Marilyn — Zuni

Clah, Johnny — Navajo

Clah, Mistele — Navajo

Clark, Ben — Navajo

Clark, Chester — Navajo

Clark, Don — Navajo

Clark, Irene — Navajo

Clark, ShonaBear — Other Tribes-Creek

Claw, Bertha — Navajo

Claw, Silas — Navajo

Claw-Gums, Emma — Navajo

Cling, Alice W. — Navajo

Clitso, Ann B. — Navajo

Cody, Lola S. — Navajo

Cole, Ruth — Other Tribes-Creek

Coleman, Gwen — Other Tribes-Choctaw

Concho, Carolyn — Acoma

Concho, Frances — Acoma

Concho, Isidore — Acoma

Conner, Lois Jean — Other Tribes-Miwok

Conover, Margaret S — Other Tribes-Osage-Sioux

Conrad, Beverley — Other Tribes-Mohawk

Contway, Bruce — Sioux-Chippewa

Coochyamptewa, Delores — Hopi

Coochyamptewa, Kencrick — Hopi

Coochyamptewa, Paul — Hopi

Cook III, Bruce A. — Other Tribes-Haida-Arapahoe

Coolidge, Frances — Navajo

Coolidge, Stephan — Navajo

Coonsis, Phyllis — Zuni

Coriz, Alonzo J. — Santo Domingo

Coriz, Angel — Santo Domingo

Coriz, Brenda — Santo Domingo

Coriz, Fabian — Santo Domingo

Coriz, Helen M. — Santo Domingo

Coriz, Ione — Santo Domingo
Coriz, Irvin — Santo Domingo
Coriz, Joseph — Santo Domingo
Coriz, Joseph — Santo Domingo
Coriz, Julian — Santo Domingo
Coriz, Lorenzo B. — Santo Domingo
Coriz, Louise — Santo Domingo
Coriz, Marie — Santo Domingo
Coriz, Marie A. — Santo Domingo
Coriz, Mary C. — Santo Domingo
Coriz, Mary R. — Santo Domingo
Coriz, Matthew — Santo Domingo
Coriz, Nestoria P. — Santo Domingo
Coriz, Pam — Santo Domingo
Coriz, Rudy — Santo Domingo
Coriz, Tom — Santo Domingo
Coriz, Tonita — Santo Domingo
Corpuz, Knee-Know — Other Tribes-Squamish
Correa, Prudy — Acoma
Coyote, Cecilia — Navajo
Coyote, Mac — Navajo
Craig, Gracie — Navajo
Craig, Johnson — Navajo
CrazyHorse, Cippy — Cochiti
Creations, Natani — Navajo
Crespin, Angie — Santo Domingo
Crespin, Don — Santo Domingo
Crespin, Nancy — Santo Domingo
CroneNaranjo, Nancy — Santa Clara

Croslin, Larry A. — Cherokee
Croslin, Jr., Squirrel — Cherokee
Crow, Tis Mal — Cherokee-Lumbee
Cruz, John — Other Tribes-San Juan
Cummings, Donna S. — Other Tribes-Arapaho
Cummings, Edison — Navajo
Curley, Emma J. — Navajo
Curley, Polly — Navajo
Curley, Presley — Navajo
Custer, Ira — Navajo
Dahl, Arlene — Other Tribes-Menominee
Dahozy, Louva — Navajo
Dailey, Saraphine — Navajo
Dailey, Sue — Other Tribes-Laguna-Zuni
Dailley, Buffy — Navajo
Dallasvuyaoma, Bennard — Hopi
Darden, Steven A. — Navajo-Cheyen
Dark Mountain, Dawn — Other Tribes-Oneida
Daubs, Gerry — Jemez
David, Betty — Other Tribes-Spokane
David, Neil — Hopi
Davidson, Harold — Navajo
Davis, Alex F. — Other Tribes-Seneca-Cayauga
Davis, Danny — Navajo
Davis, Darla K. — Acoma
Davis, Kate — Navajo
Davis, Mary Lou — Navajo

Davis, Ralph — Other Tribes-Choctaw-Navajo

Davis, Roderick — Hopi

Davis, Jr., Anselm G. — Other Tribes-Choctaw-Navajo

Dawa, Alice — Hopi

Dawa, Bernard — Hopi

Dawahoya, Alice — Hopi

Dawangyumptewa, David — Hopi

Dawavendewa, Cedric — Hopi

Dawavendewa, Gerald — Hopi

Dawavendewa, Richard L. — Hopi

Dawes, Cheryl — Navajo

Dawes, Lucy — Navajo

Dawes, Lyna A. — Navajo

Dawes, Nelvis — Navajo

Dawn, Winter — Sioux

Dawn'A D — Navajo

Dawson, Nancy — Other Tribes-Kwagiutl

Day, Sr., Jonathan — Hopi

Deale, Roger — Navajo

Deel, Thomas — Navajo

Defender, Ed — Sioux

DeJolie, LeRoy — Navajo

Della, Ben — Other Tribes-Makah

Denetchilee, Harry — Navajo

Denipah, Marian — Navajo-SanJuan

Dennison, Laura — Navajo

DeRoche, Troy — Other Tribes-Blackfeet

Deschinny, Isabell — Navajo

DesJarlais, Larry J. — Other Tribes-Chippewa

Deutsawe Jr., Robert K. — Other Tribes-Laguna-Zuni

Diaz, Tina — Santa Clara

Dili, Lawrence — Other Tribes-San Juan

Dishface, Norbert — Navajo

Dodson, Charlene — Other Tribes-Choctaw

Dodson, Clay — Other Tribes-Choctaw

Doering, Mavis — Cherokee

Dominguez, Paula C — Acoma

Donohoe, Michael J. — Sioux

Doonkeen, Eula — Other Tribes-Seminole

Dowdy, Argus — Other Tribes-Choctaw

Draper, David — Navajo

Drums, Pueblo — Other Tribes-Taos

Du Sault, Guy — Other Tribes-Huron-Wendat

DuBoise, Adeline K — Other Tribes-Potawatomi

Dubray, James C. — Sioux - Oglala

Dubray, Thomas — Sioux - Oglala

Dudley, MaryJane — Apache

Duran, Joe — Other Tribes-San Juan

Duran, Linda — Other Tribes-Choctaw-Apache

Durand, Anthony J — Other Tribes-Picuris

Durand, Cora — Other Tribes-Picuris

Durham, Jim — Cherokee

Duwyenie, Carol — Hopi

Duwyenie, Debra — Santa Clara

Duwyenie, Joseph — Hopi

Duwyenie, Mary — Hopi

Duwyenie, Megan — Hopi

Duwyenie, Preston — Hopi

Dyea, Lance A. — Other Tribes-Laguna

Eagle, Black — Other Tribes-Shoshone-Yokut

Eagle, Lone — Other Tribes-Chippewa

Early, Bertha — Other Tribes-Laguna-Cochiti

Early, Max — Other Tribes-Laguna-Cochiti

Eckleberry, Mary — Santa Clara

Edaakie, Patty — Zuni

Edaakie, Raylan — Zuni

Edaakie, Robert A. — Isleta

Edaakie, Sheryl — Zuni

Edaakie, Strallie — Zuni

Edd, Arlene — Navajo

Edwards, Debbe — Cherokee

Edwards, Ken — Other Tribes-Colville

Edzerza, Fred "Koshon" — Other Tribes-Tahitan

Ellsworth, Rolland — Navajo

Elwood, Lyn — Navajo

Elwood, Melvin — Navajo

Emerson, Anthony C — Navajo

Emerson, Travis E. — Navajo

Emery, Dorothy — Other Tribes-Chippewa-Jemz

Emery, Terry — Other Tribes-Chippewa-Jemz

Engler, Jean — Cherokee

English, Sam — Other Tribes-Chippewa

Enjady, Oliver — Apache-Mescalero

Era, Vickie Tunyu — Other Tribes-Alutiq

Eriacho, Ola — Zuni

Eriacho, Tony — Zuni

Esalalio, Bobbie — Zuni

Eskeets, Darrel — Navajo

Estevan, Charleen J. — Acoma

Etcitty, Phyllis B. — Navajo

Etcitty, Violet — Navajo

Ethelbah, Upton — Santa Clara-SantaClara-Apa

Etsitty, Erne — Navajo

Etsitty, Fannie — Navajo

Eulynda, Joe — Navajo

Eustace, Christina A — Zuni-Cochiti

Eustace, James — Cochiti

Eustace, James B. — Zuni-Cochiti

Eustace, Kiera — Zuni-Cochiti

Eustace-Hanelt, Jolene — Zuni-Cochiti

Eustace-Othole, Eric — Zuni-Cochiti

Everly, Margaret — Navajo

Farrell, Matilda R. — Navajo

Fawn, Patty — Other Tribes-Kwaitul-Chero.

Fernandes, Roger — Other Tribes-Lower Elwha S-Klallam

Ferrara, Jeanette — Isleta

Fields, Anita — Other Tribes-Osage

FireCrow, Jr., Joseph — Other Tribes-Cheyenne

Flett, George — Other Tribes-Spokane

Floan, Karen — Other Tribes-Ojibwe

Floresca, Jerry — Other Tribes-Colville

Flower, Snowflake — Cochiti

Fogarty, Joyce G.T. — Sioux

Folwell, Hank — Santa Clara

Folwell, Jody — Santa Clara

Folwell, Polly — Santa Clara

Folwell, Susan — Santa Clara

FortunateEagle, Adam — Other Tribes-Chippewa

Foster, Gilbert — Navajo

Foster, Rosanna — Navajo

Fourhawks, Leonard — Other Tribes-Mohawk-Chey.

Fowler, Cindy N. — Navajo

Fragua, B.J. — Jemez

Fragua, Bonnie — Jemez

Fragua, Cindy — Jemez

Fragua, Cliff — Jemez

Fragua, Glendora — Jemez

Fragua, Janeth — Jemez

Fragua, Juanita C. — Jemez

Fragua, Laura — Jemez

Fragua, Linda L. — Jemez

Fragua, Melinda T — Jemez

Fragua, Philip — Jemez

Fragua, Rose T. — Jemez

Fragua, Virginia — Jemez

Fragua Tsosie, Emily — Jemez

Francis, Cinibah — Navajo

Francis, George — Navajo

Francisco, Rikki — Other Tribes-Pima

Frank, Esther — Navajo

Frank, sr., Richy — Navajo

Franklin, Irene W. — Navajo

Franklin, W.B. — Navajo

Franklin, Sr., Ernest — Navajo

Franklin-Pablo, Connie — Navajo

Frazier, Marsha — Cherokee

Frazier, Scott — Sioux-Crow

Fred, Glenn D. — Hopi

Fredericks, Aaron J. — Hopi

Fredericks, Evelyn — Hopi

Frewin, Dan — Navajo

Frewin, Lapita — Navajo

Fritz, Armand — Hopi

Fulton, Johnson & — Navajo

Funmaker, Martin — Other Tribes-Ho-Chunk

Gachupin, Bertha — Jemez

Gachupin, Clara — Jemez

Gachupin, Debrah C. — Jemez

Gachupin, Delia J. — Jemez

Gachupin, Henrietta T — Jemez

Gachupin, Laura — Jemez

Gachupin, Wilma M. — Jemez

Gallegos, Andrew — Other Tribes-Santa Ana

Gambaro, Retha W. — Other Tribes-Muscogee (Creek)

Garcia, Barbara C — Santo Domingo

Garcia, Corrine — Acoma

Garcia, David — Santo Domingo

Garcia, Dennis — Santo Domingo

Garcia, Fawn N. — Hopi

Garcia, Gail — Santo Domingo

Garcia, Gregory — Santo Domingo

Garcia, Helen — Santo Domingo

Garcia, Helen S. — Jemez

Garcia, James — Hopi

Garcia, Jason D. — Santa Clara

Garcia, Juan — Santo Domingo

Garcia, Juanita — Santo Domingo

Garcia, Judith — Santo Domingo

Garcia, Lillian — Santo Domingo

Garcia, Lloyd — Jemez

Garcia, Lloyd — Santo Domingo

Garcia, Lorencita — Santo Domingo

Garcia, Madeline — Santo Domingo

Garcia, Marcus — Acoma

Garcia, Margaret — Acoma

Garcia, Mavis — Santo Domingo

Garcia, Michael — Navajo

Garcia, Michael D. — Other Tribes-Yaqui

Garcia, Myra — Other Tribes-San Juan

Garcia, Nelson — Navajo

Garcia, Nick — Santo Domingo

Garcia, Petra — Santo Domingo

Garcia, Ramon C. — Santo Domingo

Garcia, Ray — Santo Domingo

Garcia, Raymond — Santo Domingo

Garcia, Reycita A. — Other Tribes-San Juan

Garcia, Reyes M. — Santo Domingo

Garcia, Robert — Apache

Garcia, Sammy — Santo Domingo

Garcia, Samuel — Santo Domingo

Garcia, Sharon N. — Santa Clara

Garcia, Sheryl — Acoma

Garcia, Tammy — Santa Clara

Garcia, Virginia — Acoma

Garcia, W. — Acoma

Garcia, Sr., Wilfred — Acoma

Garrity, Sr., Michael — Navajo

Gaspar, Dinah — Zuni

Gaspar, Duran — Zuni

Gaspar, Peter — Zuni

Gasper, Bart — Zuni

Gasper, Jolynn B. — Zuni

Gatewood, Claude — Navajo

Gaussoin, Connie T. — Other Tribes-Picuris-Navajo

Gaussoin, David — Navajo-
Picuris

Gaussoin, Wayne N. — Navajo-
Picuris

Geionety, R. W. — Other Tribes-
Kiowa

Gene, Leonard — Navajo

George, Carrie — Navajo

George, Nathan — Navajo

George, Ros — Hopi

Ghahate, Margia — Zuni

Ghahate, Rosanne — Zuni

Gibson, Sara — Navajo

Glanz, Jo Ann — San Ildefonso

Glass, Bill — Cherokee

Goldtooth, Henry — Navajo

Goldtooth, Karlis R. — Navajo

Goman, Corline — Navajo

Goman, Harrison — Navajo

Gomez, Glenn — Other Tribes-
Pojoaque

Gomez, Henrietta — Other
Tribes-Taos

Gomez, Terry — Other Tribes-
Comanche

Gonzales, Aaron — San Ildefonso

Gonzales, Barbara — San
Ildefonso

Gonzales, Cavan — San Ildefonso

Gonzales, Gabriel G. — Jemez

Gonzales, Isabel C. — San
Ildefonso

Gonzales, Jeanne — San Ildefonso

Gonzales-, Marie — San Ildefonso

Good, Sandra M — Other Tribes-
Coast Salish

Good, William — Other Tribes-
Coast Salish

Good Strike, Chandler — Other
Tribes-Gros
Ventre

Goodluck, Arnold — Navajo

Goodluck, Michael — Navajo

Goodluck, Ronald — Navajo

Goodluck, Ronaldo — Navajo

Goodluck, Virgil — Navajo

Goodman, Louise R. — Navajo

Goodshot, Imogene — Sioux

Goodwin, John "Nytom" —
Other Tribes-
Makah

Goodwin, Marian — Cherokee

Gordo, Melvin — Navajo

Gordon, David — Cochiti

Gorman, Eva — Navajo

Gorman, Harrison — Navajo

Gorman, R.C. — Navajo

Gorman, Richard — Navajo

Goseyun, Craig Dan — Apache-
San Carlos

Gowen, Connie — Other Tribes-
Seminole

Grandbois, Rollie A. — Other
Tribes-Chippewa-
Cree

Grant, Dorothy — Other Tribes-
Haida

Gray, Gina — Other Tribes-Osage

Grayson, Yvonne — Other Tribes-
Zia-Acoma

Greenwood, Donald E. —
Cherokee

Greeves, Teri — Other Tribes-Kiowa

Greyhat, Collier — Navajo

Grover, Jr., Lee — Hopi

Grummer, Brenda K. — Other Tribes-Potawatomi

Guerro, Delora A — Navajo

Guthrie, John — Cherokee

Guthrie, John — Cherokee

Gutierrez, Andrea — Santa Clara

Gutierrez, Dorothy — Santa Clara

Gutierrez, Geraldine — San Ildefonso

Gutierrez, Kristy — Santa Clara

Gutierrez, Paul — Santa Clara

Gutierrez, Rose — San Ildefonso

Gutierrez, Teresa V. — Santa Clara

Gutierrez, Tony — Santa Clara

Hacker, Paul — Other Tribes-Choctaw

Hadaway, Dow — Other Tribes-Shawnee

Hadaway, June — Other Tribes-Shawnee

Haley, Roger — Navajo

Hall-Walters, Patrice — Other Tribes-Umatilla-WallaWal

Hamana, Sandra — Hopi

Hamlett, Victoria A. —- Other Tribes-Cheyenne

Haney, Dona — Other Tribes-Seminole

Haney, Enoch K. — Other Tribes-Seminole

Hanna, Mary C. — Other Tribes-Paiute-Blackfeet

Hansen, Monica — Cherokee

Hardin, Herbert — Santa Clara

Hardy, Lucy — Navajo

Hardy, Lucy — Navajo

Harjo, Sharron A — Other Tribes-Kiowa

Harjo Jr., Benjamin — Other Tribes-Shawnee-Seminole

Harragarra, Delores — Other Tribes-Kiowa

Harris, Steveh — Hopi

Harrison, Annabell — Navajo

Harrison, Bertha — Navajo

Harrison, Daisy — Navajo

Harrison, Jimmie — Navajo

Harrison, Jimmie — Navajo

Harrison, Leo J. — Navajo

Hartman, Terry "Tuka" — Other Tribes-Yaqui

Harvey, Cecilia J. — Navajo

Harvey, Marletha S — Navajo

Harvier, Andrew — Santa Clara

Harvier, Judith — Santa Clara

Haskew, Denny — Other Tribes-Potawatomi

Haskie, Ethel — Navajo

Haskie, Mary Lou — Navajo

Haskie, Vernon C. — Navajo

Haukaas, Linda — Sioux

Haukaas, Tom — Sioux

Hawiyeh-ehi, Brad — Cherokee

Hawk, Leonard J. — Other Tribes-Yakima

Hawzipta, Gus D. — Other
Tribes-Kiowa

Hayah, Mavis — Acoma

Heffke, Eva — Other Tribes-
Inupiaq Eskimo

Heit, Chuck "Ya'Ya" — Other
Tribes-Gitxsan

Henderson, Elsie — Navajo

Henderson, H. Tafoya — Jemez

Henderson, Jesse W. — Other
Tribes-Chippewa-
Cree

Henderson, K. — Cherokee

Henderson, Lonnie — Other
Tribes-Comanche

Henry, Evelyn — Apache

Henry, Frederick — Navajo

Henry, Nusie — Navajo

Henry, Ronnie — Navajo

Henson, Brooks — Cherokee

Herder, Lula — Navajo

Herrera, Arnold — Cochiti

Herrera, Carlos — Cochiti

Herrera, Steve — Cochiti

Herrera, Tim — Cochiti

Herrera, Tomas — Cochiti

Hessing, Valjean M — Other
Tribes-Choctaw

Hesuse, Lorraine A. — Navajo

Hill, George D. — Other Tribes-
Spokane

Histia, B. Greg — Acoma

Histia, Jackie S. — Acoma

Hoahwah, Tyron — Apache-
Comanche

Hobbs, Ida Mae — Navajo

Hobbs, Terrylene — Navajo

Hodgins, L. Bruce — Navajo

Holy Eagle, Sonja — Sioux

Homer, Robert A. — Hopi-Zia

Honanie, Aaron — Hopi

Honanie, Anthony E — Hopi

Honanie, Antone — Hopi

Honanie, Delbridge — Hopi

Honanie, Ernest W. — Hopi

Honanie, Hilda — Hopi

Honanie, Jimmie — Hopi

Honanie, Philbert — Hopi

Honanie, Phillip — Hopi

Honanie, Watson — Hopi

Honga, Tyree — Other Tribes-
Hualapai

Honyouti, Barry — Hopi

Honyouti, Brian — Hopi

Honyouti, Rick — Hopi

Honyouti, Ron — Hopi

Honyumptewa, Caroline D. —
Other Tribes-
Picuris

Hood, Alan — Other Tribes-
Shoshone-
Bannock

Hood, Daisey F. — Other Tribes-
Shoshone-
Bannock

Hooee, Ferdinand — Zuni

Hooee, Sylvia — Zuni

Hosie, Margaret — Sioux

Hoskie, Anderson — Navajo

Hoskie, John — Navajo

Hoskie, Randy — Navajo

Hosteen, Virginia — Navajo

House, Conrad — Navajo

Houtz, Rusty — Other Tribes-Shoshone-Bannock

Howard, Norma — Other Tribes-Choctaw-Chicka

Huber, Grace — Navajo

Hudson, Clarissa — Other Tribes-Tlingit

Huff, Tom — Other Tribes-Seneca-Cayuga

Huhbbard, Berlinda H — Navajo

Huma, Bryson — Hopi

Huma, Marlon — Hopi

Huma, Rondina — Hopi

Humetewa, Donna — Hopi

Hummingbird, Jesse T. — Cherokee

Hung, Jason — Other Tribes-Kwa'gulth

Hunter, Cody — Navajo

Hunter, Troy — Other Tribes-Kutenai

Hustito, Charles — Zuni

Hustito, Clive J. — Zuni

Hustito, Rosalie — Zuni

Ingram, Jerry — Other Tribes-Choctaw-Cher.

Jackson, Anita C. — Cherokee

Jackson, Danny — Navajo

Jackson, Gene — Navajo

Jackson, Jan M. — Other Tribes-Klamath-Modoc

Jackson, Jim — Other Tribes-Klamath-Modoc

Jackson, Lorraine — Navajo

Jackson, Martha — Navajo

Jackson, Nathan P. — Other Tribes-Tlingit

Jackson, Norman G. — Other Tribes-Tlingit

Jackson, Ron Toahani — Navajo

Jackson, Tommy — Navajo

Jackson, Sr., Melvin — Navajo

Jacobs, III, Walter W. — Other Tribes-Nanticoke

Jacquez, Lawrence — Navajo

Jake, Rozita — Navajo

James, Cedric D. — Other Tribes-Choctaw-Chicka

James, Darius L. — Acoma

James, Darlene — Hopi

James, Darlene — Navajo

James, Jimmy — Navajo

James, PeterRay — Navajo

James, Rachel W. — Acoma

Jamon, Carlton — Zuni

Jamon, Julie — Zuni

Jamon, Marvin — Zuni

Jenkins, Michael D. — Hopi

Jensen, Alan — Navajo

Jensen, Justin — Navajo

Jensen, Melvin — Navajo

Jewelry, Winterhawk — Navajo

Jim, Clinton — Navajo

Jim, Ed — Navajo

Jim, Eleanora — Navajo

Jim, Haskie — Navajo

Jimmy, Kee John — Navajo

Jiron, Mark — Hopi

Jo-po-vi — Santa Clara
Joe, Alfred L. — Navajo
Joe, Dolly L. — Navajo
Joe, Elsie J. — Navajo
Joe, Kathleen — Navajo
Joe, Larry R. — Navajo
Joe, Rita — Navajo
Joe, Sarah — Navajo
Joest, Patta LT — Other Tribes-
 Choctaw
John, David K. — Navajo
John, Johnny — Navajo
John, Liz — Other Tribes-
 Coushatta
John, Maybelle — Navajo
John, Thompson — Navajo
John, Vicki — Navajo
Johnson, Barbara — Cherokee
Johnson, Cecilia — Navajo
Johnson, Eileen — Other Tribes-
 Winnebago
Johnson, Hattie L. — Navajo
Johnson, Katherine — Other
 Tribes-Ho-Chunk
Johnson, Kenneth — Other
 Tribes-Muscogee-
 Sem.
Johnson, Larry — Navajo
Johnson, Mary A. — Navajo
Johnson, Peter — Navajo
Johnson, Terrol Dew — Other
 Tribes-Tohono
 O'Odham
Johnson, Tommy — Navajo
Jojola, Bert — Isleta
Jojola, Joseph R. — Isleta

Jojola, Tony — Isleta
Jojola, Vernon — Isleta
Jojola, Wanda — Isleta
Jones, David G. — Other Tribes-
 Choctaw-Chero.
Jones, Paul — Navajo
Jones, Pauline — Navajo
Jones, Peter B. — Other Tribes-
 Cattaraugus
Jones, Ruthe B. — Other Tribes-
 Delaware Shaw.
Jones, Woody — Other Tribes-
 Choctaw
Joseyesva, Ross — Hopi
Juan, Jones — Navajo
Juan, Jones L. — Navajo
Juan, Wanda — Navajo
Juanico, Marie S. — Acoma
Juanico, Marietta P. — Acoma
Judge, Raymond L. — Navajo
Julian, Crystal M. — Apache-
 Jicarilla
Julian, Rainey — Apache-Jicarilla
Jumbo, Darrell — Navajo
Jumbo, Gilberto — Navajo
Jumbo, Jennifer — Navajo
JumpingEagle, Donna — Sioux-
 Oglala
June, Frances — Navajo
Kabotie, Michael — Hopi
Kady, Roy — Navajo
Kady, Wilbert — Navajo
Kahe, Gloria — Hopi
Kairaiuak, Apanguluk — Other
 Tribes-Yup'ik

Kaniatobe, Clayton — Hopi

Kaniatobe, Robert — Other Tribes-Choctaw

Kanteena, Michael — Other Tribes-Laguna

Kaskalla, Jennifer — Navajo

Kast, Arlene — Apache

Katoney, Jeanette — Navajo

Kaye, Wilmer — Hopi

Kee, Alice L. — Navajo

Keene, Adrianne R — Hopi

Keene, WayaGary — Acoma

Keene, Sr., Gus — Navajo

Keith, Shonie C. — Navajo

Kelly, Robert — Navajo

Kelsey, Melvilla R — Acoma

Kemp, Randy G. — Other Tribes-Choctaw-Creek

Kessler, Jr., John M. — Other Tribes-Shawnee

Kewanwytewa, Darrell W. — Hopi

Kewanyama, Elroy — Hopi

Kewanyama, Michelene — Hopi

Keyonnie, Christine — Navajo

Keyonnie, Julius — Navajo

Kieyoomia, Joe L. — Navajo

Kills In Sight, Vernal — Sioux - Rosebud

Kills The Enemy, Lester — Sioux - Rosebud

King, Jr., Jim B. — Navajo

Kirk, Andy Lee — Isleta

Kirk, Melanie — Isleta

Kirk, Michael — Isleta

Kirk, Michael L. — Isleta

Kirstine, Arlene — Navajo

Klopmeyer, Diana — Other Tribes-Yurok

Knife, Ivan — Sioux - Rosebud

Kohlmeyer, Royce EB — Jemez

Koinva, Anderson — Hopi

Kokaly, Mary Lou — Isleta-San Juan

Koruh, Fred — Hopi

Krumanocker, Carolyn — Other Tribes-Chickasaw

Kuka, King — Other Tribes-Blackfeet

Kurley, Yvonne — Navajo

Kuyvaya, Susie — Hopi

La Russo, Arresta — Navajo

Laahty, Ricky — Zuni

Laate, Yolanda — Zuni

Laban, Vernon — Hopi

LaFortune, Leon — Other Tribes-Coast Salish

LaFountain, Bruce — Other Tribes-Chippewa

LaFountain, Presley — Other Tribes-Chippewa

Laktonen, Jerry — Other Tribes-Sugpiaq

Lalio, Filmer L. — Zuni

Lalio, Lydia V. — Zuni

Lansing, Bob — Navajo

LaRance, Steve W. — Hopi-Assiniboine

Larney, Brian — Other Tribes-Seminole-Choctaw

LaRue, Henri K. — Other Tribes-Tlingit

Larvie, Beverly — Sioux - Rosebud

Laughing, Charlene — Navajo

Laughing, Michele — Navajo

Laughing, Mona — Navajo

LaValdo, Chavez — Navajo

Leading Fighter, Nick — Sioux - Rosebud

Learned, Brent — Other Tribes-Cheyenne-Arap

Lee, Albert — Navajo

Lee, Allison — Navajo

Lee, Buddy — Other Tribes-Kiowa

Lee, Cecelia — Navajo

Lee, Cherie — Navajo

Lee, Clarence — Navajo

Lee, Clinton — Navajo

Lee, Daniel — Navajo

Lee, Emma R. — Navajo

Lee, Harry — Navajo

Lee, Joey — Navajo

Lee, Marcelia — Navajo

Lee, Mary — Navajo

Lee, Peggy — Navajo

Lee, Stanley — Navajo

Lee, Tony — Navajo

Leeds, Martha — Other Tribes-Laguna-Pima

Leno-Shutiva, Regina — Acoma

Leonard, Leland L. — Navajo

Leslie, Nelson — Navajo

Lester, Joe — Navajo

Leuppe, Melinda — Navajo

LeValdo, Lorenzo E. — Navajo

Leverich, Laura L. — Other Tribes-Nisqually

Lewis, Bernard — Acoma

Lewis, Carmel — Acoma

Lewis, Carmen — Acoma

Lewis, Jane Y. — Navajo

Lewis, Judy — Navajo

Lewis, Lorraine Gala — Other Tribes-Laguna-Taos-Hopi

Lewis, Nelson — Navajo

Lewis, RoseMary — Santa Clara

Lewis, Sharon — Acoma

Lewis, Timm — Navajo

Lewis, Travis — Santa Clara

Lewis Garcia, Dolores — Acoma

Lewis Hanson, Anne — Acoma

Lewis Mitchell, Emma — Acoma

Leyba, Rinna R. — Navajo

Liston, Bernadine — Navajo

Liston, Joey — Navajo

Liston, Larry — Navajo

Litson, Barry — Navajo

Litson, Malvina — Navajo

Little, James — Navajo

Little Brave, Reginald — Sioux - Rosebud

Little Elk, Dorothy — Sioux - Rosebud

Littlebird, Harold — Other Tribes-Laguna-SDP

Littletree, Jasper — Navajo

Livingston, Jake I. — Navajo

Lockey, Dusti — Cherokee-Goigi-tsi-Qua

Loma, Bryan — Hopi

Loma, Herman — Hopi

Lomahaftewa, Dan V. — Hopi

Lomahaftewa, Linda — Hopi-Choctaw

Lomahoema, Carol — Hopi

Lomahquahu, Alfred Bo — Hopi

Lomatewama, Ramson — Hopi

Lomay, Peggy — Hopi

Lomayaoma, Sr., Wilmer — Hopi

Lomayestewa, Remalda — Hopi

Lone Wolf, Day — Other Tribes-Abenaki

Lonewolf, Rosemary — Santa Clara

Long, Rose — Navajo

Lonning, Odin — Other Tribes-Tlingit

Loretto, Bea — Jemez

Loretto, Estella — Jemez

Loretto, Felicia — Jemez

Loretto, Glenda K. — Jemez

Loretto, Priscilla — Jemez

Loretto, Virgil — Navajo

Louis, Deann — Acoma

Louis, Earl — Acoma

Louis, Gerri — Acoma

Louis, Irvin — Acoma

Louis, Reycita R. — Acoma

Lovato, Anthony — Santo Domingo

Lovato, Augustine — Santo Domingo

Lovato, Calvin — Santo Domingo

Lovato, Eldra — Santo Domingo

Lovato, Julian — Santo Domingo

Lovato, Maria S. — Santo Domingo

Lovato, Marie — Santo Domingo

Lovato, Mary C. — Santo Domingo

Lovato, Pilar — Santo Domingo

Lovato, Ray — Santo Domingo

Lovato, Jr., Felix — Santo Domingo

Lowden, Virginia — Acoma

Lucario, Rebecca — Acoma

Lucas, Steve — Hopi

Lucas, Yvonne E. — Hopi-Laguna

Lucas, Yvonne E. — Other Tribes-Laguna

Lucero, Diana — Other Tribes-Zia

Lucero, Diane — Jemez

Lucero, Joyce — Jemez

Lucero, Mary — Jemez

Lucero, Mary J. — Jemez

Lucero, Virginia — Jemez

Lucero-Gachupin, Carol G. — Jemez

Luger, Joanne — Other Tribes-Northern Tuchone

Lujan-Hauer, Pam — Other Tribes-Taos

Lunasee, Reynold — Zuni

Mace, Eva — Navajo

Mace, Harvey — Navajo

Mace, Lenora — Navajo

Mace, Ted — Navajo

Machauty Ware, Tom — Other Tribes-Kiowa-Comanche

Madalena, Mary T. — Jemez

Madalena, Reyes — Jemez-Zia-Cochiti

Magdalena, Carmelita — Jemez

Maha, Loren B. — Hopi

Mahape, Carl — Hopi

Mahkewa Jr., Donald — Hopi

Mahle, Gloria — Hopi

Makes Room, Donroy — Sioux - Rosebud

Maktima, Duane — Other Tribes-Laguna-Hopi

Maktima, Joe — Other Tribes-Laguna-Hopi

Maldonado, Alex — Other Tribes-Yaqui

Maldonado, Merced — Other Tribes-Yaqui

Maloney, Arnold — Navajo

Maloney, Leonard — Navajo

Maloney, Ron — Navajo

Maney, Betty — Cherokee

Mankiller, Serena — Cherokee

Mann, Lula — Navajo

Manygoats, Betty — Navajo

Manygoats, Laverna — Navajo

Maracle, David R. — Other Tribes-Mohawk

Marion, Andy — Navajo

Marshall, Alvin — Navajo

Martin, Bill — Cochiti

Martin, Bobby — Navajo

Martin, Mary — Cochiti

Martinez, Anette — Navajo

Martinez, Becky — San Ildefonso

Martinez, Bronco — Navajo

Martinez, Calvin — Navajo

Martinez, Herman — Navajo

Martinez, Leon — Navajo

Martinez, Lindolfo — Sioux - Oglala

Martinez, Philip C. — Other Tribes-Taos

Martinez, Ron — Isleta-Taos

Martinez, Ronnie — Santa Clara

Martinez, Sally — Navajo

Martinez, Sarah — Acoma

Martinez, Velma — Navajo-Pima

Martinez, Yolanda — Apache

Martinez, Yvonne — Navajo

Matthews, Dewayne — Cherokee-Chick

Mauldin, Jane M. — Other Tribes-Choctaw

McAlester, Donna B. — Other Tribes-Creek

McAllister, Pat — Cherokee

McCabe, Andrew — Navajo

McCabe, Cheryl — Navajo

McCabe, Christopher — Navajo

McCabe, Joe N. — Navajo

McCray, Herman — Navajo

McCray, Ronald — Navajo

McCullough, Michael — Other Tribes-Choctaw

McCullough, Stephen — Other Tribes-Choctaw

McHorse, Christine — Navajo

McHorse, Joel — Navajo

McIntyre, Chuna — Other Tribes-
 Yupik

McKelvey, Cecilia — Navajo

McKelvey, Celeste — Navajo

McKelvey, Celinda — Navajo

McKelvey, Lucy L. — Navajo

McKeown, Ray — Sioux

McKinley, Bill — Navajo

McLaughlin, Charles C. — Sioux

McNeil, Ken — Other Tribes-
 Tahitan-Tlingit

Meade, Marie — Other Tribes-
 Yupik

MedicineFlower, Grace — Santa
 Clara

Medina, Angelina — Acoma-Zia-
 Zuni

Medina, Elizabeth — Other
 Tribes-Zia

Medina, Marcellus — Other
 Tribes-Zia

Meeches, Garry J. — Other Tribes-
 Ojibway

Melchor, Crucita — Santo Domingo

Melchor, Marlene — Santo
 Domingo

Menchego, Art — Other Tribes-
 Santa Ana

Mentuck, Walter S. — Other
 Tribes-
 Waywayseecappo

Mermejo, Jess — Other Tribes-
 Picuris

Meshake, Rene — Other Tribes-
 Ojibway

Michaels, Dean — Hopi

Michel, Carmen — Santa Clara

Mike, Jonathan — Navajo

Mike, Ruth — Navajo

Miles, Armenia — Other Tribes-
 Cayuse-Hail

Milford, Erwyn — Navajo

Miller, Karen — Acoma

Miller, Merlinda — Acoma

Miller, Ted — Cherokee-M/P

Mirabal, Cloud Eagle — Other
 Tribes-Nambe

Mirabal, Frank — Other Tribes-
 Taos

Mirabal, Robert — Other Tribes-
 Taos

Mitchell, Anna B. — Cherokee

Mitchell, Elsie — Navajo

Mitchell, Mary — Navajo

Mitchell, Ron — Cherokee

Mitchell, Steve — Cherokee

Mitchell, Toney — Navajo

Modeste, Gus — Other Tribes-
 Coast Salish

Monague, Sandra L — Other
 Tribes-Beausoleil

Monongya — Hopi

Monongye, Jesse Lee — Navajo

Montano, Valencia — San Felipe

Montour, David A. — Other
 Tribes-
 Potawatomi

Mooya, Aldrick — Hopi

Moquino, Camille — Santa Clara

Moquino, Corn — Santa Clara

Moquino, Jen — Other Tribes-Tesuque

Moquino, Randy — Other Tribes-Tesuque

Moquino, Tom — Santo Domingo

Morgan, Jason — Navajo

Morgan, Larry — Navajo

Morgan, Malena — Navajo

Morgan, Manuel — Navajo

Morgan, Meridth C. — Other Tribes-Yakama

Morgan, Yanua — Navajo

Morris, Arnold A. — Navajo

Morris, Calvin — Navajo

Morris, Carol — Navajo

Morris, David — Other Tribes-Choctaw

Morrison, Eddie — Cherokee

Murphy, William — Navajo

Myers, Ella — Navajo

Naavaasya — Hopi

Naha, Elvira — Hopi

Naha, Emmaline — Hopi

Naha, Marty — Hopi

Naha, Rainy — Hopi

Nahohai, Josephine — Zuni

Nahohai, Milford — Zuni

Nahohai, Randy — Zuni

Nahohai, Rowena — Zuni

Nailor, Gerald — Other Tribes-Picuris

Nakai, Bernice J. — Navajo

Nakwesee — Other Tribes-Kwautil-Cherok.

Namingha, Joc elyn — Hopi

Namingha, Les — Hopi

Namingha, PamTahbo — Hopi

Namoki, Crecinda — Hopi

Namoki, Lawrence — Hopi

Namoki, Lucinda E — Hopi

Namoki, Valerie — Hopi

Namoki, Watson — Hopi

Naranjo, Betty — Santa Clara

Naranjo, Carol G. — San Ildefonso

Naranjo, Dolly — Santa Clara

Naranjo, Dusty — Santa Clara

Naranjo, Florence — San Ildefonso

Naranjo, Geri — Santa Clara

Naranjo, Gracie — Santa Clara

Naranjo, Isabel — Santa Clara

Naranjo, Jody — Santa Clara

Naranjo, Karen — Santa Clara

Naranjo, Kathy G. — San Ildefonso

Naranjo, Kevin — Santa Clara

Naranjo, Louis — San Ildefonso

Naranjo, Maria I. — Santa Clara

Naranjo, Reycita — Santa Clara

Naranjo, Robert — Santa Clara

Naranjo, Robert — Santa Clara

Naswyowma, Curtis — Hopi-Taos

Natachu, Chris — Zuni

Natesway, Charmae S. — Acoma

Natseway, Thomas — Acoma

Navasie, Dawn — Hopi

Naveek — Navajo

Neel, David — Other Tribes-Kwagiutl

Negale, Gary — Hopi

Nelson, Albert — Navajo
Nelson, Angie — Navajo
Nelson, Arkie — Navajo
Nelson, Ben — Navajo
Nelson, Bennie — Navajo
Nelson, Diane — Navajo
Nelson, Jasper — Navajo
Nelson, Jerry — Navajo
Nelson, L.Eugene — Navajo
Nelson, Laberta — Navajo
Nelson, Peter — Navajo
Nelson, Roger — Navajo
Nelson, Tonya — Navajo
Neptune, Jennifer — Other Tribes-
 Penobscot
Neptune, Martin — Other Tribes-
 Penobscot
Nequatewa, Verna "Sonwai" —
 Hopi
Nevaquaya, Lean Tate — Other
 Tribes-Comanche
Nez, Anthony — Navajo
Nez, Arlene — Navajo
Nez, Darlene — Navajo
Nez, David C. — Navajo
Nez, Delbert — Navajo
Nez, Ethel — Navajo
Nez, Gibson — Navajo-Apache
Nez, Gilbert — Navajo
Nez, Jonathan — Navajo
Nez, Julian — Apache-Navajo
Nez, Leona R. — Navajo
Nez, Michael — Navajo
Nez, Phillip A. — Navajo
Nez, Redwing — Navajo

Nez, Rick — Navajo
Nez, Rita — Navajo
Nez, Sidney — Navajo
Nez, Virgil J. — Navajo
Nez,Jr, Wallace — Navajo
Nicholas, Burt — Hopi
Nicholas, Lou — Hopi
Nicola, Tim — Other Tribes-
 Penobscot
Nofchissey, Bobby — Navajo
Nokomis — Other Tribes-Ojibwa
Nordwall, Al — Other Tribes-
 Chippewa
Nordwall, Raymond — Other
 Tribes-Pawnee-
 Chippe
Not Afraid, Julius — Sioux -
 Oglala
NunezVelarde, Sheldon —
 Apache-Jicarilla
Obrzut, Kim — Hopi
Ohmsatte, Emery — Zuni
Okuma, Jamie — Other Tribes-
 LaJolla Band
Okuma, Sandra — Other Tribes-
 LaJolla Band
Oliver, Elise — Navajo
Oliver, Marvin — Other Tribes-
 Quinalt-Isleta
Olney, Rose — Other Tribes-
 Yakama
Omaha Boy, George — Sioux -
 Rosebud
Omaha Boy, Philomine — Sioux -
 Rosebud
One Star, Anabelle — Sioux -
 Rosebud

One Star, Marion — Sioux - Rosebud

Ornelas, Barbara JT — Navajo

Orr, Meg — Other Tribes-Colville

Ortiz, Ben — San Felipe

Ortiz, Evelyn — Acoma

Ortiz, Janice — Cochiti

Ortiz, Joe — San Felipe

Ortiz, Juanita — Cochiti

Ortiz, Lester — Navajo

Ortiz, Luana — San Felipe

Ortiz, Ricardo — San Felipe

Ortiz, Santana — San Felipe

Ortiz, Seferina — Cochiti

Ortiz, Stella M. — San Felipe

Ortiz, Virgil — Cochiti

Ortiz, William — Navajo

Osceola, Betty L. — Other Tribes-Miccosukee

Osceola, Joe Dan — Other Tribes-Seminole

Osceola, Virginia — Other Tribes-Seminole

Osti, Jane — Cherokee

Othole, Gibbs — Zuni

Owens, Mary S. — Navajo

Pablo, Leslie — Navajo

Pacheco, Andrew — Santo Domingo

Pacheco, Domingo — Santo Domingo

Pacheco, Eddie — Santo Domingo

Pacheco, Gilbert — Santo Domingo

Pacheco, Gladys — Santo Domingo

Pacheco, Joe E. — Santo Domingo

Pacheco, Larry — Santo Domingo

Pacheco, Marilyn — Santo Domingo

Pacheco, Nelson — Santo Domingo

Pacheco, Norman — Other Tribes-San Juan

Pacheco, Patricia D. — Other Tribes-Laguna-Chippewa

Pacheco, Paulita T. — Santo Domingo

Pacheco, Sallie — Santo Domingo

Pacheco, Teresa L. — Santo Domingo

Pacheco jr., Ramos — Santo Domingo

Pacheco jr., Venencia — Santo Domingo

Padilla, Andy — Santa Clara

Padilla, Marcia — Santa Clara

Padilla, Thelma — Apache

Padilla, Jr., Fernando — San Felipe

Pahnke, Laurie Grimes — Other Tribes-Aleut-Unangan

Pahponee — Other Tribes-Kickapoo

Paisano, Cheryl J. — Other Tribes-Laguna-Cherok.

Paisano, Michelle — Other Tribes-Laguna-Acoma

Paisano, Ulysses G. — Other Tribes-Laguna

Pajarito, Florence — Santo Domingo

Pajarito, Joe — Santo Domingo

Pajarito, Mary — Santo Domingo

Pakootas, Lucille — Other Tribes-Colville

Palmer, Lula — Navajo

Panana, Ruby — Jemez

Panteah, Loren — Zuni

Panteah, Myron — Zuni

Paquin, Allen R. — Zuni-Apache

Paquin, AllenBruce — Jemez-Zuni-La

Paquin, Geraldine — Zuni-Laguna

Paquin, Gladys — Other Tribes-Laguna

Paquin, Glenn — Other Tribes-Laguna-Zuni

Paquin, Karen D. — Other Tribes-Laguna

Paquin, Leonard — Zuni-Laguna

Paquin, Opal — Other Tribes-Laguna-Zuni

Parker, Lonn — Navajo

Parker, Stanley — Navajo

Parrish, Albert — Navajo

Pasata, Melvin — Apache-Jicarilla

Patricio, Georgia — Acoma

Patricio, Leo — Acoma

Patricio, Lionel — Acoma

Paywa, Keith — Zuni

Pecos, Nadine — Cochiti

Pena, Amado — Other Tribes-Mestizo

Pena, Laura — Other Tribes-Santa Ana

Peone, Les — Other Tribes-Salish-Kootenai

Perdasofpy, Roger — Other Tribes-Comanche-Kiowa

Perdasofpy, Sharon — Other Tribes-Comanche-Cheyen

Perry, Marlene — Navajo

Perry, Michael — Navajo

Pesata, Joan — Apache-Jicarilla

Pesata, Lydia — Apache-Jicarilla

Pesata, Melanie — Apache-Jicarilla

Peshlakai, Davis — Navajo

Peshlakai, Linda M. — Navajo

Peshlakai, Norbert — Navajo

Pete, Geneva A. — Navajo

Peters, David — Navajo

Peters, Juanito — Navajo

Peterson, Yvonne — Other Tribes-Chehalis

Peterson Sr., Pete — Other Tribes-Skokomish

Peterson, Sr., Reggie — Other Tribes-Tlingit

Pettigrew, Raymond — Navajo

Pettigrew, Terry — Navajo

Peynetsa, Agnes — Zuni

Piaso, Melinda G — Navajo

Piaso, Thompson — Navajo

Piaso Jr., Joe — Navajo

Piche, Patricia — Other Tribes-Chippewa-Cree

Pino, Vicentita S — Other Tribes-Zia

Pino-Griego, Eleanor — Other Tribes-Zia

Pinto, Marvin — Zuni

Pioche, Dennis — Navajo

Pitt, Lillian — Other Tribes-Yakima

Platero, Charlene — Navajo

Platero, Curtis — Navajo

Platero, Edward — Other Tribes-Laguna

Platero, Fannie — Navajo

Poblano, Dylan — Zuni

Poblano, Jovanna — Zuni

Poblano, Veronica — Zuni

Point, Susan A. — Other Tribes-Coast Salish

Polacca, Delmar — Hopi

Polacca, Thomas — Hopi

Polacca, Trish — Hopi

Poley, Orin — Hopi

Poncey-Homer, Jimmie — Navajo

Poncey-Homer, Sally — Navajo

Ponder, Kimberlee — Isleta

Poolheco, Frank — Hopi

Poolheco, Terri — Hopi

Poor Bear, Darlene — Sioux - Oglala

Poor Bear Martinez, Elaine — Sioux - Oglala

Pooyouma, Gene — Hopi

Pooyouma, Margaret — Hopi

Portley, Ronald — Navajo

Portley, Ronald — Navajo-Apache

Pourier, Kevin — Sioux

Pourier, Valerie — Sioux

Pratt, Charlie — Other Tribes-Cheyenne-Arap

Preacher, Willie — Other Tribes-Shoshone-Bannock

Preston, Brian — Navajo

Priore, Jackie S. — Other Tribes-Kiowa

Proctor, Tiana — Cherokee

Prokopiof, Bill — Other Tribes-Aleut

Puhuyesva, Gayver — Hopi

Purley, Tony — Other Tribes-Laguna

Purley, Wilma — Other Tribes-Laguna-Hopi

Qoyawayma, Al — Hopi

Quam, Andrew — Zuni

Quam, Eldred — Zuni

Quam, Georgette — Zuni

Quam, Jayne — Zuni

Quam, Laura — Zuni

Quam, Lynn — Zuni

Quannie, Emerson — Hopi

Quannie, Kevin H. — Hopi

Quintana, Albert — Santo Domingo

Quintana, Cris — Santo Domingo

Quintana, Shelly — Santo Domingo

Quotskuyva, Gerry — Hopi

Rabbit, Bill — Cherokee

Rabbit, Traci — Cherokee

Radcliffe, Sylvia B. — Navajo

Rael, Joseph E. — Other Tribes-Southern Ute

Rael, Sr., Joseph E. — Other Tribes-Southern Ute

Rainstorm, J. D. — Other Tribes-San Juan-Laguna

Ramone, Dennis T. — Navajo

Rankin, Heidi BigKnife — Other Tribes-Shawnee

Rattey, Harvey — Other Tribes-Pembina-Assini

Rattler, Polly — Cherokee

Ray, Marilyn — Acoma

Real Rider, Austin — Other Tribes-Pawnee

Reano, Angie — Santo Domingo

Reano, Charlene — San Felipe

Reano, Charlene L — Santo Domingo

Reano, Charlotte — Santo Domingo

Reano, Dena — Santo Domingo

Reano, Denise — Santo Domingo

Reano, Frank — San Felipe

Reano, Irene — Santo Domingo

Reano, Joe L — Santo Domingo

Reano, Percy — Santo Domingo

Reano, Rose — Santo Domingo

Red Bird, Andrew — Sioux - Rosebud

Red Bird, Vida — Sioux - Rosebud

Red Star, Kevin — Other Tribes-Crow

Redbird — Cochiti

Redbird, Ernest R. — Other Tribes-Kiowa

Redbird, Petur S. — Other Tribes-Seminole-Creek

Redbird, Robert — Other Tribes-Kiowa

Redbird, Robert Jr. — Other Tribes-Kiowa

Redbird, Steven — Other Tribes-Kiowa

Redbird, Tonia — Other Tribes-Kiowa

Redbird, Tony — Other Tribes-Kiowa

Redbird, Will — Other Tribes-Kiowa

Redfox, Mark — Other Tribes-Arikara-Lakota

Redhorse, Jennifer C. — Navajo

Reeves, Daniel — Navajo

Relton, Steve — Other Tribes-Mi'kmaq

Reyna, Sharon D. — Other Tribes-Taos

Richard, Reuben — Navajo

Richards, Woody — Sioux

Roach, Jean — Sioux

Roberson, Bill "Wolf" — Cherokee

Rodriguez-C, Margaret — Other Tribes-Laguna

Rogers, Alta — Other Tribes-Paiute-Yurok

Rogers, Kay B. — Navajo

Rogers, Michael — Other Tribes-Paiute

Rogers, Michael R. — Other Tribes-Paiute

Rogge, David A — Hopi

Rogge, Mary Coin — Hopi

Roller, Cliff — Santa Clara

Roller, Jeff — Santa Clara

Roller, Susan — Santa Clara

Roller, Toni — Santa Clara

Romero, Annette — Cochiti-San Ild.

Romero, Maria P. — Cochiti

Romero, Marie G. — Jemez

Romero, Shawna A. — Other Tribes-Paiute-Taos

Rope, Evelyn — Apache

Rorex, Jeanne — Cherokee

Rose (Naranjo), Marian — Santa Clara

Rosetta, Jessie — Santo Domingo

Rosetta, Paul — Santo Domingo

Rousseau, J. — Sioux

Rowlodge III, Arthur R. — Other Tribes-Arapaho-Choct.

Roy, Silas — Hopi

Roybal, Gary A. — San Ildefonso

Roybal, Peter A. — Other Tribes-Pojoaque

Roye, Paladine — Other Tribes-Ponca

Ruminer, W. Keith — Other Tribes-Seminole-Creek-Choctaw

Runnels, Gary — Navajo

Runnels, Jennifer — Navajo

Runningwolf,Sr, Gale — Other Tribes-Blackfeet

Russell, Archie J. — Other Tribes-Pima

Sacoman, Beverly Jose — Apache-Mescalero

Sahme, Jean — Hopi

Sakeva,Jr., Alfonso — Hopi

Sakiestewa, Abel — Hopi

Sakiestewa, Ramona — Hopi

Sakiestwea, Lydia — Hopi

Salas, Bennie — Other Tribes-Zia

Salvador, Maria "Lilly" — Acoma

Salvador, Sofie — Isleta

Sam, Ben — Navajo

Sam, Daniel V. — Other Tribes-Picuris

Sam, Fannie — Navajo

Sam, Mike — Navajo

Sam, Pauline — Navajo

Sam, Sherry — Navajo

Sanchez, Albert L. — San Felipe

Sanchez, Deborah J. — Isleta

Sanchez, Fern M. — Other Tribes-Picuris

Sanchez, Kathy WanPovi — San Ildefonso

Sanchez, Russell — San Ildefonso

Sanchez, Vivian — Santo Domingo

Sandia, Geraldine — Jemez

Sandia, Natalie — Jemez

Sandia, Rachael — Jemez

Sandman, Lorenzo — Navajo

Sandman, Lynda — Navajo

Sando, Caroline — Jemez

Sandoval, Casey — Navajo

Sandoval, Mary B. — Navajo

Sandoval, Patricea — Navajo-
Cherokee

Sandoval, Raye C. — Navajo

Sapa, Wambli — Sioux

Sarracino, Caroline — Acoma

Sarracino, Pauline — Jemez

Sarracino, Raphael — Other
Tribes-Laguna

Sarracino Jr., Ralph — Other
Tribes-Laguna

Sarracino Jr., Vivian — Jemez

Sauceda-Halliday, Michelle —
Other Tribes-
Yaqui

Saufkie, Griselda — Hopi

Saufkie, Joyce Ann — Hopi

Saufkie, Lawrence — Hopi

Savage, Jeff — Other Tribes-
Chippewa

Schrupp, Nelda — Other Tribes-
Ihunktewan

Schultz, Marilou — Navajo

Scott, Marie — Navajo

Scott, Patrick — Navajo

Scott, Quenby — Navajo

Seabourn, Bert — Cherokee

Sehuanes-Urbaniak, Enilse —
Other Tribes-
Guianbiano

Sekakuku, Gloria — Hopi

Sekakuku, Jr., Sidney — Hopi

Sekaquaptewa, Selwyn W. —
Hopi

Self, Gale C. — Other Tribes-
Choctaw

Selina, Alberta — Hopi

Selina, Roger — Hopi

Selina, Vanessa — Hopi

Selina, Weaver — Hopi

Seonia, Caroline — Jemez

Seoutewa, Charlotte — Zuni

Seoutewa, Eldrick — Zuni

Sequaptewa, Raymond — Hopi

Serbin, Sal — Sioux-Assini.

Setalla, Dee — Hopi

Setalla, Pauline — Hopi

Sevier, Jackie — Other Tribes-
Arapaho

Sheirbeck, Jock — Sioux -
Rosebud

Shelton, Bobbi — Cherokee

Shelton, Henry — Hopi

Shelton III, Peter H. — Hopi

Shemayme, Shirly — Other
Tribes-Picuris

Shepherd, Cindy — Navajo

Shepherd, Doug — Navajo

Shepherd, Rosabelle — Navajo

Sherer, Deborah — Other Tribes-
Blackfeet

Sherer, Deborah — Other Tribes-
Blackfeet

Shields, Joe — Sioux - Rosebud

Shields, Judy — Acoma

Shields, Roger — Sioux - Rosebud

Shije, Cornelia J — Jemez

Shije, Eusebia — Other Tribes-Zia

Shirley, Genevieve — Navajo

Shirley, Irma J. — Navajo

Shirpoya — Isleta

Shorty, Ambrose L — Navajo

Shorty, Ben D. — Navajo

Shorty, Eddy — Navajo

Shot, Raymond — Sioux - Rosebud

Shotridge, Israel — Other Tribes- Tlingit

Shurley, Walter — Navajo

Shurley-Olivas, Laura G. — Navajo

Shutiva, Stella — Acoma

Sice, Howard — Other Tribes- Laguna-Hopi

Silversmith, Deborah — Navajo

Silversmith, Mark — Navajo

Simplico, Noreen — Zuni

Simpson, Melody — Acoma

Simpson, Samuel — Navajo

Sine, Duke W. — Apache

Singer, Mary — Santa Clara

Singer, Penny — Navajo

Singer, Tammy — Other Tribes- San Juan-S.C.

Skywolf, Joseph — Other Tribes- Lumbee-Apache

Slaughter, Marylou — Other Tribes-Duwamish

Slick, Lucinda — Navajo

Slim, Grace — Navajo

Slim, Marvin — Navajo

Slim, Michael — Navajo

Slim, Michelle — Navajo

Slim, Victoria — Navajo

Sloan, Jarvis — Navajo

Small, Mary — Jemez

Small, Simon — San Felipe

Small Bird, Sierra — Other Tribes-Shawnee-Paiute

Smith, Ann — Other Tribes- Kwanlin Dun

Smith, Daniel — Navajo

Smith, Hanson — Navajo

Smith, Harold R. — Navajo

Smith, Jack — Navajo

Smith, Jimmy — Navajo

Smith, Lorraine — Navajo

Smith, Lucille — Navajo

Smith, Patrick — Navajo

Smith, Stan — Navajo

Smith, Sr., Daniel R. — Navajo

Smoke, Suzanne — Other Tribes- Ojibway

Snow, Alice — Other Tribes- Seminole

Snow, Carol — Other Tribes- Seneca

Sockyma, Lee — Hopi

Sockyma, Michael — Hopi

Sockyma, Theodora — Hopi

Solomon, Floyd — Other Tribes- Laguna-Zuni

Solomon, Reba J. — Other Tribes- Kiowa-Cheyenne

Solomon, Verna — Other Tribes- Laguna

Sosa, Cindy — Isleta

Soseeah, Berdel — Zuni

Spencer, Alicia — Navajo

Spencer, Julie — Navajo

Spencer, Sadie — Navajo

Spilsbury, Delaine — Other Tribes-Shoshone

Spotted Horse, Gloria Black — Sioux - Rosebud

Standing Elk, Lyndon — Other Tribes-Cheyenne

Standing Elk, Virginia N. — Navajo

Stanley, Ilona — Other Tribes-Ojibwa

Steffler, Larry — Other Tribes-Sauk

Stepetin, Larissa — Other Tribes-Assiniboine-Aleut

Stevens, Jacquie — Other Tribes-Winnebago

Stock, Midge Dean — Other Tribes-Seneca

Stone, Diana — Sioux - Rosebud

Stone, Linda — Sioux - Rosebud

Stone, Mary — Cherokee

Stone, Jr., Roy — Sioux - Rosebud

Storer, Sanford — Navajo

Storm, Mary Jane — Other Tribes-Seminole

Stroud, Virginia — Cherokee-Creek

Studer, F. Maxine — Cherokee

Suazo, Anita L. — Santa Clara

Suazo, Candelaria — Santa Clara

Suazo, David Gary — Other Tribes-Taos

Suazo, Joseph — Santa Clara

Suazo, Marie — Santa Clara

SuazoNaranjo, Bernice — Other Tribes-Taos

Suina, Anthony — Cochiti

Suina, Dena M — Cochiti

Suina, Vangie — Cochiti

Sullivan, Dorothy — Cherokee

Sullivan, Lola — Navajo

Sundheim, Joyce — Other Tribes-Penobscot

SunFlower, LaHoma — Santa Clara

Susunkewa, Manfred — Hopi

Susunkewa, Norma — Hopi

Susunkewa, Sheryl L. — Hopi

Swallow, Suzanna — Sioux - Rosebud

Swett, Rose — Navajo

Syliboy, Alan — Other Tribes-Mi'kmaq

Szabo, Linda T. — Sioux - Lakota

Szabo, Paul — Sioux - Lakota

Tabaha, Fannie — Navajo

Tafoya, Brenda — Jemez

Tafoya, Celes — Santa Clara

Tafoya, Cresencia — Santa Clara

Tafoya, Emily — Santa Clara

Tafoya, Ernest — San Ildefonso

Tafoya, Forrest — Santa Clara

Tafoya, Harriet — Santa Clara

Tafoya, Jennifer — Santa Clara

Tafoya, Juan — San Ildefonso

Tafoya, Judy — Santa Clara

Tafoya, Laura — Santa Clara

Tafoya, Lincoln — Santa Clara

Tafoya, Linette — Santa Clara

Tafoya, Lorenzo — Santo Domingo

Tafoya, Lu Ann — Santa Clara

Tafoya, Mary L. — Santo Domingo

Tafoya, Michelle T — Santa Clara

Tafoya, Mida — Santa Clara

Tafoya, Quincy — Santa Clara

Tafoya, Robert M. — Santa Clara

Tafoya, Vangie — Jemez

Tafoya, Wanda J. — Santa Clara

Tahbo, Mark — Hopi

Tahbo-Howard, Dianna — Hopi

Tahe, Zane — Navajo

Taho, Blanche — Navajo

Taho, Mark — Navajo-Hopi

Tahy, Carrie A. — Navajo

Tait, Isaac — Other Tribes-Nisga'a

Talachy, Pearl — Other Tribes-Nambe

Talahaftewa, Evangeline — Hopi

Talahaftewa, Roy — Hopi

Talahytewa, Stacy — Hopi

Taliman, Alice — Navajo

Tallman, Helen — Navajo

Tapia, Frank — Santa Clara

Tapia, Mae — Santa Clara

Tapia, Ramona — Santa Clara

Tapia, Sue — Other Tribes-San Juan

Tapia, Thomas — Other Tribes-Tesuque

Tapia, Tom — Other Tribes-San Juan

Tapia, Wenona — Santo Domingo

Tarbell, Marnie Lyn — Other Tribes-Mohawk

Tarbell Boehning, Tammy — Other Tribes-Mohawk

Tasyatwho, Marie S. — Navajo

Tawaventiwa, Lomasohu — Hopi

Taylor, Alvin — Hopi

Taylor, Cindy — Hopi

Taylor, Lillie T. — Navajo

Taylor, Mary — Navajo

Taylor, Max — Hopi

Taylor, Milson — Hopi

Taylor, Tsosie — Navajo

Taylor, Urshel — Other Tribes-Pima-Ute

Tchin — Other Tribes-Blackfeet-Narragan

Teasyatwho, Ambrose — Navajo

Teasyatwho, Cherileen — Navajo

Teasyatwho, Elnora — Navajo

Teller, D. — Navajo

Teller, Everett — Navajo

Teller, M. — Navajo

Teller, Mary C. — Navajo

Teller, Robin — Isleta

Teller, Stella — Isleta

Tenakhongva, Clark — Hopi

Tenorio, Doris E. — Santa Clara

Tenorio, Gabby — Santo Domingo

Tenorio, Howard — Santo Domingo

Tenorio, Margaret — Santo Domingo

Tenorio, Marilyn — Other Tribes-SDP-Navajo

Tenorio, MaryEdna — Santo
 Domingo

Tenorio, Raymond — Santo
 Domingo

Tenorio, Robert — Santo
 Domingo

Tenorio, Roderick — Other
 Tribes-SDP-
 Navajo

Tenorio, Teresa — Navajo

Tenorio, Veronica — Santo
 Domingo

Tenoso, Don — Sioux

Terry, Martha — Navajo

Tewa, Bobbie — Other Tribes-San
 Juan-Hopi

Tewayguna, Miriam — Hopi

Thadei, Lois Chichinoff — Other
 Tribes-Aleut,
 Sealaska

Thielen, Sally — Other Tribes-
 Chippewa

Thomas, Edward R. — Other
 Tribes-Chippewa

Thomas, Eleanor — Navajo

Thomas, Gilbert — Navajo

Thomas, Joseph — Other Tribes-
 Laguna-Pima

Thomas, Paulson — Navajo

Thomas, Vernon — Navajo

Thompson, Betsy — Navajo

Thompson, Carla — Sioux -
 Rosebud

Thompson, Herb — Navajo

Thompson, Mae M. — Navajo

Thompson, Marlene — Navajo

Thompson, Michael — Navajo

Thompson, Paul — Navajo

Thompson, Veronica — Navajo

Thompson, Willie — Navajo

Thorne, George L. — Cherokee

Tiger, Dana — Other Tribes-
 Muskogee

Tiger, Jon Mark — Other Tribes-
 Creek

Tioux, Bea Duran — Other Tribes-
 Tesuque

Titla, Philip — Apache

Todachine, Deanna — Navajo

Toddy, Irving — Navajo

Tohlakai, Paul C. — Navajo

Toledo, Eva — Navajo

Toledo, Everette — Navajo

Toledo, Helen — Navajo

Toledo, Herbert — Navajo

Toledo, Lena Jo — Sioux -
 Rosebud

Toledo, Minnie — Navajo

Toledo, Toney — Navajo

Tolth, Sam — Navajo

Tom, Harold — Navajo

Tom, Jack — Navajo

Tom, Leroy — Navajo

Tom, Louis — Navajo

Tom, Mary — Navajo

Tom, Terrance — Navajo

Tome, Bessie — Navajo

Tome, Jasper — Navajo

Tomeo, Jim — Other Tribes-
 Colville

Tonips, Gordon — Other Tribes-
 Comanche-Kiowa

Torivio, Dorothy — Acoma

Torivio, Frances — Acoma

Torivio, Jackie — Acoma

Torivio, Mike — Acoma

Torres, Beatrice — Other Tribes-San Juan

Torres, Gordan — Apache-San Carlos

Tortalita, Edward — Santo Domingo

Tortalita, Eilleen — Santo Domingo

Tortalita, Florence — Santo Domingo

Tortalita, Lorenzo — Santo Domingo

Tortalita, Vickie — Santo Domingo

Tosa, Laverne L — Jemez

Tosa, Phyllis M. — Jemez

Tosa, Sefora — Jemez

Touchine, Angeline — Navajo

Touchine, Ben — Navajo

Towne, Loretta — Navajo

Toya, Anita — Jemez

Toya, Benjamin — Jemez

Toya, Camilla — Jemez

Toya, Damian — Jemez

Toya, Eloise — Jemez

Toya, Gary N. — Acoma

Toya, George — Jemez

Toya, Geraldine — Jemez

Toya, Inez V. — Acoma

Toya, Jacob M. — Jemez

Toya, Judy — Jemez

Toya, Lawrence — Jemez

Toya, Mary Rose — Jemez

Toya, Maxine — Jemez

Toya, Norma — Jemez

Toya, Ruby — Jemez

Toya Fragua, Melinda — Jemez

Toya-Toledo, Yolanda — Jemez

Tracey, Ray — Navajo

Tracy, Cecil — Navajo

Tree, Robert — Navajo

Trujillo, Charles — Other Tribes-Sandia

Trujillo, Elizabeth — Cochiti

Trujillo, Gabe — Cochiti

Trujillo, Ivan — Cochiti

Trujillo, Katy — Cochiti

Trujillo, Leonard — Cochiti

Trujillo, Mary — Cochiti

Tsabetsaye, Edith — Zuni

Tsabetsaye, Tiffany — Zuni

Tsavadawa, Bertram — Hopi

Tse Pe, Dora — San Ildefonso

Tse-PeSisneros, Jenifer — Santa Clara

Tsee-PinTorres, Elvis — San Ildefonso

Tsethlikai, Fabian — Zuni

Tsideh, Than — San Ildefonso

Tsinijinnie, Evelyn — Navajo

Tsinijinnie, Felix — Navajo

Tsinijinnie, Joanne L. — Navajo

Tsinnie, Oliver Z. — Hopi-Navajo

Tsinnie, Orville — Navajo

Tsipa, Carlos — Zuni

Tso, Brian — Navajo

Tso, Ervin Dee — Navajo

Tso, Evelyn — Navajo

Tso, Faye B. — Navajo

Tso, Geraldine — Navajo

Tso, Justin — Navajo

Tso, Lavern — Navajo

Tso, Marie — Navajo

Tso, Susie — Navajo

Tso, Tommie M — Navajo

Tsosie, Calvin — Navajo

Tsosie, Danny R. — Navajo

Tsosie, Ervin — Navajo

Tsosie, Gloria — Navajo

Tsosie, Jennifer E. — Navajo

Tsosie, Leonard — Jemez

Tsosie, Lyndon B. — Navajo

Tsosie, Marie — Navajo

Tsosie, Mary S. — Jemez

Tsosie, Nelson — Navajo

Tsosie, Robert D. — Navajo-Picuris

Tubinaghtewa, Buddy — Hopi

Tumequah, Pemwah — Other Tribes-Laguna-Kickapoo

Turquoise, Ben — Navajo

Tuttle, Sonny — Sioux-Arapaho

Twinhorse, R. — San Felipe

Two Eagle, Carol — Sioux - Rosebud

Two Eagle, Lonnie — Sioux - Rosebud

Underwood, Joanna — Other Tribes-Chickasaw

Underwood, Susan T. — Other Tribes-Shawnee

Underwood V., Joyce L. — Other Tribes-Chickasaw

Upshaw, Ron — Zuni-Navajo

Vail, Geri — Navajo

Vail, Skeeter — Navajo

Valencia, Kenneth — San Felipe

Valencia, Nat — San Felipe

Vallo, Delma — Acoma

Vallo, Freida H. — Acoma

Vallo, Kim M. — Acoma

Van Fleet, Daniel — Other Tribes-Mohave-Apache

Van Wert, Gordon F. — Other Tribes-Chippewa

Vanderhoop, Evelyn — Other Tribes-Haida

Vandever, Nellie — Navajo

VanMechelen, Nadine — Other Tribes-Yurok-Karok-Talowa

Vann, Donald — Cherokee

Vargas, Ruth — Other Tribes-Aztec

Vaughn, Karole W. — Navajo

Velarde, Carol — Santa Clara

Velarde, Cris — Apache

Velarde, Mary M. — Apache-Jicarilla

Velarde, Pablita — Santa Clara

Velarde, Sandra — Santa Clara

Velarde, Tricia — Santa Clara

Velarde, Yolanda — Santa Clara

Velasquez, Bruce — San Felipe

Vicente, Sr., Otta — Navajo

Vicenti, Carson N. — Apache

Vicenti, Ed — Zuni

Vicenti, Jennie — Zuni

Vicenti, Nelson — Zuni

Victorino, Sandra — Acoma

Vigil, Carol D. — Jemez

Vigil, Charlotte — San Ildefonso

Vigil, Doug — San Ildefonso

Vigil, Ethel — Santa Clara

Vigil, Felix — Jemez

Vigil, Gordon — Other Tribes-Nambe

Vigil, James A. — Jemez

Vigil, Lonnie — Other Tribes-Nambe

Vigil, Paul — Jemez

Vigil, Victor — Jemez

Vigil-Toya, Georgia — Jemez

Vit, Linda C. — Other Tribes-Karok-Cree

Vogel, Micah — Other Tribes-Sallawish

Volante, Raymond — Other Tribes-Tohono O'Odham

Volante, Velveeta — Apache

W-Benally, Elizabeth — Navajo

Waconda, Pat — Other Tribes-Laguna-Kickapoo

Wadsworth, Bertha — Hopi

Wagner, Alois — Santo Domingo

Wall, Adrian — Jemez

Wall, Kathleen — Jemez

Wall, Stephan — Other Tribes-Chippewa

Wallace, Darrell L. — Navajo

Wallace, Denise H. — Other Tribes-Aleut

Wallace, Roberta A. — Cherokee-Apache

Walters, Daniel A. — Navajo-Pawnee

Walters, Roy M. — Navajo

Waquie, Corina Y. — Jemez

Warlow, Suzanne — Other Tribes-Yupik Eskimo

Warner, Dell — Other Tribes-Lower Cayuga

Washburn, Tim — Navajo

Watts, Ginny — Cherokee-Comanche

Watts, Judy — Navajo

Wayne, Lorraine — Navajo

Weahkee, Daniel I. — Zuni-Navajo

Weahkee, Sharon — Navajo

Wells-Norlin, Gloria — Other Tribes-Chippewa

Wero, Alberta — Navajo

Weryackwe, Jr. — Other Tribes-Comanche

Wesley, Tillier — Other Tribes-Creek

Westika, Angie — Zuni

Westika, Nancy — Zuni

Westika, Sheldon — Zuni

Westika, Todd — Zuni

White, Amos — Navajo

White, April — Other Tribes-Haida

White, Irene — Navajo

White, John A. — Cherokee
White, Kathy — Navajo
White, Kenneth — Navajo
White, Kenneth T — Navajo
White Buffalo, Judy — Sioux - Rosebud
White Dove, Shyatesa — Acoma
White Owl, Marlene — Other Tribes-Cayuse-NezPerce
White Owl, Maynard — Other Tribes-Cayuse-NezPerce
Whitebird, Mel — Other Tribes-Cheyenne
WhiteEagle, Jason — Santa Clara
Whitehorne, Geraldine — Navajo
Whitehorse, Jerome — Navajo
WhiteManRunsHim, Heather — Other Tribes-Crow
Whiterock Jr., John — Navajo
Whiteshield, Ardena — Other Tribes-So. Cheyenne
Whitethorne, Baje — Navajo
Whitethorne, Ed — Navajo
Whitethorne, Hank — Navajo
Whitethorne, Olivia — Navajo
Whitman, James C. — Other Tribes-Mandan-Hidatsa
Whitman, Kathy — Other Tribes-Mandan-Hidatsa
Williams, Arlene N. — Navajo
Williams, Clara — Navajo
Williams, Helen — Navajo

Williams, Lorraine — Navajo
Williams, Robert — Navajo
Williams, Rose — Navajo
Williams, Rosie — Navajo
Willie, Roger — Navajo
Willie, Valorie — Navajo
Willie, Jr., Harrison — Navajo
Willis, George S. — Other Tribes-Choctaw
Wilson, Clara — Navajo
Wilson, Harrison — Navajo
Wilson, Jimmy — Navajo
Wilson, Les — Navajo
Wilson, Rita — Navajo
Witt, Felice — Sioux - Oglala
Witt, Santee — Sioux - Oglala
Wollett, Patty A. — Cherokee
Woodie, Bonnie — Navajo
Woodie, Dolly — Navajo
Woodis, Lucita — Navajo
Woods, Agnes — Navajo
Woody, Jr., Ben — Navajo
Woolenshirt, James K. — Navajo
Wright, Gerald — Sioux - Rosebud
Yabeny, Harry E. — Navajo
Yatsayte, Mike — Zuni
Yauney, Kathryn — Cherokee
Yazzen, Ben — Navajo
Yazzie, Alice — Navajo
Yazzie, Angie — Other Tribes-Taos
Yazzie, Carl — Navajo
Yazzie, Darlene — Navajo
Yazzie, Darrell — Navajo

Yazzie, Douglas — Navajo
Yazzie, Ed — Navajo
Yazzie, Elmer — Navajo
Yazzie, Evelyn — Navajo
Yazzie, Gary — Navajo
Yazzie, Herman — Navajo
Yazzie, Jimmy J. — Navajo
Yazzie, John — Navajo
Yazzie, John — Navajo
Yazzie, Kathy — Navajo
Yazzie, Larry — Navajo
Yazzie, Leo L. — Navajo
Yazzie, Loretta — Navajo
Yazzie, Louis — Navajo
Yazzie, Lynda T. — Navajo
Yazzie, Raymond — Navajo
Yazzie, Rose — Navajo
Yazzie, Sharon — Navajo
Yazzie, Sharon C. — Navajo
Yazzie, Shirley — Navajo
Yazzie, Susan — Navajo
Yazzie, Tim — Santo Domingo
Yazzie, Venaya J — Navajo
Yazzie, Wil — Navajo
Yazzie, Jr., Kee — Navajo
Yazzie, Jr., Louis — Navajo
Yellow, Francis J. — Sioux
Yellowfish, Edward W. — Other
 Tribes-Comanche-
 Otoe
Yellowhair — Navajo

Yellowhair, Anita — Navajo
Yellowhair, Manuel — Navajo
Yellowhair, Rosie — Navajo
Yellowhawk, Jim — Sioux-
 Iroquois
Yellowhorse, Alvin — Navajo
Yellowhorse, Artie — Navajo
Yellowhorse, Ben — Navajo
Yellowhorse, Betty — Navajo
Yellowhorse, Elsie — Navajo
Yellowhorse, Lynol — Navajo
Yellowhorse, Robert — Navajo
Yellowman, Gordon — Other
 Tribes-Cheyenne
Yellowman, Juan — Navajo
Yepa, Alvina — Jemez
Yepa, Emma — Jemez
Yepa, Ida — Jemez
Yepa, Lawrence — Jemez
Yepa, Lupita — Jemez
Yonnie, Darrell — Navajo
Young, Montie — Cherokee
Youngblood Lugo, Nancy —
 Santa Clara
Youvella, Sr., Alexander — Hopi
Yoyokie, Elsie — Hopi
Yoyokie, Gary — Hopi
Yungotsuna, Elmer — Hopi
Zephier, Mitchell — Sioux
Zohnie, Ida — Navajo
Zuni, Povi — Other Tribes-San
 Juan

About The Author

Robert Painter's first experience with Native American Indian Art came while serving as Director of Social Services for the City of Gallup, New Mexico. Included in the programs of a neighborhood center under his supervision was a sheltered workshop that trained Native Peoples the art of silversmithing. In his spare time, Robert learned from Navajo instructor Wilson Yazzie, the basics of this wonderful art form.

Having been a university professor before moving west, in addition to his duties with the City of Gallup, he taught a group of Navajo HeadStart teachers in a small classroom in Crownpoint on the eastern edge of the Navajo Nation. In this building, at this time, was the budding Crownpoint Weavers Association and their periodic auctions of Navajo rugs. Here Robert began to learn about Navajo rugs and even more about the Navajo people.

After his stint in Gallup, Robert opened a Native Arts gallery in Naples, Florida, known as The Squash Blossom, bringing the art of the Indian Southwest to Southwest Florida. At that time he became a charter member of the fledgling Indian Arts & Crafts Association and has had an abiding interest in Native arts for over twenty five years. In recent years, he has owned and managed The Eagle Dancer gallery in

Albuquerque, participated in Powwows and art events in the southeastern U.S. and developed major art events in Florida and New Mexico for Native artists.

Currently, as the president of First Nations Art, Inc., a non-profit organization dedicated to assisting Native artists in the pursuit of their craft, he is trying to help artists expand their markets to other areas of the United States and to Europe. Mr. Painter tries to attend most of the major Native art events across the country and manages to include most of the smaller events in the southwest as well.

He is also a member of the SouthWestern Association for Indian Arts, Inc., the Friends of the Indian Pueblo Cultural Center in Albuquerque, the New Mexico Indian Tourism Association and is a charter member of the National Museum of the American Indian, Smithsonian Institution and has supported the National Campaign for the construction of the museum for several years.

First Nations Art also supports Futures For Children, an Albuquerque based program that works closely with Native Children in the area. A portion of the proceeds from the sale of this directory will be used to support projects of Futures For Children.

Notice to Artists

If you would like to be included in the next
edition of The Native American Indian Artist
Directory please send the following
information to:

First Nations Art, Inc.
P. O. Box 7596
Albuquerque, NM 87124
or
e-mail: www.Painter60@aol.com

Name
Mailing Address
Tribal Affiliation
Type of Art
Brief Description of Art
Phone Number (can be a message phone)
e-mail address (if available)
web site address (if available)

Ordering Information

If you would like additional copies of The Native American Indian Artist Directory **please follow the instructions below.**

Please send the following information:

Name

Mailing Address

Number of Directories

Check or money order (sorry, no credit cards)

Send $19.95 + $3.00 (each) shipping & handling to:

First Nations Art
P. O. Box 7596
Albuquerque, NM 87124

Please send e-mail inquiries about wholesale accounts to: www.Painter60@aol.com or write to the address listed above. Thank you.

Valliant Since 1918

Printing • Copying • Legal Forms

Valliant Printing

A Native American Company serving the Native American Business Community

We are a full service Commercial Printer and Copy Shop with a Complete Bindery.

- Typesetting
- Graphic Design
- Digital/traditional prepress
- 4 color printing
- Full color copies
- Letterpress
- Long and short-run printing

Valliant Printing

Is proud to bear the symbol that
helps keep our community in
view. We are a Native American
owned and operated company,
and by imprinting this logo on
your materials, we reinforce the
prominence of Native American
businesses in this region.
As part of the Native American
community, we recognize our
heritage as a source of
great pride.
Show support by continuing to
do business with Native
American companies.

Valliant Printing
615 Gold Ave. SW
505.247.4175-phn
505.246.8891-fax
1.800.432.4608
www.valliant.com

NOTES

NOTES

NOTES

NOTES